HRH

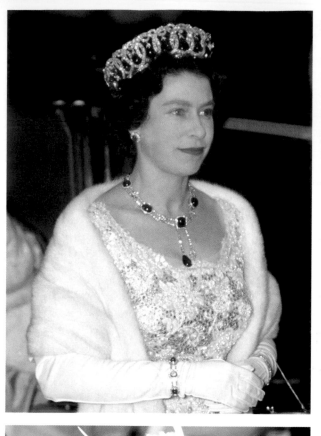
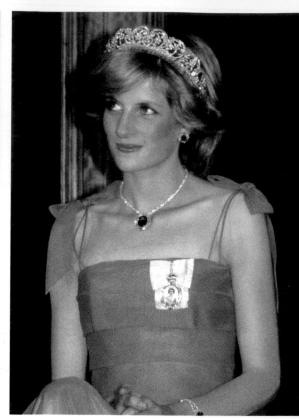

HRH

SO MANY THOUGHTS
ON ROYAL STYLE

ELIZABETH HOLMES

CELADON
BOOKS

NEW YORK

www.celadonbooks.com

Book design by Shubhani Sarkar,
sarkardesignstudio.com

Library of Congress Cataloging-in-Publication Data

Names: Holmes, Elizabeth, 1980- author.
Title: HRH : so many thoughts on royal style / Elizabeth Holmes.
Other titles: Her Royal Highness
Description: First edition. | New York : Celadon Books, 2020.
Identifiers: LCCN 2020024954 | ISBN 9781250625083 (hardcover) |
 ISBN 9781250625090 (ebook)
Subjects: LCSH: Princesses—Great Britain—Biography. | Queens—Great
 Britain--Biography | Clothing and dress—Great Britain. | Elizabeth II, Queen
 of Great Britain, 1926- | Diana, Princess of Wales, 1961-1997. | Catherine,
 Duchess of Cambridge, 1982- | Meghan, Duchess of Sussex, 1981-
Classification: LCC DA591.A1 H65 2020 | DDC 941.085092/52—dc23
LC record available at https://lccn.loc.gov/2020024954

Our books may be purchased in bulk for promotional, educational, or business
use. Please contact your local bookseller or the Macmillan Corporate and
Premium Sales Department at 1-800-221-7945, extension 5442, or by email at
MacmillanSpecialMarkets@macmillan.com.

First Edition: 2020

10 9 8 7 6 5 4 3 2 1

For Matthew

CONTENTS

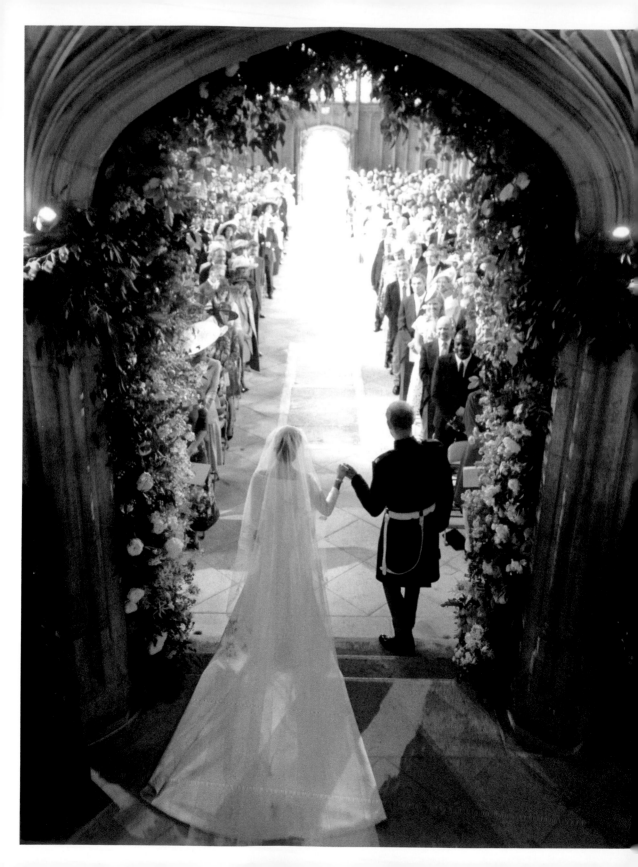

INTRODUCTION

What they are wearing is the way they make their statement,
it's the way that they claim their place in history.

ROBIN GIVHAN, *THE WASHINGTON POST*

THE MORNING THAT MEGHAN MARKLE MARRIED PRINCE HARRY, I SET MY ALARM for long before dawn, giving myself plenty of time to shower, do my hair and makeup, and properly attach my fascinator. I was not headed to St. George's Chapel at Windsor Castle (as much as I wished I were!), but I had splurged for my own VIP accommodations: a room at the Four Seasons near my California home, some 5,000 miles from the happy couple. I was on assignment for *Harper's Bazaar*, tasked with providing my exclusive commentary on the festivities, and the hotel room gave me space to work away from my husband and young children. I was alone there, but it sure didn't feel like it. Clutching my iPhone, I had a bevy of fellow royal enthusiasts on hand waiting to discuss—and gush! — with me on social media. I changed from the fluffy white hotel robe into the fresh set of pajamas I bought for the occasion (and ironed in advance, naturally). Perched on the end of the bed, I flipped on the television and waited anxiously for the first glimpse of the bride and her dress.

My carefully orchestrated viewing party of one was much more considered than the first royal wedding I watched live back in 2011. When Kate Middleton married Prince William, I was in the throes of planning my own nuptials and found myself hopelessly drawn to the real-life fairy tale of a commoner finding her prince. I pulled an all-nighter in order to follow along, having flown cross-country the night before to Los Angeles from New York. My now-husband picked me up at the airport and we raced through the empty city streets, listening to the pre-event coverage on the radio. I made it to a television just moments before the future Duchess of Cambridge appeared in the back seat of a chauffeured Rolls-Royce.

Will and Kate's wedding was my introduction to the House of Windsor. I had been aware of the fancy family across the pond—my college roommate and I definitely talked about Will once or twice—but I wasn't entrenched in its regular happenings or long history. I was too young to follow Diana in real time; the Queen was less of a stately figurehead to me than an adorable, elegant grandma clad in very colorful clothing. But Kate felt like

a contemporary with a really compelling story. I was intrigued enough to keep tabs on the wedding planning, and hooked by the time the big day rolled around.

I still smile thinking about it. I held my breath as Kate stepped out of the car in her stunning Alexander McQueen gown and swooned as the newlyweds exited the church to the joyous combination of church bells and cheers. The hastiness of their first kiss (or was it a peck?) on the balcony of Buckingham Palace made me chuckle, as did the crowd's demand for a do-over. When pictures emerged of Kate's second dress for the evening reception, my heart soared. She was wearing a sparkly belt that looked a lot like the one I planned to wear to my own reception later that year. It was all utterly enchanting and turned me into an enthusiastic royal follower.

Their wedding coincided with a new professional chapter for me. Many years into my decade-long run at the *Wall Street Journal*, I moved from covering corporate news to the features team. As a newly minted style reporter, I sat in the front row at fashion weeks in New York and London, and interviewed big-name designers and stylists for A-list celebs, as well as some of the stars themselves. Writing for a newspaper renowned for its financial coverage, my articles focused on the inner business workings of the global fashion industry. I looked at how brands were built and marketed, as well as how collections were designed and positioned to entice shoppers. I had always loved clothes and known how beautiful they could be; my reporting taught me just how much influence and meaning fashion held, too.

In 2017, my royal interests and professional pursuits merged when I began commenting on Kate and Meghan via social media. It started quite casually, as I screenshotted pictures and punctuated them with quippy asides like "HERE FOR IT!" The pithy remarks were my way of delighting in the pageantry or poking fun at the formality. But the more I followed the women's appearances, the more I saw beneath the shiny veneer. Their clothes were sending a message, which I was able to parse after years of reporting in this space. I began doing my own research on the history of royal fashion; my commentary grew much more informed around a profound appreciation for the thought these women put into their outfits.

By Harry and Meghan's wedding, in the spring of 2019, decoding royal fashion had become part of my job. It was so exciting to see a biracial American woman join the royal family, and the sartorial choices that day felt deeply meaningful. I delighted in the Queen's choice of a vibrant neon green coat and hat, which ensured she stood out in the crowd. The mother of the bride, Doria Ragland, wore an eye-catching shade of paler lime that coordinated so nicely (and, I want to believe, quite purposefully) with Her Majesty; the floral embroidery around the bottom half of Doria's coat was reminiscent of the design on her daughter's veil. Kate's Alexander McQueen coat dress resembled a style we had seen her wear before, a gracious attempt to avoid stealing the spotlight.

But it was Meghan's sleek, strikingly minimal gown that moved me to tears. Designed by Clare Waight Keller, the first female British head of the famed French fashion house Givenchy, it featured a bateau neckline and just six exquisitely placed seams. Without a hint of lace or sparkle, it was worlds away from the massive, frothy confection that nearly swallowed up Princess Diana on her wedding day. Meghan's dress was modern and sophisticated, representing the global appeal of the woman wearing it. "It was just very much *not* a princess dress," said Robin Givhan, the Pulitzer Prize–winning fashion critic at the *Washington Post*. "She wasn't going to be floated down the aisle like a prize."

ROYAL FASHION IS SINGULAR IN ITS PURPOSE AND ITS POWER. HRH IS SHORT FOR "Her Royal Highness," a title that comes with great responsibility. These women are global superstars, but they are not celebrities or politicians with agency to do or say as they please. Members of the Firm, as the family is known, don't traditionally give revealing, personal speeches; the interviews they grant are rare and mostly focused on charitable work. What they do is appear in public, quite often, stepping out to support an existing endeavor or draw attention to a new initiative. They are there to be seen, and photographs of these carefully staged moments go around the world in seconds. The first thing that jumps out in those pictures, before we know what event Kate is attending or what cause Meghan is championing, is what they are wearing. A flood of fashion coverage ensues, with style reporters and fan sites rushing to track down every detail of their outfits. The scrutiny is intense. "But it also affords them an opportunity," Emily Nash, royal editor at *Hello!* magazine, told me. "They understand the unique power they have to convey these messages without saying a word."

We can never know for certain what a royal woman is trying to say with her clothing—after all, the family lives by the motto "Never complain, never explain." But we can make educated guesses, based on research and firsthand accounts from palace insiders that reveal the considerable thought behind their looks. Some of the messages are quite obvious, like when Kate wore a traditional shalwar kameez and dupatta on tour in Pakistan, a gracious gesture to the host nation. Others can be more subtle, offering clues about what matters to them, as seen in Meghan's dedication to wearing smaller brands founded by women or committed to sustainability. Beyond a single moment, their outfits can have a broad and profound cultural effect, too. Both duchesses wore dresses displaying their still-visible baby bumps soon after giving birth, helping to normalize postpartum bodies for generations to come.

With their considered style of dressing, Kate and Meghan are following in the footsteps of Queen Elizabeth II and Diana, Princess of Wales. These two towering figures in the

modern British monarchy paved the sartorial way with their wildly different (and at times opposing) approaches to style. The Queen took to the throne after her father's sudden death, with her uncle's chaotic abdication still lingering in the country's consciousness, and has kept her appearance astonishingly consistent for decades. Her hat, coat, and bag—and perhaps even her corgis—have served as a calming uniform in the most turbulent times. Diana leaned into the fun and feeling of fashion, unlocking its ability to shock and awe. Her sequins and shoulder pads rejuvenated interest in the royal family and she used that exposure to her benefit, turning to fashion to reclaim her voice amid her disastrous divorce.

These days royal clothing is also a reason to care about, and keep tabs on, the contemporary members of a centuries-old institution. Kate and Meghan are beautiful women in beautiful clothes, decked out in stately coat dresses and towering stilettos, topped off with feathery fascinators and glittering jewels. Fashion magazines and fan sites chronicle their every choice breathlessly, and shoppers rush to buy whatever they can afford. The duchesses know what they wear grabs our attention and—here's the important part—it opens the door to learn more. If you like Kate's floral dresses, you might see that she's wearing a floral dress in a garden she helped put together; while she has your eye, maybe you'll notice she's keen to promote the benefits of outdoor play for young children, as part of her commitment to early childhood education. It all serves a much higher purpose.

But mostly, if you like Kate in a floral dress, you might like Kate. And you might be excited about her future as queen consort. If you're British, that might mean you are willing to go along with this pageant (and I say that with love) for another generation. For those of us abroad, especially in the United States where we revel in the spectacle without investing our tax dollars or national identity in it, we can see Kate in a floral dress and smile. It reinforces the idea that the royal family is Britain's top cultural export, and anything but its continued existence would be positively unthinkable.

"ROYAL FASHION IS RIGHT AT THE HEART OF THE REPRESENTATIVE MONARCHY," SAID Robert Lacey, British historian and advisor to *The Crown*, the award-winning television drama chronicling the life of Queen Elizabeth II. Put another way: "These royal characters are actors, and the clothes they are wearing are stage costumes." In the 1600s, Henrietta Maria married King Charles I in a wedding dress adorned with fleurs-de-lis, a symbol of her French heritage. Two centuries later, during the Industrial Revolution, Queen Victoria brought handmade lace back into fashion with her wedding gown of lace from Honiton. The small town in the county of Devon had been struggling to compete with machine-made alternatives, and the royal nod led to a massive resurgence in demand.

Queen Victoria's reign coincided with the rise of photography and then film, spreading pictures and footage of the monarch throughout the British Empire. "She would have been one of the most recognizable figures in the world in the nineteenth century," said Carolyn Harris, a historian, author, and royal commentator. The sovereign took a keen interest in the new medium. She sat for formal portraits but also much more casual photographs. Clad in everyday attire, these pictures helped make her more accessible than her predecessors. After her husband died, Queen Victoria wore only black to signal her mourning; she even insisted the women around her do the same. Continuity has become something of a royal fashion tenet. Queen Mary, Queen Elizabeth II's grandmother, stuck to her floor-length Victorian-style dresses even as shorter dresses became fashionable in the 1920s and 1930s.

You can imagine a studious and serious young Princess Elizabeth taking notes on the women who came before her while shaping her own sartorial strategy. The Queen ascended to the throne in 1952, at the age of just twenty-five, and kicked off her reign with a glamorous charm offensive. Once established as a formal figurehead, she devised a uniform of sensible skirt suits and mastered the art of fashion diplomacy, incorporating local colors, symbols, and styles into her wardrobe on tour. The Queen has always known how special it is for people to catch a glimpse of her and has long worn bright, solid shades because it allows her to be seen in a crowd. "Her presence is intended to be an uplifting event and her clothes represent that," said Victoria Murphy, a royal correspondent. Every aspect of an ensemble is considered, including the cut of a coat's armhole to permit waving and hand-shaking. Even her hair has stayed astonishingly the same, the perfect brushed-back set curls to hold a hat or a tiara.

The other side of steadfastness is that by the 1970s royal fashion wasn't particularly exciting—and then along came Lady Diana Spencer. The nineteen-year-old aristocrat was a demure dresser when she became engaged to Charles in 1981—one might even say a tad frumpy, favoring baggy sweaters and modest skirts. She sought early fashion advice from *British Vogue* editors and underwent a spectacular makeover, turning her new royal life into a runway. She delighted in fashion and began experimenting with it in a way that no contemporary royal woman had before or frankly has since. Diana quickly mastered the language of clothes and used her wardrobe to send messages both professional and personal (the latter being particularly novel). She understood how a fabulous outfit could empower the wearer and wow the viewer. Her entrance onto the royal scene coincided with the rise of glossy weekly magazines like *People* that were thrilled to have her as their cover star. The Princess of Wales quickly became a worldwide sensation.

Diana's tragic death in 1997 brought to a close a chaotic, scandal-filled decade for the royal family, one that wreaked havoc on its approval ratings. The Firm lay low without a young star for years, until Prince William began dating Catherine Middleton. The pair met

at the University of St. Andrews, Diana's eldest son falling for a quiet commoner from an upper-middle-class family. Their extended courtship was subjected to press scrutiny for years. Through it all, Kate kept her head down and her style buttoned up. The couple got engaged in 2010, when Kate was twenty-eight, and she continued to favor relatively simple styles from High Street brands. Her off-the-rack wardrobe introduced a new and novel idea to the Firm: *Royals, they're just like us!* They're obviously not, but there was (and, perhaps, still is) something so enticing about relating to them. Style sites chronicling Kate's choices began to pop up, identifying not just her dresses but her shoes, her hats, and her jewelry. Thanks to the advent of online shopping, what Kate wore quickly sold out. There was even a name for the phenomenon: the "Kate Effect." It added an intense new dimension to the fandom and gave the duchess the ability to put a brand on the map just by wearing it.

Meghan Markle's arrival in 2017 attracted a new audience, inspired by her confident and relaxed Southern California style. People who had never cared about the institution took a look when a biracial American joined its ranks. It was a massive opportunity for the royal family to finally diversify. At age thirty-six, Meghan was a fully fledged career woman working as a successful television actress. She knew how to use clothes to tell a story, having spent time on set with a costume designer and on the red carpet with a stylist. She was also an influencer, boasting nearly two million followers on Instagram alone, with a keen understanding of what makes digital fashion coverage sing. Her savvy upped the game, bringing the British Royal Family and its fashion into the modern age.

––––––––––

IF YOU THINK GETTING DRESSED IN THE MORNING IS A CHALLENGE, CONSIDER WHAT these women face. They must please their fans who are clamoring for exciting styles, while simultaneously sustaining and promoting the monarchy. The latter requires them to make their choices within a strict set of parameters. There are a few occasions with written rules but far more pervasive are the nebulous myths of "protocol," like when a woman must wear hosiery or what shades of nail polish are acceptable. It's part of a broader cultural insistence on sophisticated modesty, an expectation that they be composed and presentable at all times. "They are literally there as visual representations of a country," said Vanessa Friedman, fashion director of the *New York Times*. Being a member of the royal family is a life, not a job. And there is no reprieve. "As soon as they leave their houses, they are representing," Friedman added. "You're never really off duty if your job is the crown." Fashion can be problematic, too. Sartorial messaging is not a selective tool. We can't celebrate Kate for wearing Beulah London, a small British brand focused on women's empowerment, and ignore her decision to wear Dolce & Gabbana after the Italian luxury house made headlines for a racist marketing campaign.

Always watching are the U.K. taxpayers, who demand that the royal family walk an impossible line of special yet sensible. They must be deserving stewards of the Sovereign Grant, the tens of millions of pounds given by the government to fund the Queen's duties each year. The money primarily goes to maintaining the monarch's residences—not their clothes—but it's still an easy target for criticism. The royals do not accept freebies, as a celebrity might; they cover those costs themselves.

All of this plays out in the media, a necessary, if at times unwelcome, dance partner. The royal family relies on the press to spread their message and amplify their cultural importance, while the news outlets doggedly chronicle their every move—and outfit—to attract readers and viewers. In the Queen's early days, there was a distance and discretion to the reporting. That meant her clothing messages had to be quite obvious. On a visit to California, for example, she wore a gown with orange California poppies. By the time Meghan became Harry's girlfriend, invasive paparazzi were able to capture the smallest details. Among the earliest confirmation that the two were dating was a shot of Meghan's delicate necklace featuring the letters "H" and "M." *Us Weekly* deemed it "Royally adorable!"

The intense coverage has amped up the economic stakes, too. Designers of Diana's clothes were credited only sporadically; now, nearly every time Kate or Meghan appears, the brand they are wearing is identified on social media. Sometimes the company will blast out a press release or post a picture on social media. If the item is currently in stores, it almost always sells out. The press, and more recently bloggers, keep a tally of their estimated annual expenditures. These guesses are, at best, extremely rough because nobody knows what price royals actually pay (although it's likely less than traditional retail prices). But the numbers, sometimes reaching into the six figures, are spread widely and used by their critics as symbolizing a life of excess. The frenzy led to a bit of reluctance by aides to share fashion details, no matter how much work or thought went into the ensemble.

"I can see [the palace's] frustration because it can detract from the message they are trying to get over, which is a charity they're giving to, the issues that they're trying to highlight," said Richard Palmer, royal correspondent for Britain's *Daily Express* newspaper. "And all the bloody press wants to talk about is what she's wearing." It's quite one-sided, too, with the focus and the dissection falling almost exclusively on the women rather than the men. "I'm not inundated with requests on Charles's outfits," Palmer added, stressing that the coverage is driven by the interest from readers. "I think many young women dream about being a princess."

––––––––

AND THEREIN LIES THE CONTINUED APPEAL OF THE BRITISH ROYAL FAMILY TO A generation of fans raised on Disney movies. These royal highnesses are part of the fantasy of a real-life fairy tale. We get up early to watch their weddings, we delight over the births

of their babies, we devour photographs of them on magazine covers in the supermarket checkout aisle.

The royal family's drama has a cinematic quality about it, too, filled with betrayal, broken hearts and—as seen through both Diana and Meghan—breaking free. There is a tragic, torturous aspect of this immensely privileged existence. The late Princess of Wales was hugely criticized for overstepping in her quest to open up the monarchy. Her private life was the source of endless prying and ridicule by the press. Palace aides threatened by her popularity sought to cast her as difficult and unwell.

The Duchess of Sussex exposed a new generation of royal fans to an even more sinister undercurrent. Meghan was subjected to hateful racist coverage in the press, with harmful narratives painting her as an unworthy outsider. Rumors were rampant about rifts and hostile exchanges behind the scenes, too. Legal documents said Meghan felt "unprotected by the Institution, and prohibited from defending herself." It was awful to watch the abuse unfold; the famously unbending and tight-lipped House of Windsor made it worse, doing very little to publicly support Meghan and Harry until it was too late.

Decades of turmoil have changed how and what the royal family shares with the public. In Diana's day, photographers were invited to capture candid photos of the family in their private residences. "In a way, fashion has replaced that," said Elizabeth Angell, digital director of *Town & Country* and *Elle Decor*. Clothing is one of the few remaining glimpses we have into their personal lives.

"Their outfits are the first thing I notice and the first thing I want to talk about," said Kaitlin Menza, a writer and former co-host of the *Royally Obsessed* podcast with Lisa Ryan. Clothing is a powerful point of connection. Take the Madewell jean jacket Meghan wore to a beach in Cape Town, South Africa, on tour in the fall of 2019. "That happens to be the staple of just about every woman in New York," Ryan said. "She was wearing our uniform and it felt like, 'Oh, wow, she's one of us.'"

Why do we care so much about what these women wear? We care because they care, and they care because they know the world is watching. Parsing their savvy and smart messages is a way of respecting their efforts.

My thoughts shared in this book are based on extensive reporting and research, including a few firsthand accounts from those in the royal fold. As you peruse these pages, I think you might be surprised, as I was, at the ways in which the Queen, Diana, Kate, and Meghan are unique and yet connected, too—and the collective story they tell. Their wardrobes are a treasure trove of meaning. Beyond the specific analysis of any one look, my hope is for us all to see the power of fashion. If this is one way these women speak, then this is one way we should listen.

ELIZAB

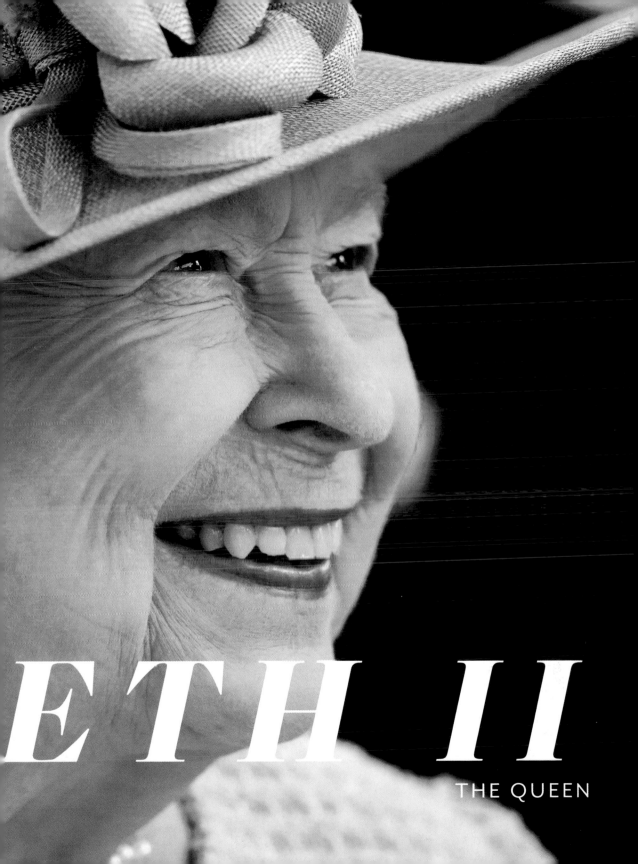

ETH II

THE QUEEN

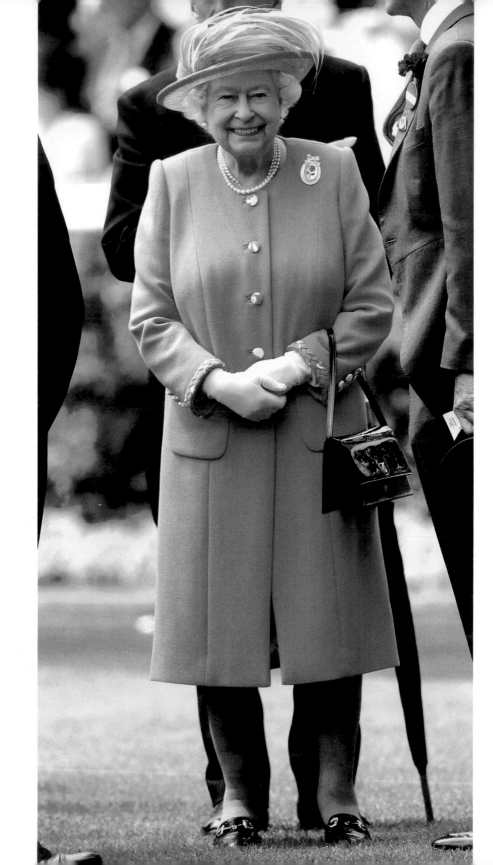

CLOSE YOUR EYES AND PICTURE QUEEN ELIZABETH II. WHAT IS SHE wearing?

My guess is you've conjured up an image of Her Majesty in a simple coat that hits just below her knees. It's a pretty pastel or, more likely, a vibrant, saturated hue, maybe a rich coral or a sunny yellow. On her head rests a coordinating hat with a brim big enough to hold a piece of flair, like a feather or a flower, but not large enough to obscure her face. The hem of a printed dress peeks out around her knees and bright white gloves cover her hands. Pearls dot her ears and lie, in strands of three, around her neck; a brooch is pinned on her left side. Her shoes and bag are sturdy and black.

The longest-reigning British monarch in history has redefined what it means to dress like a queen. Her look, settled on long ago and honed over several decades, is impressive in its creativity; there is, after all, no crown required. The lasting image of Her Majesty will be this bright and bold daytime style, rather than the rarer occasions in which she is clad in the sovereign's full regalia. Her look is at once totally timeless and utterly unique. Never before, and likely never again, will anyone dress like she does.

"She's a strategic genius," said Vanessa Friedman, fashion director of the *New York Times*. "She understood that she was going to be looked at, always—as you would if you're the Queen—and that she would need a kind of public uniform. And she picked one."

Let's take a minute to appreciate Her Majesty, because who else among us can pull off chartreuse with such aplomb? I find the consistency of her clothes immensely calming. She looks the same day in and day out, setting and fulfilling our expectations without ever feeling stale. It's nearly all custom-made, aside from perhaps a Barbour jacket and some Hermès scarves, which means there isn't the frenzy to chronicle or shop her looks. They are hers and hers alone.

At its core, Her Majesty's wardrobe is about function, not fashion. The head-to-toe color allows her to be seen in crowds, whether at a ribbon cutting or amid her royal offspring on their famous balcony appearances. Every detail is considered, from the depth of the neckline (lower and cooler in spring, higher come fall) to the shape of the skirt (pleats added when extra movement might be needed). The sturdy block heel of her shoes helps her to stand for hours at a time. Her purse handles are long enough to hang comfortably but not so long as to inhibit hand-shaking. The positioning of the bag sends its own message, as to whether the Queen would like to continue a conversation or move along. And then there are her daytime hats, the colorful discs that cover her head when she leaves the palace. Very few modern women wear a hat as part of their work uniform, aside from perhaps members

of the armed forces, notes Robert Lacey, a British historian and biographer: "It's a reminder that the Queen is indentured to a service, to a job."

"I HAVE TO BE SEEN TO BE BELIEVED," QUEEN ELIZABETH II FAMOUSLY ONCE SAID. She was right: the Queen serves as Head of State, a lofty title for a largely symbolic position. As a constitutional monarch, she cannot make or pass legislation (that's up to Parliament) nor does she take a political stance. Her power is in her public presence, a series of highly choreographed appearances. At home, she is the steady hand of the nation; on tour, she is a glittering ambassador to promote its economic and strategic interests abroad. The National Portrait Gallery deemed the Queen "the most portrayed individual in history," associated with more than 950 portraits. She was crowned in the first televised coronation in 1953, which brought her into her subjects' homes. And she has been there ever since, her image plastered on teacups and reimagined on bobblehead dolls.

In her role, the Queen is said to care not about fashion but about clothes, and the power they hold. She was born into royalty and dressed for display from an early age, and she has carried those lessons with her throughout her long life. She dresses with an eye toward what is appropriate, rather than what silhouette is in vogue. "More than anybody in the world, she dresses according to occasion, duty, hosts, guests, custom, formality," said Sali Hughes, a Welsh journalist and author of the book *Our Rainbow Queen*.

The Queen's annual calendar serves up the same series of engagements year after year— the royal equivalent of lather, rinse, repeat—in a mix that is formal and fun. She is at her grandest for the State Opening of Parliament, making her way down the aisle in a fur-trimmed velvet cape so heavy it requires several young boys to carry it. Every June, she peacocks with panache at Royal Ascot. For the five-day series of horse races, the Queen wears her brightest, boldest daytime fashion of the year. The bookies take bets on what color her hat will be.

Looking the part of a queen requires, as one would expect, some sparkle. When the occasion calls for it, she is very willing to pile on the bling. We're talking a tiara with chunky earrings, a statement necklace, and a brooch with a few bracelets, too. It's following the belief put forth by her ancestors that a visual display of wealth conveys the monarch's power and influence. Jewels are much more fun when worn, after all. (Elizabeth's grandmother, Queen Mary, wore a tiara to dinner every night.) During a tour of Southern Africa while their father was king, sisters Elizabeth and Margaret would disembark the royal train in dressing gowns and jewels to show locals their finery.

And yet, as fancy as she can be, the Queen is also immensely frugal. New jewelry has often been made using stones taken from other, more dated pieces. She repeated her

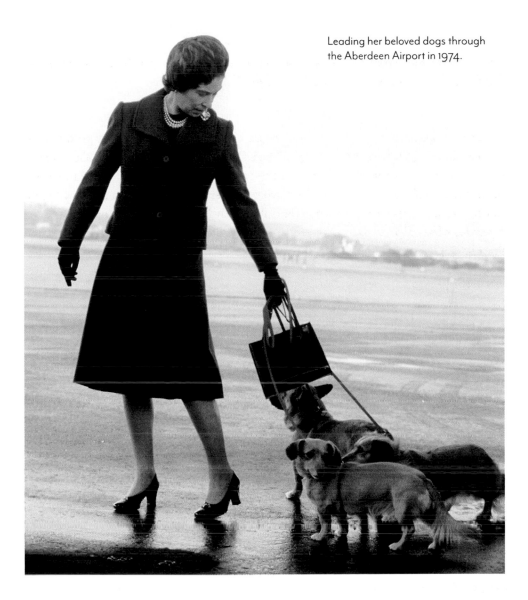

Leading her beloved dogs through the Aberdeen Airport in 1974.

coronation gown six times after its debut (six!), in part to show it off to the world, but also one has to guess that meant no need for six *other* gowns.

These days the Queen's wardrobe is handled by a team that includes five dressers, a dressmaker, and a milliner. It is an immense logistical undertaking with looks planned far in advance and recorded in a spreadsheet to ensure repeats are properly spaced. It is, nearly always, the same combination of shapes in a rotating rainbow of shades. "There's absolutely nothing modern about the way she dresses," said Robin Givhan, fashion critic at the *Washington Post*. But that's the point. The Queen is a living monument, a symbol of consistency and

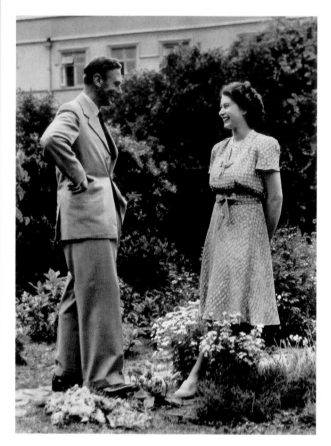

Sharing a smile with her father, King George VI.

reassurance. Can you imagine the alternative, if she were fluttering about in designs from one couture house to the next? What if she wore whatever style was trending? As Givhan put it: "It would be unnerving."

———

ELIZABETH ALEXANDRA MARY WAS born on April 21, 1926, the eldest child of the Duke and Duchess of York. She was never meant to be queen. Her father was the second son of King George V, taking her family out of the direct line of succession. Elizabeth and her sister, Margaret, were very much in the royal fold and able to enjoy its benefits but spared the scrutiny of being direct heirs (much like Princesses Eugenie and Beatrice today).

For most of Elizabeth's early life, her wardrobe was in the hands of her longtime dresser Margaret MacDonald. A Scotswoman who began as an under-nurse for Elizabeth's parents, MacDonald first served as a nursemaid to young Lilibet, as the princess was known. The pair shared a room until Elizabeth was eleven, and MacDonald even accompanied Elizabeth on her honeymoon. MacDonald was famous for her frugality, teaching the young princess to smooth wrapping paper in order to use it again, and hang her clothes up herself each night.

Elizabeth grew up in austere times, when rationing was often required and thriftiness was prized. The fashion mantra at the time was "make do and mend"—and that applied to the royal family, too. "The children could not have been more simply dressed. They wore cotton frocks, mostly blue with a flower pattern, and little cardigan coats to match when it was cool," recalled the girls' former governess Marion Crawford, in a 1950 memoir *The Little Princesses*. (The publication got her ghosted from the royal family for life—'twas a serious scandal at the time to divulge the inner life of the royal family.) Crawford described their wardrobes as "almost severe." Kate appears to have taken notes; Princess Charlotte and Prince Louis often sport their big brother Prince George's hand-me-downs.

In 1936, the course of history—and Elizabeth's life—changed forever. That December, less than a year after Elizabeth's uncle became King Edward VIII, he abdicated in order to marry Wallis Simpson, a twice-divorced American. Divorce is a part of the royal family's narrative today; three of the Queen's four children are divorced, and Harry married Meghan after her first marriage ended in divorce. But back then, it was a deal breaker. The abdication was a time of massive, existential crisis for the monarchy, undermining its core notions of duty and sacrifice. The very purpose of inherited power was called into question when the rightful heir just quit, for something as comparatively trivial as love.

Elizabeth's father, famously an introvert with a stammer, became king, which made the ten-year-old princess the heiress presumptive. (She was not called the heir apparent, because some holdouts still hoped her parents would produce a son.) You might be thinking how romantic that sounds, a crazy series of events that would rearrange the stars to set the young princess up for a dazzling future. Not quite. Rocked by the scandal of the abdication, the family assumed the mantle dutifully, but not eagerly. "Poor you," was six-year-old Margaret's reaction to the news her sister would one day "have to be" queen. Bertie, as Elizabeth's father, Albert, was known, chose to become King George VI to project continuity from the tenure of his own father, King George V. Reluctantly, "We Four" as the King, Queen, and two princesses referred to themselves, gave their lives over to the institution. The future of the monarchy, as uncertain as it had ever been, rested on their shoulders.

Just as the young family settled into its new fate, World War II began. Buckingham Palace was struck with a series of German bombs in 1940, nearly killing the King and Queen. Elizabeth spent much of the war guarded by troops at Windsor Castle, her whereabouts considered a national secret. She begged her father to be a part of the war effort, an unprecedented move for a princess. The King relented and Elizabeth became the first female member of the royal family to achieve full-time active status in the armed services working as a mechanic. Her stint in uniform was brief but the resulting pictures serve as a lifelong testament to her seriousness and sense of duty.

In the post-war period of peace, with renewed hopes of prosperity, Princess Elizabeth was repositioned once again. She was photographed in soft-focus portraits wearing floral dresses and glamorous gowns, a youthful and feminine beacon of hope. But even this new stage had a sensible bent. Many of Elizabeth's ensembles originally belonged to her mother and had been remade to fit her.

The war, coupled with Elizabeth's looming destiny, meant that she did not, at any point, experience a rebellious teenage phase—or even a hint of wild adolescent abandon. (Margaret's words are ringing in my ears: "Poor you" is right.) The burden of duty and sacrifice was placed on her young shoulders and molded her into the staunch sovereign we follow today. On the occasion of her twenty-first birthday, she sealed her own fate: "I declare before

you all that my whole life whether it be long or short shall be devoted to your service," she said in a radio address. With those three words—"my whole life"—she pledged herself to her country and the Commonwealth. Being queen, Elizabeth made it clear, was a lifelong calling.

ELIZABETH'S STEADFASTNESS HAS SERVED HER WELL IN LIFE AND IN LOVE. AT THE age of just thirteen, she fell for a dashing, rowdy cadet at the Royal Naval College. Five years her senior, Lieutenant Philip Mountbatten was the only son of Prince Andrew of Greece and Denmark and Princess Alice of Battenberg. Still, his pedigree wasn't ideal, coming from a broken family within dissolved monarchies. Courtiers discouraged the relationship. But Philip was tall, handsome, and oh-so-spirited; Elizabeth, although she had several other suitors, is said to have never looked at another. If you are going to be defiant about one thing in life, it might as well be who you share it with, am I right?

Philip asked Elizabeth's father for her hand in marriage in 1946, when the princess was twenty. The King gave his permission but asked the pair to wait, given Elizabeth's young age, for a formal announcement until after her duties on the Southern Africa tour were complete. (It seems the Queen did not learn any lessons here. She clearly supported Charles's proposal to Lady Diana Spencer when Diana was just nineteen. More on that in a bit.)

Their engagement was announced on July 9, 1947, via the Court Circular, and the wedding was scheduled for November. It was a massive pick-me-up for post-war Britain, with Elizabeth spectacularly delivering on the desire for the fairy-tale princess. Her dress was made of elaborately embroidered duchesse satin with a fifteen-foot silk tulle full court train. She wore pearls given to her by her father and Queen Mary's Fringe Tiara, on loan from her grandmother for the occasion. With the spectacle came scrutiny, too. Ahead of the wedding, inquiries were made about the origins of the silkworms used in the design (can you even!). The palace confirmed they were from China, rather than Italy or Japan, which had recently been enemy territories.

Elizabeth enjoyed five years of marriage, and the birth of two children, before fate threw in another plot twist. King George VI died suddenly in 1952, at the age of fifty-six, his reign lasting just fifteen years. Nobody could have known then just how epic Elizabeth's tenure would be, that she would surpass the previous sixty-three-year record reign held by Queen Victoria. At the time, doubts swirled around the twenty-five-year-old, with a tearful Prime Minister Winston Churchill lamenting: "She is only a child."

So it's no surprise that Elizabeth was determined to be taken seriously. "Keeping her dignity was paramount," wrote biographer Sally Bedell Smith. "And in doing so she frequently obeyed Queen Mary's injunction against smiling." A no-smiling strategy! Can you imagine

if Kate or Meghan tried to do something like that? Anything less than a grin is pounced on by the press. But it suited the Queen, who isn't particularly smiley by nature. It also means that when she does flash a big grin, you can see how genuine it is.

Elizabeth spent more than a year preparing for her coronation, the elaborate religious and symbolic occasion of the investiture ceremony. She paced the ballroom at Buckingham Palace with bedsheets and weights as a stand-in for her robe and train. She wore the crown, too, to get used to the weight on her head. Sir Norman Hartnell, the British designer and influential tastemaker who made the Queen's wedding dress, was given the honor of designing her coronation gown. Elizabeth requested symbols of the United Kingdom and Commonwealth countries—including the Canadian

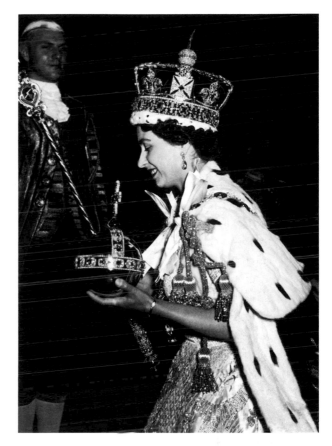

Arriving at Buckingham Palace after her coronation in 1953.

maple leaf, New Zealand fern, and Pakistani wheat—be portrayed in sumptuous silver, gold, and pastel embroidery on her white satin gown. The day itself was a smashing success, with celebrations around the globe. "The coronation was like phoenix-time. Everything was being raised from the ashes," the Queen's sister, Princess Margaret, later said. "There was this gorgeous-looking, lovely young lady, and nothing to stop everything getting better and better."

IN NOVEMBER 1953, SHORTLY AFTER HER CORONATION, THE QUEEN AND PRINCE Philip embarked on an epic tour of the Commonwealth lasting nearly six months. Elizabeth brought more than 100 new outfits designed by Hartnell and Hardy Amies, another influential designer in these early years. Hartnell established a set of parameters for the Queen's wardrobe that wouldn't inhibit her duties. This was, after all, a wardrobe for work. "Her hat has to be off her face so that her picture can be taken and it can't be so big that she has to

hold it to keep it from blowing away," he told the *New York Times*. "After all, a queen needs one hand for accepting a bouquet, and another for shaking hands." That first decade was the most conventionally fashionable time of Elizabeth's reign, with ladylike circle skirts and peep-toe pumps during the day and sparkling ball gowns dripping with diamonds at night. Her petite, hourglass figure was compared to that of a pinup's.

But a decade later, amid the counterculture of the 1960s, the public began to question the role and the expense of the royal family. "The English are getting bored with their monarchy," Malcolm Muggeridge, a British journalist, said in 1964. The solution the Windsors came up with was access. Why not open up the famously closed castle?

The Firm commissioned a documentary called, quite simply, *Royal Family*. Prince Philip led the charge, having enjoyed a warm reception to his own television appearances. "I think it's quite wrong that there should be a sense of remoteness or majesty," he said when asked about the film. "If people see, whoever it happens to be, whatever head of state, as individuals, as people, I think it makes it much easier for them to accept the system or to feel a part of the system."

Rather than dip a toe into these new waters, they plunged into the deep end. Filming *Royal Family* lasted a year, the resulting footage edited down to a 110-minute special. There was plenty of time devoted to the Queen performing her professional responsibilities, but what resonated were the personal moments (as they always do). In addition to being a stately, regal monarch, the Queen was a wife and a mother, working at a cluttered desk and buying her son ice cream. At the family barbecue, Philip grilled sausages while Elizabeth made salad dressing. It was a major moment of normalcy, and the public devoured it. Tens of millions of people tuned in, and the sentiment shifted back to the royal family's favor.

But critics quickly offered a rebuttal, suggesting the Queen had revealed too much. What was the point of a monarch without the mystique? Why pay extravagant sums for them to live such ordinary lives? We shall never know how the Queen felt about it but consider this: she controls the copyright to the film and has not allowed it to be aired in its entirety since. What I wouldn't give to screen it!

Eventually, the monarchy would adopt an "of the people" approach, but credit for that goes beyond Her Majesty. The 1980s were defined by Di-mania, with Charles's marriage to Lady Diana Spencer, and her subsequent rise to unparalleled global adoration. The young princess's tactile nature, with her literal embrace of her fans, made the arm's-length Queen look removed in comparison. Fashion played a role here, too. Diana's clothes were dazzling, often quite fashionable, and always teeming with emotion. There were ruffles and sparkles and shoulder pads, oh my! Meanwhile, Elizabeth carried on in her boxy suits. The Queen's graying hair, still styled in the same helmet of curls, didn't help much either.

Diana's entrance into the royal family had given it a jolt of fresh enthusiasm, but she and

Charles nearly exploded it with their ruinous marriage. The Queen did her best to stay above the fray, a strategy that more or less worked until Diana's tragic, sudden death in 1997. The Brits abandoned their "stiff upper lip" approach and openly wept in the streets. Meanwhile, the Queen remained out of view, ensconced at Balmoral Castle, choosing to comfort her grandsons rather than console the nation. The ire of the British public at the Queen's absence felt strong enough to topple it all. That is, until Her Majesty resurfaced, greeting the crowds outside of Buckingham Palace and delivering a televised address clad in somber black. In a touching tribute, she called Diana "an exceptional and gifted human being."

The Queen returned to that personal approach in early 2020, with the dramatic departure of Harry and Meghan. Although discussions of a new arrangement for the couple had been ongoing, the decision by the Duke and Duchess of Sussex to announce their intentions came as a surprise to the Queen. Sources in the press described her as "hurt" by their actions. In the end, Her Majesty acted swiftly and decisively, declining their request to live as part-time royals and instead permitting them to leave entirely. They would keep their HRH styling but not use it, nor would they use the word "royal" in their branding. The harshness of the decision was tempered greatly by its delivery. The Queen released a pair of emotional statements, referring repeatedly to Harry as "my grandson" and expressing her simultaneous sadness and support. "Harry, Meghan, and Archie," it read, "will always be much loved members of my family."

THESE DAYS, THE QUEEN ENJOYS AN ENVIABLE U.K. APPROVAL RATING IN THE SEVENTies, making her the most popular royal. Words frequently used to describe her by fans include respected, dignified, and dedicated. I'm fascinated by her unwavering and absolute commitment to her role. She has given her entire life to be queen, at great sacrifice to her personal interests as well as her children and marriage. Elizabeth lives a life of extreme comfort and privilege, yes, but you've got to give it to her: she's still fulfilling her duties well into her nineties.

Her triumphant image rehab in the 2000s has included—and I believe is due in large part to—an impressive wardrobe makeover compliments of Angela Kelly, the Queen's senior dresser and personal assistant. The daughter of a Liverpudlian dockworker, Kelly rose from working the ironing board to becoming the Queen's first in-house designer, steering Her Majesty to the colorful, eye-catching clothes she wears today. She has become the Queen's frank and funny confidante, filling the companionship void left by the deaths of Elizabeth's mother and sister. The pair are said to roar with laughter, though Kelly takes her job incredibly seriously. Her nicknames include "AK-47" and "the Queen's Gatekeeper."

Kelly began offering more input on the Queen's wardrobe in the early 2000s, several years into her tenure as senior dresser. Her Majesty's frocks were looking dated and the

colors felt tired. "I could not help thinking that the Queen's style needed to change quickly, before she was made to look older than she was—which some of the old designs did," Kelly wrote in her second book, *The Other Side of the Coin*. (This book, unlike that of the former governess, was sanctioned by the palace.) Her Majesty invited Kelly to a fitting, not something she had previously been privy to, and Kelly gave her unvarnished opinion to a designer and a milliner. "The hats were too masculine and their patterns too large," Kelly recalled. (If I may interject: she was right.) "The Queen needed something more chic, fitted, and elegant." Someone grab the fainting couch! Similar episodes followed at subsequent fittings with other designers. "I became their worst nightmare," Kelly wrote.

Eventually, Her Majesty asked Kelly to sketch a few of her own designs, which she did, even suggesting clothing made from fabrics already filling the shelves of the Queen's stockroom. My guess is that sensibility touched the thrifty monarch's heart. "Before long, Her Majesty's wardrobe was being revitalized as, piece by piece, vibrant colors and stylish cuts made their way onto the rails," Kelly wrote.

Combing through photo archives of the Queen, the transformation is striking. Between the late 1990s and the early 2000s, pictures of Elizabeth evolve from frumpy to fabulous, a sort of Technicolor arrival in Oz. The Queen is a towering figure, undoubtedly, but she is small in physical stature. And, as we know, smiling isn't her thing. Yet the bolder colors, added pieces of texture, and slimmer silhouettes help her leap off the page, or on a screen, or in a crowd.

Under Kelly, the process of dressing the Queen has gotten much more efficient, too. In the beginning of Elizabeth's reign, designers would sketch possibilities to be reviewed in a meeting at Buckingham Palace. With Kelly, she can approve multiple sketches in an hour or less. Outfits now require only two fittings, not three. Elizabeth has long kept the number of fashion brands she wears to a minimum, which strikes me as an immensely practical move to streamline the process. But she never wears just one label, which could be perceived as an unseemly monopoly. These days it's between Kelly and Stewart Parvin, a London-based British couturier.

Even with her new, invigorated look, the Queen's wardrobe is not stylish in any kind of conventional sense—nor has it ever really meant to be. "The Queen and the Queen Mother do not want to be fashion setters. That's left to other people with less important work to do," Hartnell told the *New York Times*, describing a royal aesthetic as "non-sensational elegance." An outfit can last the Queen for decades (the benefits of trendless dressing!). Each wearing of an ensemble is recorded, and repeats are intentionally spaced out so as not to disappoint a crowd. After the second or third public outing, it will either be reworked into a new design or relegated to private holidays or meetings.

For the Queen, it always comes back to color. It is the most important element of her wardrobe, discernible to even the most novice fashion followers, and highly visible thanks to the

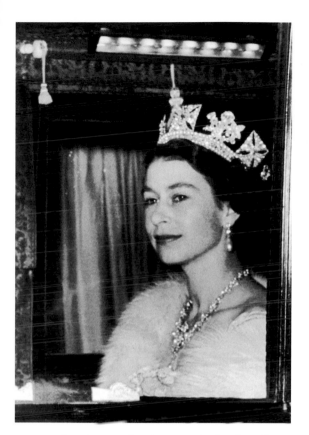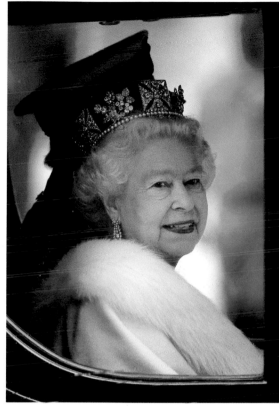

In a glass coach on her way to her first State Opening of Parliament in 1952 (left) and again sixty years later.

single, solid hues she favors. The shades change with the seasons: spring is for pastels, while summer is for more vibrant shades. Autumn ushers in more subdued colors and come winter, there are jewel tones. I often wonder what she must feel like getting dressed each morning, slipping into a bright coat or placing a festooned hat on her head. Each balcony appearance or walkabout in a crowd means appearing before throngs of spectators, clad in a wardrobe designed so that they can see her—so that they can, as she says, believe her.

"To each of that thousand, that person is going to remember that moment for the rest of his or her life," said Victoria Arbiter, a royal commentator for CNN whose father served as a press secretary to the Queen. There's a decent chance that many in the crowd will attempt a cell phone photograph, taken from far, far away. Once again, Her Majesty's wardrobe delivers, Arbiter said. "They can say, 'You see that tiny pink dot? That's the Queen.'" ✦

SO MANY THOUGHTS ON
Elizabeth II

PRINCESS ELIZABETH, OR LILIBET, as she was known, was born into royalty but raised rather sensibly and, at times, even frugally. Her layette was hand-stitched by her mother, then known as the Duchess of York, and her grandmother Queen Mary. For the first several years of her life she wore frilly white dresses before transitioning to a series of smart plaid skirts and wool jumpers. Elizabeth's mother and sister, Princess Margaret, showed an interest in the finer side of fashion, but Elizabeth couldn't be bothered. "Lilibet never cared a fig. She wore what she was told without argument," said her governess Marion Crawford. "She was never happier than when she was thoroughly busy and rather grubby."

The future Queen's first real moment of royal glamour came when she was eleven years old at her father's coronation. Elizabeth wore a cream dress with bows, a velvet robe lined with fur, and elbow-length

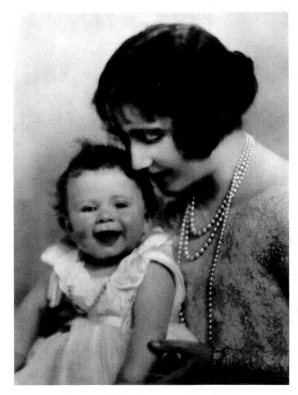

As a baby, Princess Elizabeth wore mostly white.

gloves for the occasion. The custom gold coronets for the girls, lined in velvet and edged in ermine, were deemed too heavy, and lighter-weight silver ones were made. "I did not see the children that morning until they were dressed. They came to me very shyly, a little overawed by their own splendor and their first long dresses," Crawford writes.

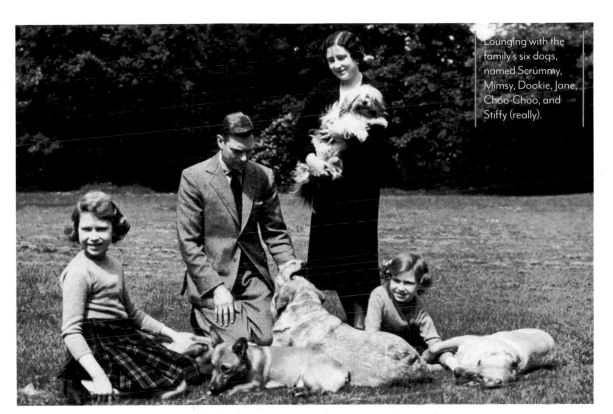

Lounging with the family's six dogs, named Scrummy, Mimsy, Dookie, Jane, Choo-Choo, and Stiffy (really).

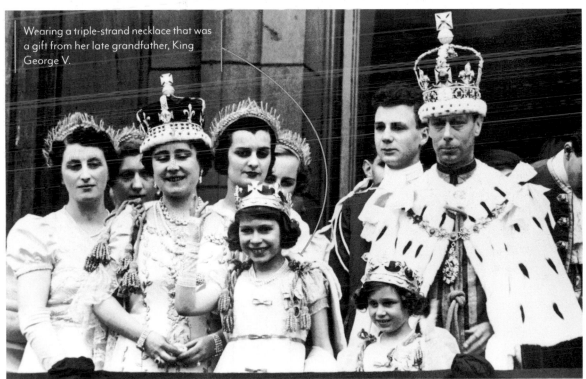

Wearing a triple-strand necklace that was a gift from her late grandfather, King George V.

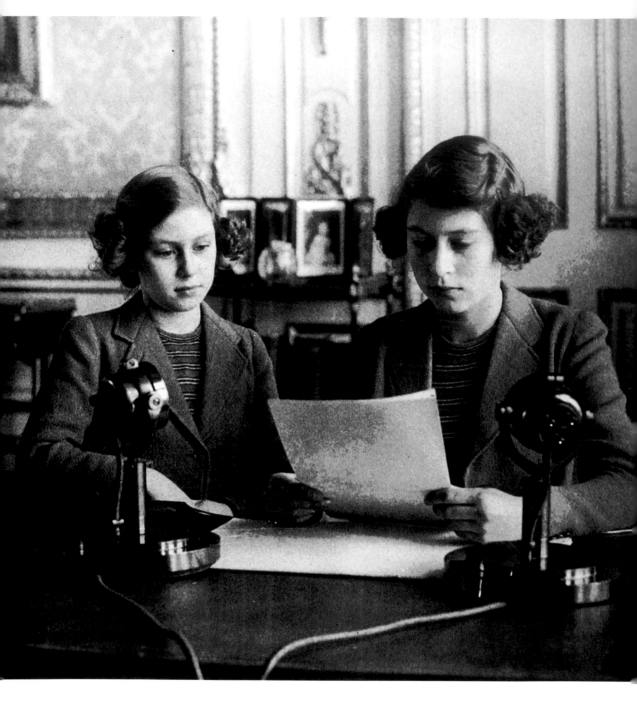

We children at home are full of cheerfulness and courage.

PRINCESS ELIZABETH IN A WORLD WAR II RADIO ADDRESS
FROM WINDSOR CASTLE

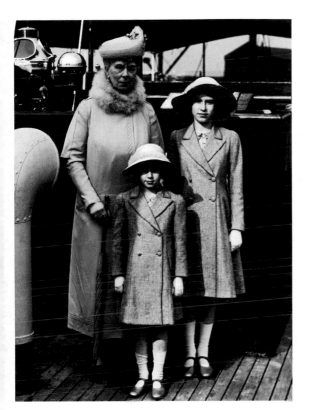

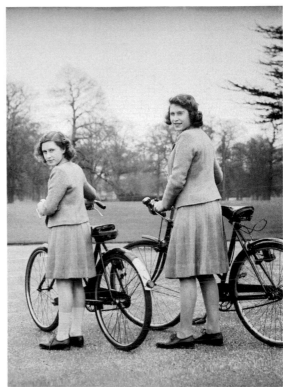

Princess Elizabeth matched with Princess Margaret through childhood and into her teenage years, seen here posing for a photograph with their grandmother, Queen Mary (left) and riding bicycles at Windsor.

ELIZABETH AND MARGARET, ALTHOUGH FOUR YEARS APART IN AGE, DRESSED similarly or identically for years. It made for the most charming portraits. There's something so calming and intentional about the continuity, especially important given what a chaotic, existential crisis her uncle's abdication was for the family. The matching began as young children and continued well into Elizabeth's teens, including for the princess's first radio address, during World War II. It had the effect of keeping the future Queen looking girlish for longer. I can't help but wonder if a little more sartorial independence would have suited Elizabeth better in the long run? Been a source of confidence, perhaps? Her willingness to twin with Margaret says a lot to me about the princess's view of clothing. No fashion-obsessed person I know would wear what she is told, especially if it meant wearing the same thing as a younger sibling. Perhaps that was the point! Matching clothing takes away any sense of personal style and turns the garments into a uniform. Instead of making an individual statement, Elizabeth was showing she was part of a team with a joint goal.

By the King's order, she is to be treated exactly the same as any other student officer, with no special privileges because of personal rank.

ASSOCIATED PRESS

IN THE SPRING OF 1945, AT THE AGE OF EIGHTEEN, ELIZABETH JOINED THE AUXIL-iary Territorial Service, the women's branch of the British Army. The princess had begged her father to be a part of the war movement, becoming the first female member of the royal family to achieve full-time active status in the armed services. The Associated Press called her "Princess Auto Mechanic." Margaret was initially jealous until she "saw how very unbecoming khaki was," their governess recalled. To be sure, Second Subaltern Elizabeth Windsor, as she was known, was afforded comforts fitting of her status. She did not bunk in the camp with her ATS peers; she slept at Windsor Castle. And her uniform was, by one account, much more tailored and pressed than those of her peers. By the end of the war, Elizabeth had become a Junior Commander.

Photographs of a serious Princess Elizabeth in uniform were replaced with a softer, more glamourous image during the post-war rebuilding. The world needed a hopeful fairy tale to follow and Elizabeth was positioned as its bright future.

Pivoting after the war, in a romantic and glamorous portrait with Princess Margaret.

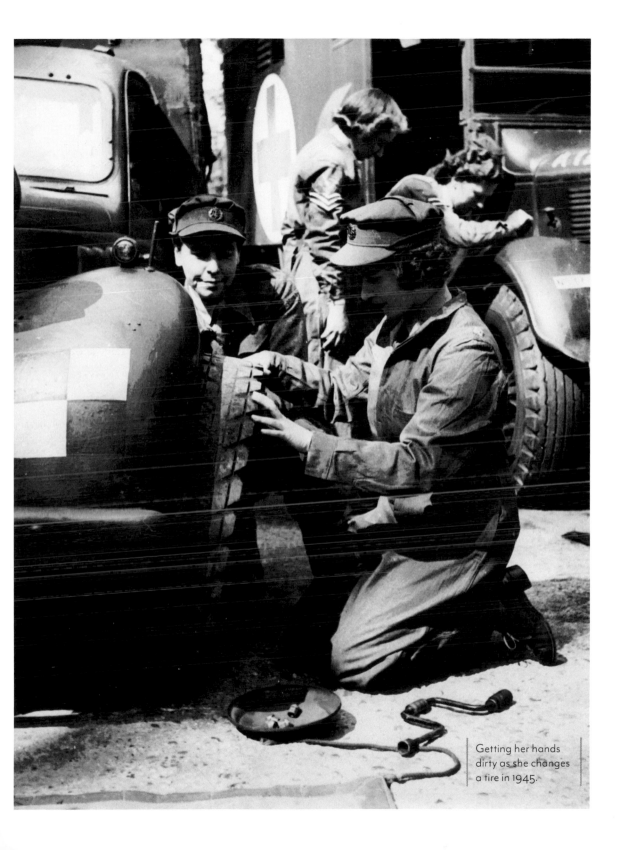

Getting her hands dirty as she changes a tire in 1945.

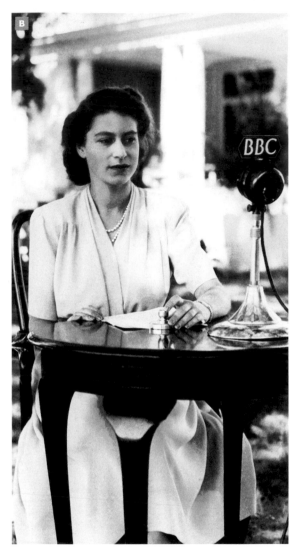

Peep those peep-toe pumps, a favorite style of the princess's, as she was inspecting the guard of honor assembled in South Africa; still, there's a sensible block heel.

O N THE EVE OF HER TWENTY-FIRST BIRTHDAY, IN THE SPRING OF 1947, PRINCESS Elizabeth and her family set sail on the HMS *Vanguard* for a three-month tour of Southern Africa. Designer Norman Hartnell, who would go on to create Elizabeth's wedding and coronation gowns, was tasked with outfitting Princess Elizabeth, her sister, and the Queen Mother. He put together an array of sensational fashion, in pastels and florals, paired with white gloves and topped off by fanciful hats. (A) It delighted the crowds on tour and the press back at home. "The official evening dresses they took with them were really

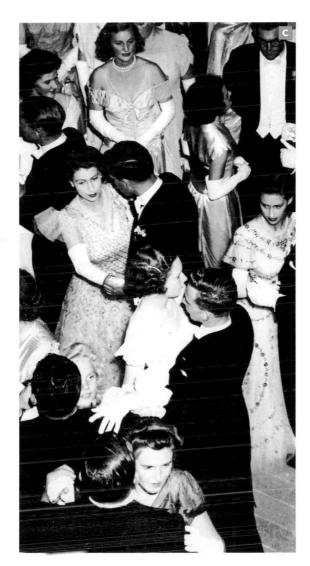

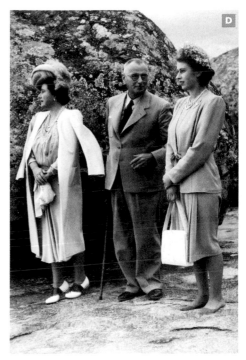

During a hike in Zimbabwe, Elizabeth's mother (above left) damaged her shoes on the rocky terrain. The princess gave the Queen her flats and made the trip in stocking feet.

beautiful," recalled Elizabeth's former governess Marion Crawford. "Picture frocks they were mostly, with wide skirts and the lovely embroideries at which Mr. Hartnell excels." (C) Picture frocks! That tells you what was the priority, doesn't it?

During the trip, Elizabeth gave the most defining radio address of her life, in which she pledged herself entirely to the monarchy. (B) She did not write the text, but its tone matched her matter-of-fact self. "I declare before you all that my whole life whether it be long or short shall be devoted to your service," she said.

A

> *Philip had a capacity for love which was waiting to be unlocked, and Elizabeth unlocked it.*

PATRICIA MOUNTBATTEN,
PHILIP'S COUSIN

A T THE AGE OF THIRTEEN, DURING a tour of the Royal Naval College at Dartmouth, Princess Elizabeth fell hard for a young cadet five years her senior. The pair share a set of great-great-grandparents and had met several years before, when Elizabeth was much younger. But it was at this moment that she became utterly infatuated with the tall, blond "Philip of Greece." They saw each other sparingly in the intervening years, but kept in touch through written correspondence.

Although she had many suitors, Elizabeth was determined to marry Philip. He was a problematic choice; his family exiled from Greece when his uncle was forced to abdicate. His mother was institutionalized and his father was largely absent. And yet, young Elizabeth prevailed. Her father agreed to the proposal so long as the couple waited to share the news until the following year, when Elizabeth would be twenty-one. The press caught on before, when the pair attended the wedding of their mutual cousin. (A) The two shared a quick but adoring gaze as Elizabeth removed her fur coat.

After their relationship was official, the public was skeptical. A newspaper poll found that 40 percent of readers were against the marriage. But, how happy does Lilibet look in this portrait, the day their engagement was announced in July 1947? (B)

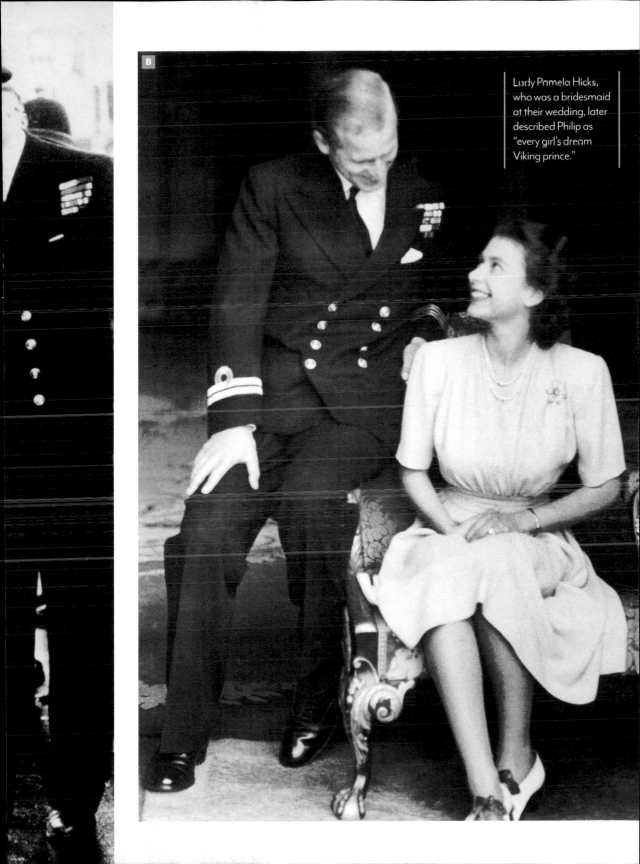

B

Lady Pamela Hicks, who was a bridesmaid at their wedding, later described Philip as "every girl's dream Viking prince."

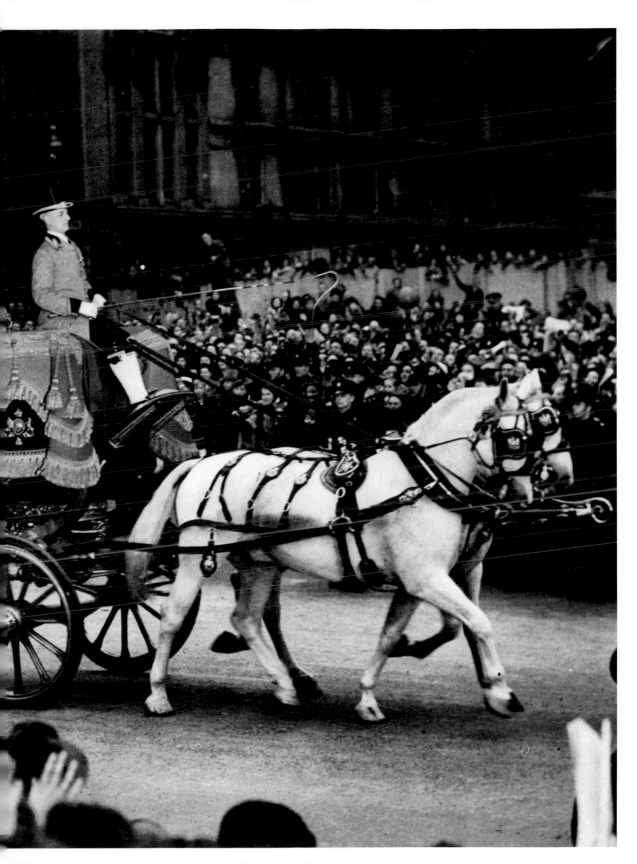

A flash of color on the hard road we have to travel.

WINSTON CHURCHILL

WHEN PRINCESS ELIZABETH MARRIED LIEUTENANT PHILIP MOUNTBATTEN ON November 20, 1947, post-war Britain was still recovering from the devastation of World War II. The public was desperate for the fairy tale of this striking young couple, and Elizabeth's wedding gown had the heavy charge of lifting the nation's collective mood. On that chilly and damp day, she chose a design inspired by Botticelli's famous Renaissance painting *Primavera*, symbolizing rebirth and the coming of spring.

Norman Hartnell, who would go on to become the most influential imagemaker of Elizabeth's early years, designed what he later called "the most beautiful dress I had so far made." The age-old game of guessing what a royal bride would wear goes way back: Hartnell ordered the windows of his studio whitewashed and had a manager sleep on site to ensure secrecy. A royal press secretary grew annoyed by the onslaught of media inquiries into the smallest of details, including a question from the Women's Press Club of London about what cosmetics Elizabeth planned to wear. *Were such details really worthy of publication?* he asked.

The princess's dress was, in today's parlance, a crowdsourced endeavor; her bridesmaids voted on several sketches Hartnell submitted. With the cutbacks required in the wake of the war, Elizabeth used rationing coupons to cover the costs. Hundreds of women sent theirs to her, looking to help the princess have the dress of her—and perhaps, as *Vogue*'s Hamish Bowles later posited, *their*—dreams. Those coupons were returned with a thank-you note, since it was not legal to transfer them. Before the gown, train, and veil were sent to Buckingham Palace, each of the seamstresses involved, down to the most junior apprentice, placed a stitch in the gown so they could say they had been a part of this moment.

As perfect as the day was, and it was heralded as spectacular, what I find most endearing is the one nearly imperceptible crack. The Princess was loaned Queen Mary's Fringe Tiara, made from a diamond necklace given to Queen Victoria for her wedding. The frame cracked as she was heading to the ceremony (can you imagine!). "We have two hours and there are other tiaras," her mother calmly said. Thankfully, a jeweler was able to repair it, albeit somewhat hastily. Look closely at the top center and you can see the inconsistent spacing between the diamond spears.

Elizabeth wore just two pearl strands on her wedding day; the shorter one is said to have belonged to Anne, the last Stuart Queen; the longer is believed to have come from Queen Caroline, the wife of King George II.

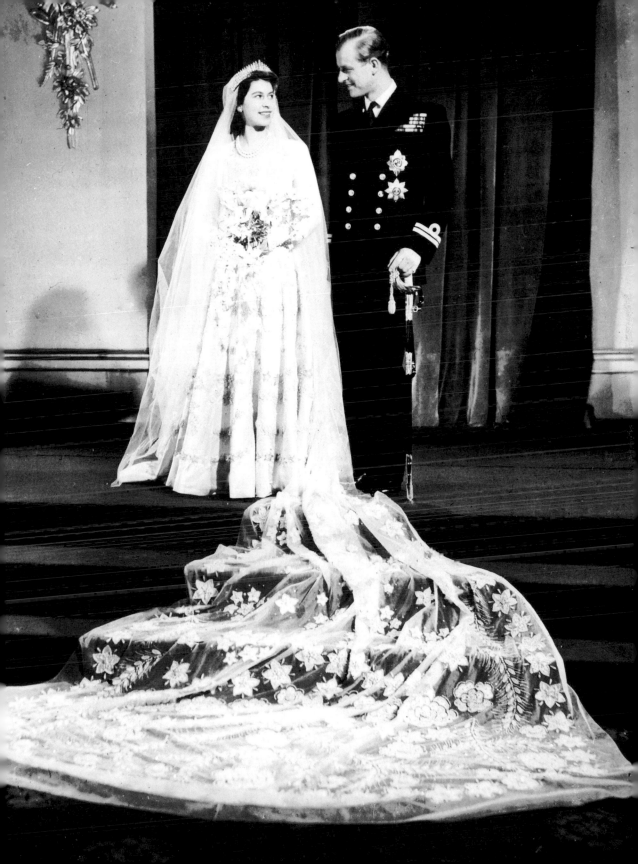

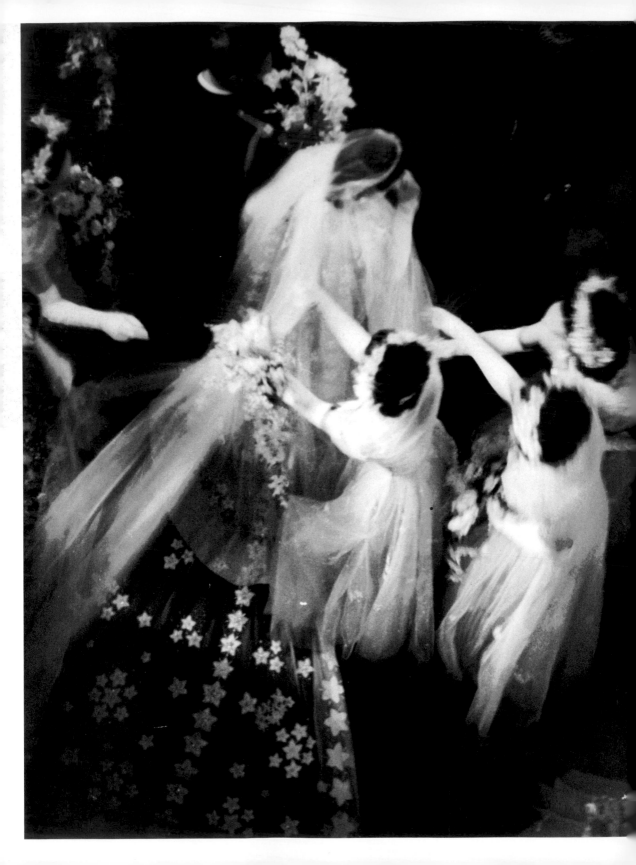

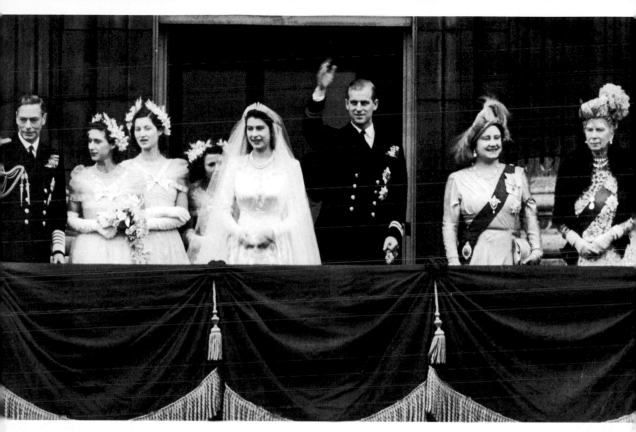

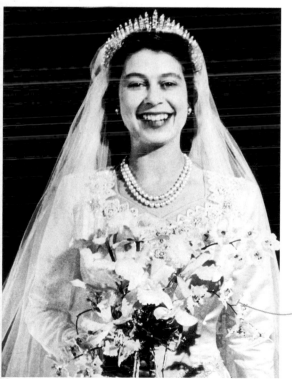

Norman Hartnell was given less than three months to create Elizabeth's dress, made of duchesse satin with a fifteen-foot silk tulle train. The petite princess wore her highest pair of heels on her wedding day, made from the same satin as her dress. Philip wore his naval uniform decorated with the Order of the Garter star, which had been given to him by Elizabeth's father the day before. The King had bestowed the same honor on Elizabeth eight days prior, to ensure that she would be more senior than her groom.

Elizabeth's bridal bouquet of white orchids included a sprig of myrtle, a tradition that dates back to her great-great-grandmother, Queen Victoria.

When I was a little boy, I read about a fairy-tale princess, and here she is.

PRESIDENT HARRY TRUMAN

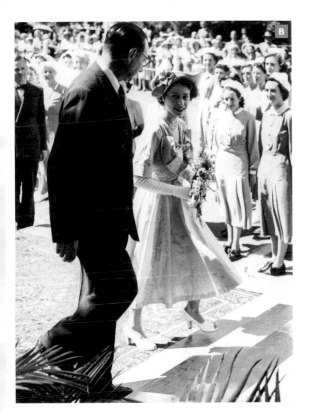

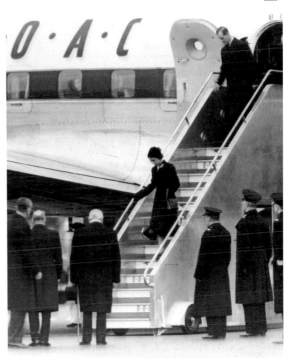

Elizabeth arrived in Kenya in 1952 as a princess (left)
and returned home a few days later as the Queen

ELIZABETH SPENT MUCH OF HER EARLY MARRIED LIFE ON THE MEDITERRANEAN island of Malta, where Philip was stationed as a naval officer. But as King George VI's health deteriorated, she was increasingly called upon to represent the sovereign. In late 1951, she made a state visit to North America, traveling in an open-topped convertible through chilly Canada in order to be seen by as many well-wishers as possible. Elizabeth then flew to Washington for her first trip to the United States. She was greeted at the airport by President Harry Truman and a twenty-one-gun salute. (A)

Just a few months later, the young couple was sent on a lengthy trip beginning in Nairobi, Kenya. (B) Elizabeth carried out a few official duties upon arrival but then retreated to a remote resort for a bit of fun and rest before the full itinerary started. It was there that she was given the news of her father's passing, on February 6, 1952, at the age of fifty-six. Elizabeth was just twenty-five. Her team had forgotten to pack a black ensemble, so after the lengthy flight home Elizabeth waited on the tarmac for one to be delivered. (C) The new Queen changed into the somber coat and hat before getting off the plane.

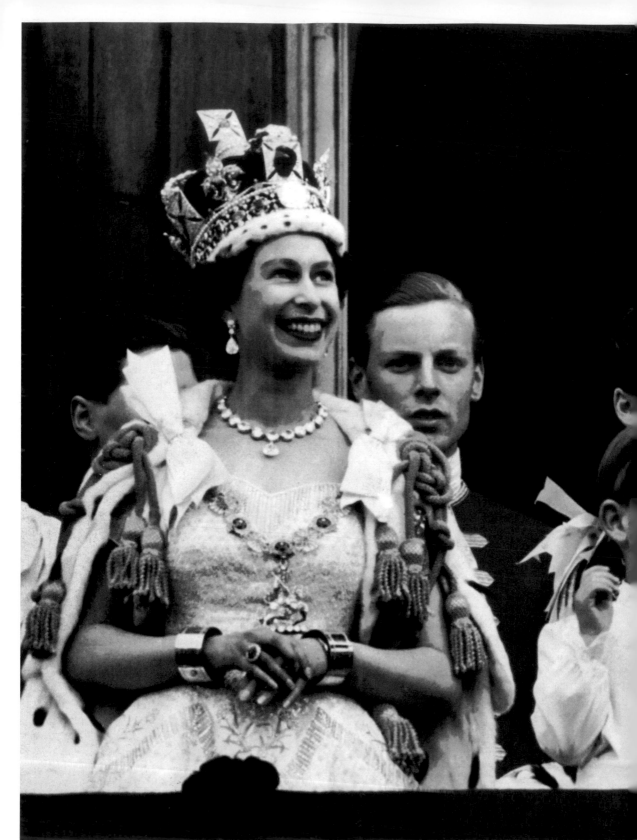

Glorious.

THE QUEEN'S REACTION WHEN SHE TRIED ON
HER CORONATION GOWN

D URING THE EXTENSIVE PLANNING OF QUEEN ELIZABETH II'S CORONATION, THE British Broadcasting Corporation made a suggestion: why don't we televise the event? The Queen's courtiers said no immediately, believing the sacred ceremony to mark the formal investiture of the monarch was meant for the privileged ones chosen to attend at Westminster Abbey. But Her Majesty decided to permit the cameras, so long as there were no close-ups. Her reasoning: "I have to be seen to be believed." Twenty-seven million people in the United Kingdom alone tuned in to the broadcast on June 2, 1953, with millions more watching around the globe.

The first televised coronation called for a gown that would dazzle, even in pixelated form on small black-and-white television screens. Norman Hartnell's triumphant turn as her wedding dress designer earned him a place in history with her coronation gown, too. He submitted several sketches for consideration, all in white satin per Elizabeth's request. The one she selected is widely regarded as one of the most important works by a British couturier of the twentieth century. The sweetheart neckline elegantly framed her face and left ample room for the adornment of the robes. Meanwhile, her tiny waist was accentuated by a full skirt that remained stiff thanks to a nine-layered underskirt.

Hartnell knew that this gown would hang in museums for the rest of time, so its details needed to sing, too. "I thought of the sky, the earth, the sun, the moon, the stars, and everything heavenly that might be embroidered on a dress destined to be historic," the designer wrote in his autobiography. Symbols of the Commonwealth—including a Canadian maple leaf, an Australian wattle, and a New Zealand silver fern—were interwoven with English roses and Scottish thistles. Elizabeth asked that colorful thread be added as part of the embroidery to distinguish it from her wedding gown. The skirt was particularly ornate, which was fitting as it was the most visible part of the dress once the robes were layered on top.

Having rehearsed in the hallways of Buckingham Palace, the young Queen projected an enviable confidence when the day arrived. Spectators along the carriage procession remarked on how happy she looked. Before she headed down the aisle of Westminster Abbey, she turned to her maids of honor and said, "Ready, girls?"

Given the heavy robes and crowns the Queen wore for the long ceremony, the coronation gown was made as lightweight as possible.

| **44** | HRH

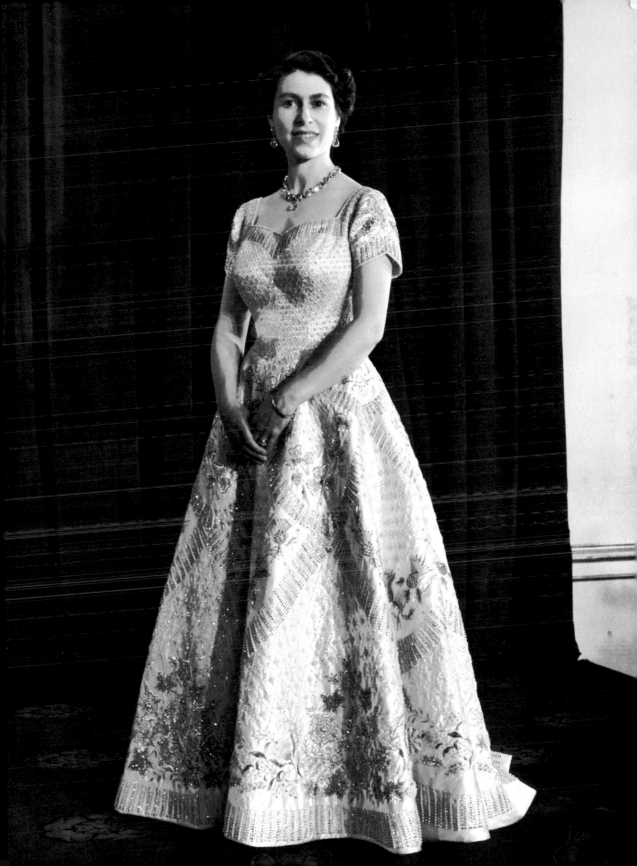

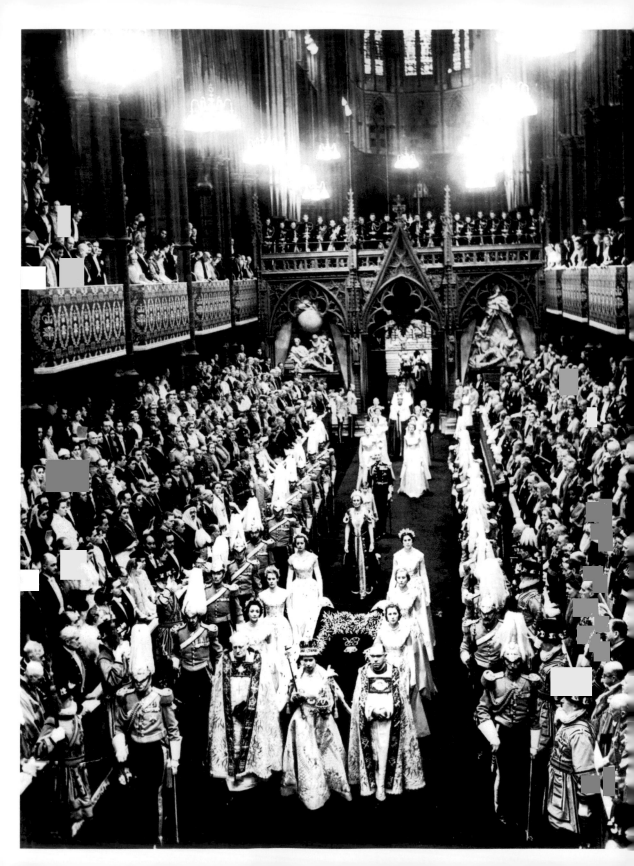

Elizabeth had six maids of honor, all young, aristocratic women; they wore Hartnell dresses, too, with smelling salts sewn in their gloves in case the pressure of the tight waist and the big moment overcame them. The VIP in the crowd was Prince Charles, who at age four was the first child to attend his mother's coronation. The Queen was crowned with St. Edward's Crown, made in 1661 of solid gold and weighing four pounds, twelve ounces. For the return to Buckingham Palace and her balcony appearance, Elizabeth wore the newer Imperial State Crown, which was commissioned for her father's coronation.

A dress that deserves to be seen! The Queen rewore her coronation gown several times, including for the 1954 Opening of Parliament in New Zealand.

ELIZABETH'S EARLY YEARS AS queen were dazzling, by far the most fashionable of her reign. She joined the male-dominated ranks of world leaders with her femininity not only intact but on display, embracing ladylike 1950s style. Daytime appearances saw a proliferation of circle skirts and fantastic hats. At night, she wowed in sparkling ball gowns topped off with tiaras. I adore her over-the-elbow white gloves. What fun it must have been to follow such a glamorous young monarch in real time.

Just a few months after the coronation, Elizabeth and Philip set sail on the Royal Yacht *Britannia* for a six-month tour of the Commonwealth, from November 1953 to May 1954. The tour was a statement in every way, from the breadth to the pace to the clothes she wore. She brought with her more than 100 outfits created specifically for the trip, which included thirteen countries and 40,000 miles traveled. They were the handiwork of Norman Hartnell, maker of her wedding and coronation gowns, and Hardy Amies, another designer who would become hugely influential in her daywear attire.

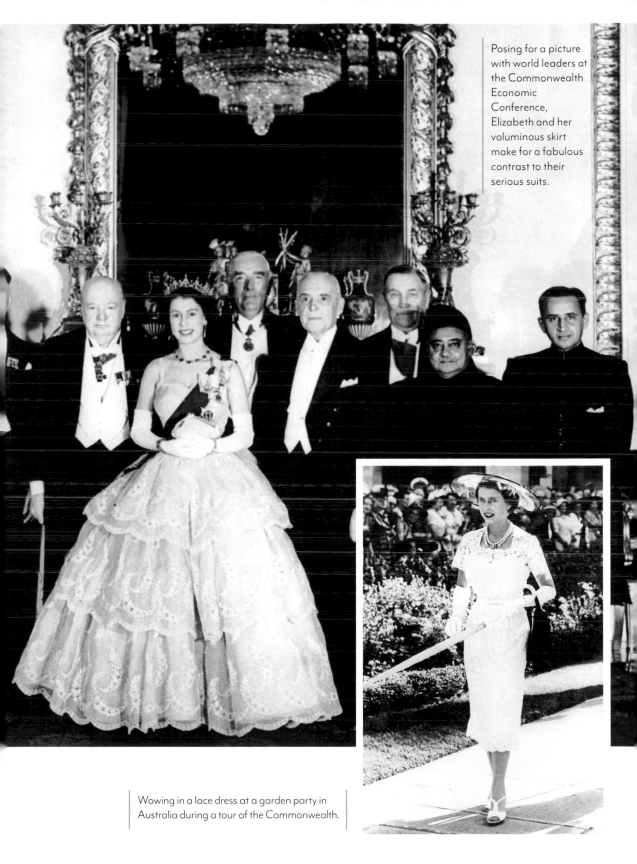

Posing for a picture with world leaders at the Commonwealth Economic Conference, Elizabeth and her voluminous skirt make for a fabulous contrast to their serious suits.

Wowing in a lace dress at a garden party in Australia during a tour of the Commonwealth.

Most people have a job and then they go home.
In this existence, the job and the life go on together, because you can't really divide it up.

THE QUEEN

THE FIRST TWO OF ELIZABETH'S FOUR CHILDREN WERE BORN WHILE SHE WAS A princess, with Prince Charles arriving in 1948 and Princess Anne two years after that. A full decade later, Elizabeth became the first reigning monarch to give birth in more than a century with the arrival of Prince Andrew. Prince Edward completed the family in 1964, born when Elizabeth was thirty-seven. As much as her children have come to define her, the Queen has kept her public mothering moments to a minimum. There are very few photographs of her visibly pregnant (pictures of her in that "condition" were discouraged). Her maternity style, if one can call it that, consisted of her usual suits and coats, the latter much looser as her pregnancies progressed.

Princess Elizabeth in 1948 (left) about four months pregnant with Prince Charles.
Seventeen years later, as the Queen, posing for a portrait with her four children.

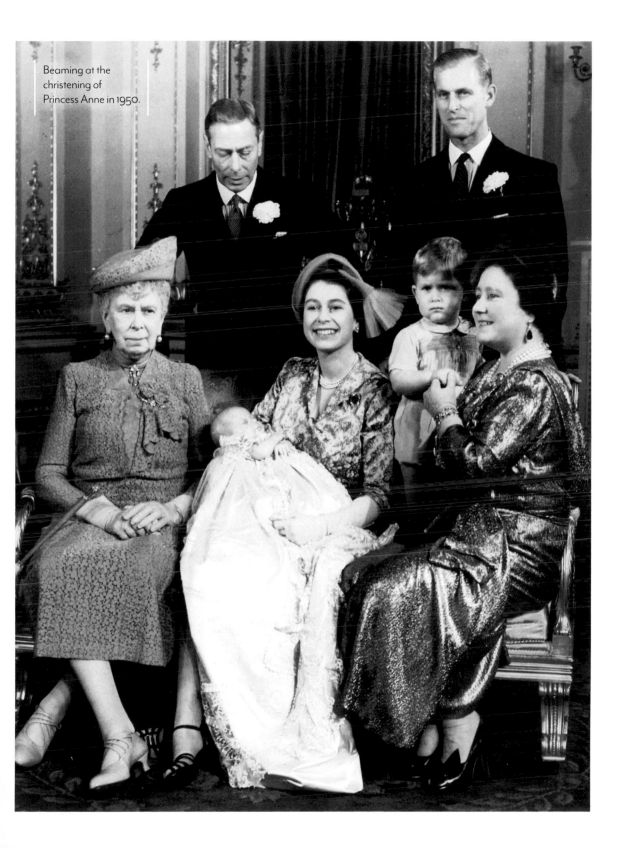

Beaming at the christening of Princess Anne in 1950.

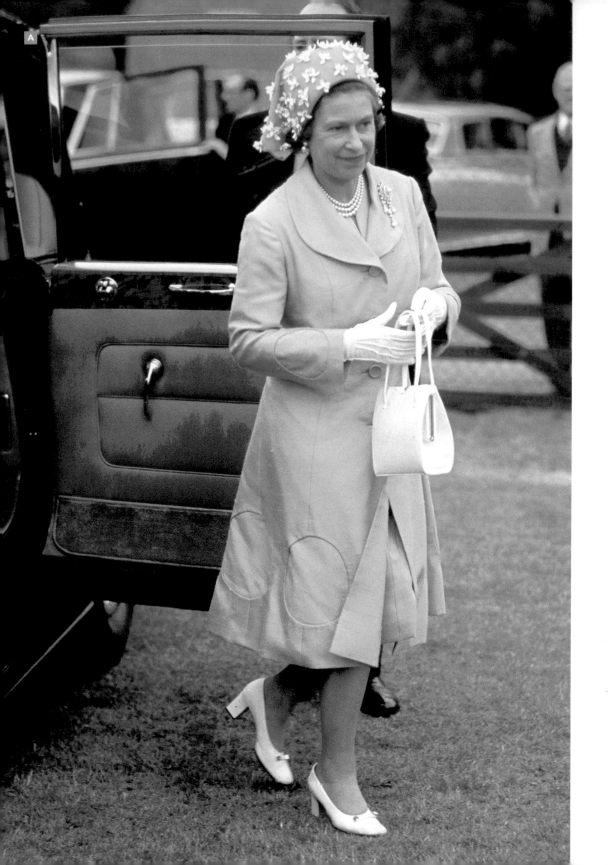

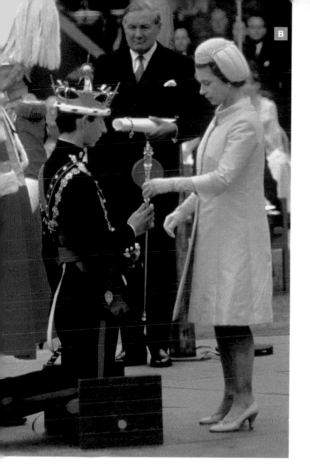

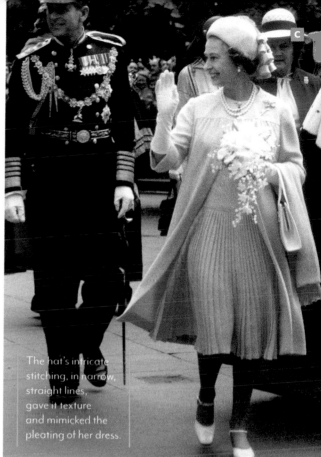

The hat's intricate stitching, in narrow, straight lines, gave it texture and mimicked the pleating of her dress.

BY THE TIME THE QUEEN REACHED HER MID-FORTIES, SHE HAD ESTABLISHED HER solid, bright daywear uniform. But Elizabeth was still open to experimenting, seeking out hats that would "please the camera." They often sat low and close to her head, framing her face for the photographers. Milliner Simone Mirman was behind some of Her Majesty's most memorable pieces. Mirman designed the lime green cloche the Queen wore for a day of polo in 1973. (A) Covered in white flowers, it looked "as though the Queen were wearing the posies with which she is always presented," the *Guardian* recalled. The Tudor-inspired hat for Prince Charles's investiture as Prince of Wales on July 1, 1969, was made of the same silk as her primrose-yellow Norman Hartnell coat, and embroidered with pearls. (B) The iconic tassel design Elizabeth wore for her Silver Jubilee Service of Thanksgiving in 1977, marking twenty-five years on the throne, was Mirman's stylish take on the Scottish tam. (C) The twenty-five tassels were described as bells but were actually flowers, with green stems and yellow stamens. A reminder to us all she had bloomed in her role? A Labour politician dismissed it as resembling "a disconnected switchboard."

THE QUEEN IS FAMOUSLY QUITE stoic in her public appearances. But if there is one occasion we are guaranteed to get an ear-to-ear grin it is the Royal Windsor Horse Show. Her Majesty is an avid and lifelong equestrian; the horse show, held near Windsor Castle, is her happy place. Elizabeth is believed to have attended every year since it began in 1943. In the 1970s and 80s, it was an occasion for some very fun fashion. (How about that cape!) These days, she almost always wears one of her signature silk headscarves.

Sporting a hands-clasped smile in 1976 (below) and 1988 (far right). The Queen was particularly stylish while attending in 1979 (middle), wearing a navy suit one day and a pink cape another. Horse show but make it fashion.

THE QUEEN HAS UNDERTAKEN SOME 300 overseas visits during her tenure, making her the most widely traveled monarch in history. Months of planning go into a royal tour wardrobe. Her Majesty's dressing team researches how women in the host nation dress and decides how much the Queen should nod to that out of respect while not giving up her own authority and style. Local designers are considered and colors are evaluated for the potential to flatter or offend. My favorite approach is her use of signature florals, like the orange California poppies adorning her gown on a visit with the Reagans in 1983. (A)

Dressing to impress is part of the job, too, and failure to do so comes with consequences. During a 1984 visit to Canada, Toronto newspapers said the fifty-eight-year-old Queen looked "tired" and "dowdy." (B) (By this moment in time, Diana was wowing the world with her flashy fashion. The comparison must have been rough.) Two years later, while visiting the Great Wall of China, she cut a much more stylish figure in a perfectly fitted suit. (C)

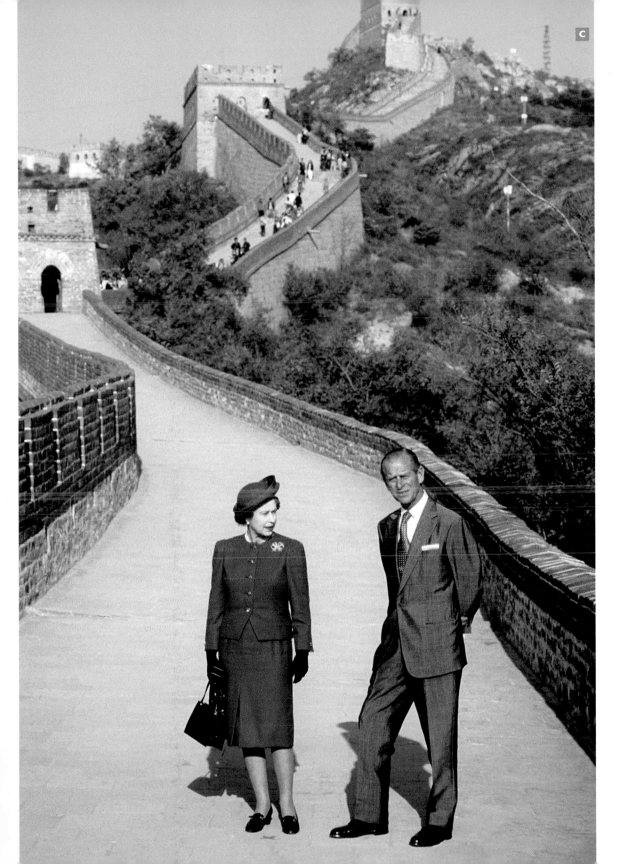

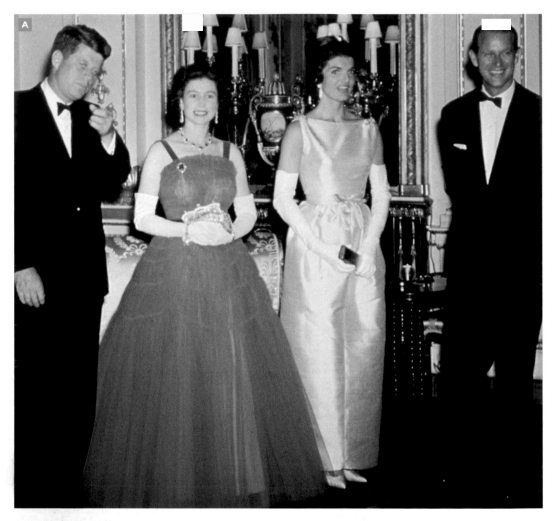

A

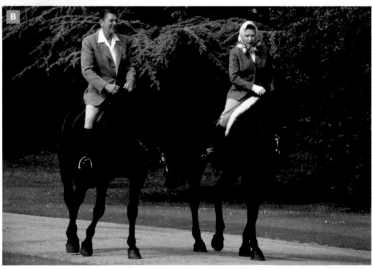

B

First Lady Michelle
Obama wore a
stunning white
silk-georgette gown
by Tom Ford, an
American designer
who was based in
London for many
years. How's that for
sartorial diplomacy?

She is truly one of my favorite people.

PRESIDENT BARACK OBAMA

T HE QUEEN HAS HELD AN AUDIENCE WITH TWELVE OF THE LAST THIRTEEN SIT-
ting U.S. presidents (sorry to Lyndon Johnson). The wardrobes on both sides play a
big part of these joint appearances. American leaders often take style notes from the sover-
eign. President Ronald Reagan went horseback riding with Her Majesty during a 1982 visit
to Windsor Castle, twinning in their jodhpurs and blazers. (B)

John F. Kennedy was the first American president to dine at Buckingham Palace in more
than four decades when he and wife Jackie did so in 1961. (A) There are several similarities
between what the thirty-five-year-old Elizabeth and the thirty-one-year-old First Lady
wore: blue dresses, white gloves, metallic clutches, lots of jewels. But the First Lady, fresh
off a dazzling tour of Paris, was celebrated for her more modern, streamlined silhouette
with its bateau neckline. She later remarked how she didn't care for Elizabeth's tulle gown
with its thick straps, or her "flat" hairstyle. The mood was much less tense when President
Barack Obama dined at an official state dinner in 2011. (C) Just look at those smiles!

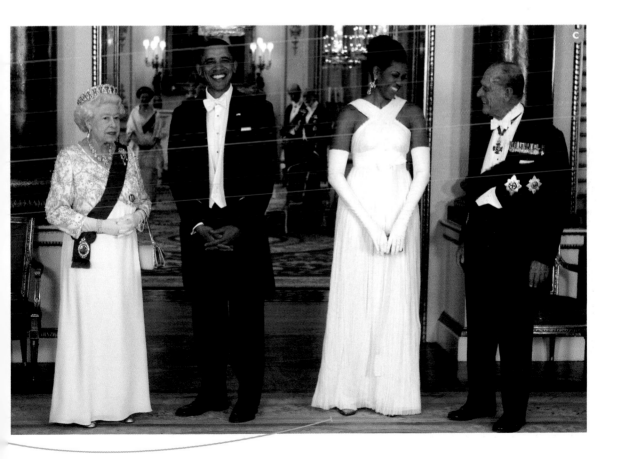

You can't look down to read the speech. You have to take the speech up.
Because if you did, your neck would break.

THE QUEEN ON THE IMPERIAL STATE CROWN

FUN FACT: THE QUEEN DOES NOT wear a crown all that often. The one event on the annual calendar when the signature accessory is guaranteed to make an appearance is the State Opening of Parliament. The tradition, which brings together the House of Lords, the House of Commons, and the Queen, dates back to the sixteenth century. As a base for the regalia, the Queen wears a white state dress. The Robe of State is layered on top, secured by a series of ribbons and carried via satin handles by page boys. The Queen rides to the occasion in a glass coach wearing the Diamond Diadem, made in 1820 for the coronation of King George IV. (B) She then swaps it for the Imperial State Crown, commissioned for her father's coronation in 1937. (C) The Queen twists it from side to side to secure it, no hair clips needed. She then takes her place on the throne to deliver a speech, which is written for her by the Prime Minister and cabinet.

Her Majesty is joined on some occasions by members of her family, an exciting chance to see them in their finery. In 1981, a few months after their wedding, Prince Charles attended with Princess Diana. (A)

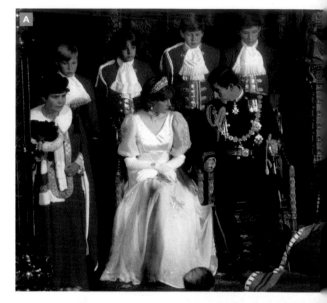

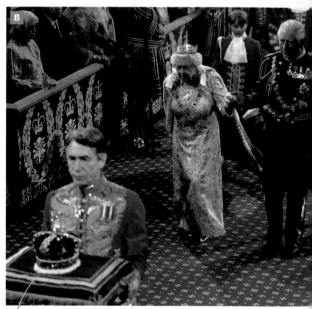

Giving herself a break. In 2019, at the age of ninety-three, the Queen chose to wear the lighter diadem for the procession and her speech. The heavier crown came along on its own pillow.

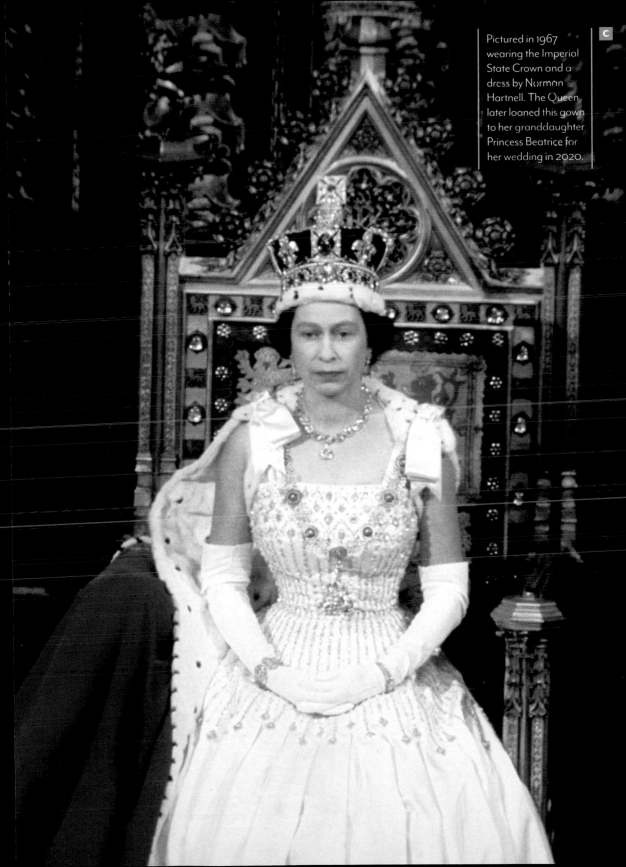

Pictured in 1967 wearing the Imperial State Crown and a dress by Norman Hartnell. The Queen later loaned this gown to her granddaughter Princess Beatrice for her wedding in 2020.

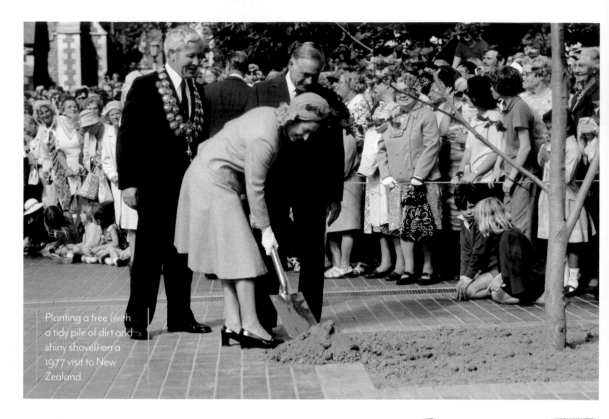

Planting a tree (with a tidy pile of dirt and shiny shovel) on a 1977 visit to New Zealand.

Unveiling a plaque to commemorate her visit to Royal Worcester Porcelain in 2001. The Queen's coat matches the dishes behind her.

FANCY MOMENTS ASIDE, MORE OF the Queen's time is spent on routine engagements. One has to wonder how many ribbons she has cut, or how many bouquets of flowers she has received. These exchanges are her chance to connect with the people, and she often leaves something behind, a plaque or a tree to remember her by. Her wardrobe at these moments is at its most functional, allowing her to bend or reach without any restrictions.

Receiving coordinating posies on a visit to Chester with Meghan in 2018 (above) and cutting a ribbon for the opening of a bridge in Scotland in 2017.

I am quite sure that most people try to do their jobs as best they can, even if the result is not always entirely successful.

<div align="center">THE QUEEN</div>

THE 1990S WERE A DECADE OF SCANDAL AND TRAGEDY for the royal family. In 1992, Sarah Ferguson, then the wife of Prince Andrew, was photographed sunbathing topless and having her toes sucked; Diana's shocking bouts of bulimia and attempts at suicide in response to the pressures of royal life and Charles's affair were detailed in Andrew Morton's biography. And then Windsor Castle caught on fire. The Queen, in a speech to mark the fortieth anniversary of her succession, famously deemed the year "annus horribilis." The deep emerald green she wore looked black, the color Her Majesty reserves for mourning, in many of the photographs. "I sometimes wonder how future generations will judge the events of this tumultuous year," the Queen said in her remarks. "There can be no doubt, of course, that criticism is good for people and institutions that are part of public life."

Five years later, with the tragic death of Princess Diana, the Queen faced some of the harshest criticism of her reign. She was on summer holiday at Balmoral Castle when the car crash happened. Her Majesty remained there for several days to console William and Harry, much to the outrage and disappointment of the grieving public back in London. "Show Us You Care," ordered the *Express*. "Your People Are Suffering / Speak to Us Ma'am," begged the *Mirror*. When she did emerge, several days later, she wore head-to-toe black. Everything about her ensemble was familiar, from her style of hat to the pearls around her neck. Her sartorial response was a reminder that there is comfort in consistency.

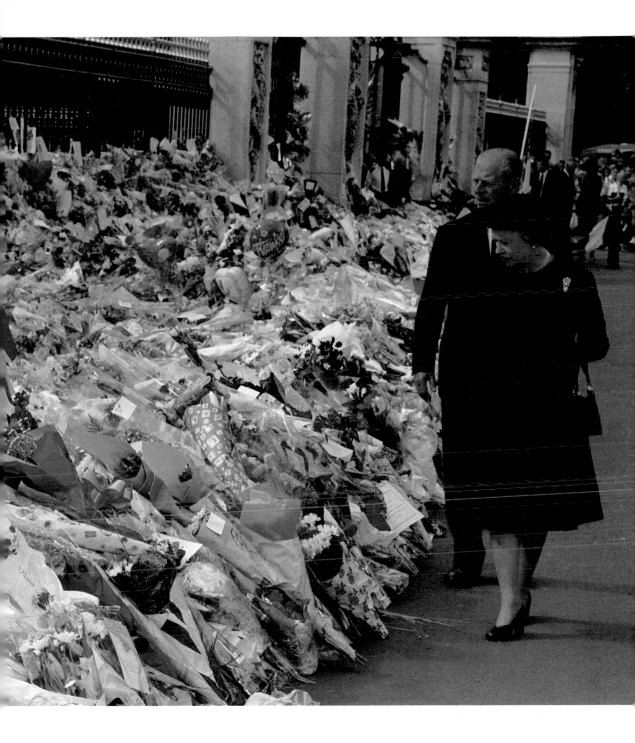

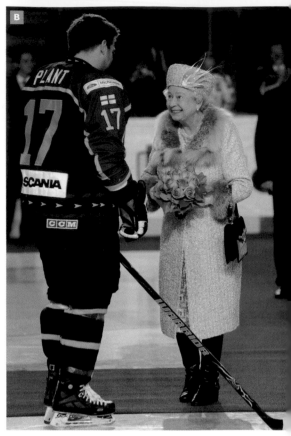

AS THE NEW MILLENNIUM NEARED, THE QUEEN'S WARDROBE UNDERWENT A slow but dramatic makeover in the hands of her senior dresser and personal assistant, Angela Kelly. Once the housekeeper to the British ambassador to Germany, Kelly joined the Queen's dressing team in 1994. Just a few years into her tenure, thanks to Kelly's talents and outspokenness, she began designing clothes for the Queen herself.

A pivotal moment in their relationship came at the Commonwealth Games in 1998. (A) Kelly suggested the Queen wear a coral hat backward to better suit her—and Her Majesty did! Later, Kelly began attending fittings with the Queen, offering frank analysis of dated styles and unflattering prints. The Queen's ensembles have since taken a turn toward the delightful. For a 2008 hockey game, she wore sequins and knee-high boots. (B)

In 2018, the Queen and Kelly attended London Fashion Week, sitting in the front row alongside Anna Wintour, editor in chief of *Vogue*. (C) Her Majesty's appearance was a surprise to present the inaugural Queen Elizabeth II Award for British Design.

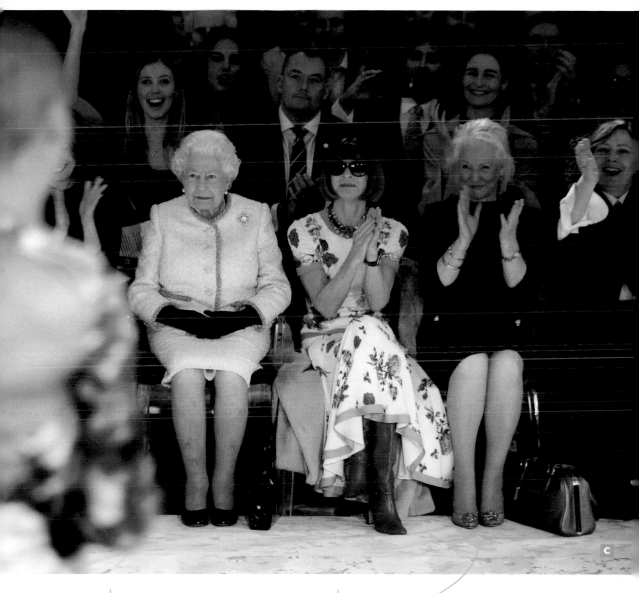

Sporting a tweed suit for London Fashion
Week, designed by Angela Kelly (right) and
inspired by Chanel's iconic style.

Swapping out the decorative elements, the Queen described this as "a very useful dress."

AMONG THE MOST ENDEARING ASPECTS OF THE QUEEN'S WARDROBE IS HOW SENsible it is at times. Her Majesty has maintained a sense of frugality in her dressing, dating back to her austere upbringing. Take the white state dinner dress she wore to the Commonwealth Heads of Government state dinner in Trinidad in 2009. (A) The bird embellishments seen around the skirt, of the scarlet ibis and cocorico, were removed for a visit to Canada the following year. In their place, the Queen's senior dresser, Angela Kelly, added an array of maple leaves around the right shoulder. (B)

The Queen prefers a slightly longer handle on her custom made bag so that it hangs without catching on her cuffs.

Indeed, Kelly often looks for ways to make do with what is on hand. She once snipped a few blooms off a faux potted plant in a palace storeroom and used them to adorn the Queen's hat for Royal Ascot in 2017. (D) Her designs pair fashion with function, achieving a look with whatever practical means are required. For a 2012 appearance, the Queen wore what appeared to be a vibrant blue buttonless coat open over a dress. (C) But look closely and you'll see that there is a fabric panel, in the same print as her skirt, to hold the coat open at a constant width.

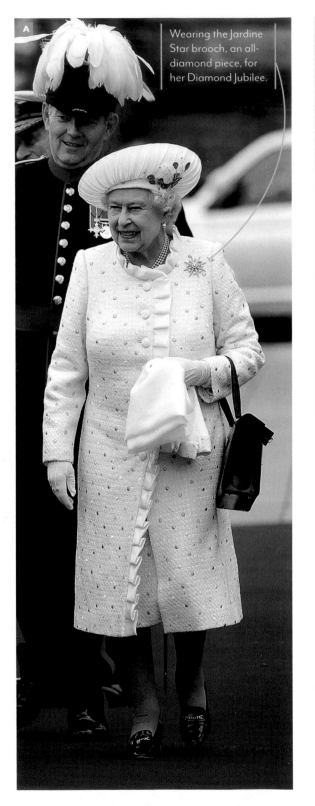

A

Wearing the Jardine Star brooch, an all-diamond piece, for her Diamond Jubilee.

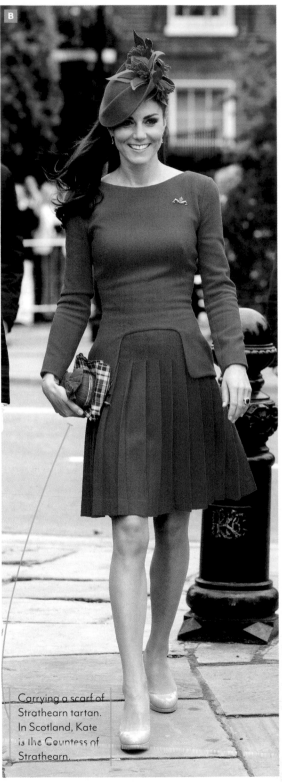

B

Carrying a scarf of Strathearn tartan. In Scotland, Kate is the Countess of Strathearn.

You would expect a lot of grandeur and a lot of fuss,
but actually what really resonates with me is her love for the simple things.

THE UNITED KINGDOM CELEBRATED THE QUEEN'S DIAMOND JUBILEE IN 2012, marking six decades on the throne. Her Majesty was fêted with a series of stately events, including a massive boat parade with more than 600 vessels and an estimated one million spectators. As the guest of honor at the River Pageant, Her Majesty wore a white bouclé wool coat by Angela Kelly. (A) The gold and silver threading recalled the embroidery on her coronation gown, while the Swarovski crystals resembled diamonds. The bright white helped the Queen stand out against the red upholstery of the boat. The Duchess of Cambridge, who had joined the family just a year prior, blended in with her jaunty red Alexander McQueen dress. (B) The men aboard the vessel wore blue military uniforms; together the family formed the colors of the Union Jack flag.

At age eighty-six, the Queen still had a few surprises left in her. She appeared alongside James Bond in a short film as part of the 2012 Olympics. (C) The design was a tall order, needing to suit the Queen for the video and the Opening Ceremony, as well as work for her stunt double. Kelly chose peach, a shade that would be visible but not reflect any of the competing countries' flags.

The outfit would say the queen even if the queen wasn't in the outfit.

THE NEW YORK TIMES

THE QUEEN EMBRACED COLOR WITH A NEW GUSTO AS SHE ENTERED HER NINTH DECADE. Her well-established uniform of a colorful coat and smart hat took on a new spirit when made in even more vibrant hues. "We live in a culture where women pass a certain age and they're meant to just disappear," said Sali Hughes, author of *Our Rainbow Queen*. "They're meant to maintain a dignified silence, and just grow old gracefully and not be noticed." By doing the opposite, the Queen has made a profound statement about her place in the cultural landscape; she demands to be seen. The shades have a whimsical quality about them, too, livening her look and eliminating any risk of seeming stuffy or staid. The same could be said for the playful embellishments adorning her hats. What has remained: the Queen's trusty heels, handbags, and gloves.

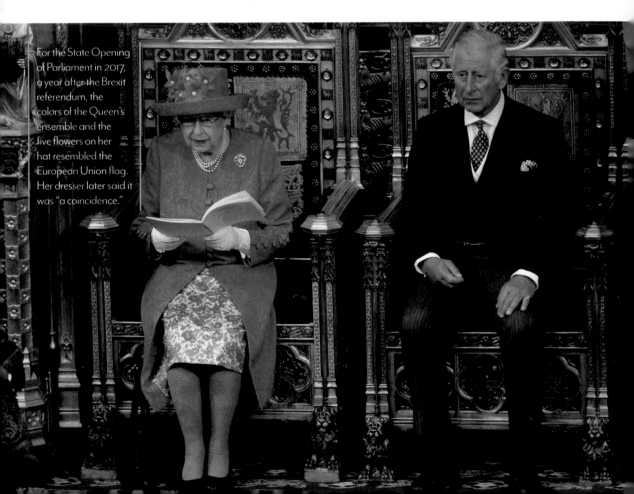

For the State Opening of Parliament in 2017, a year after the Brexit referendum, the colors of the Queen's ensemble and the five flowers on her hat resembled the European Union flag. Her dresser later said it was "a coincidence."

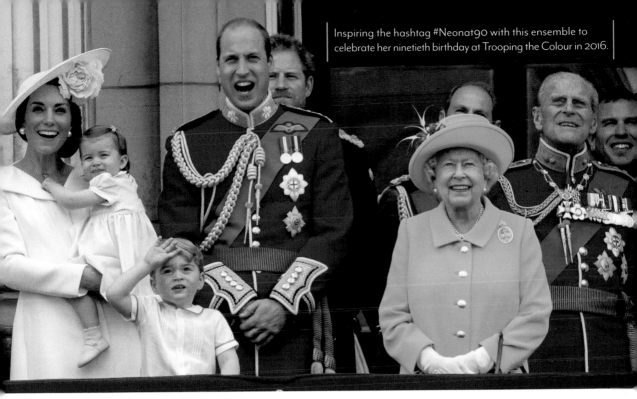

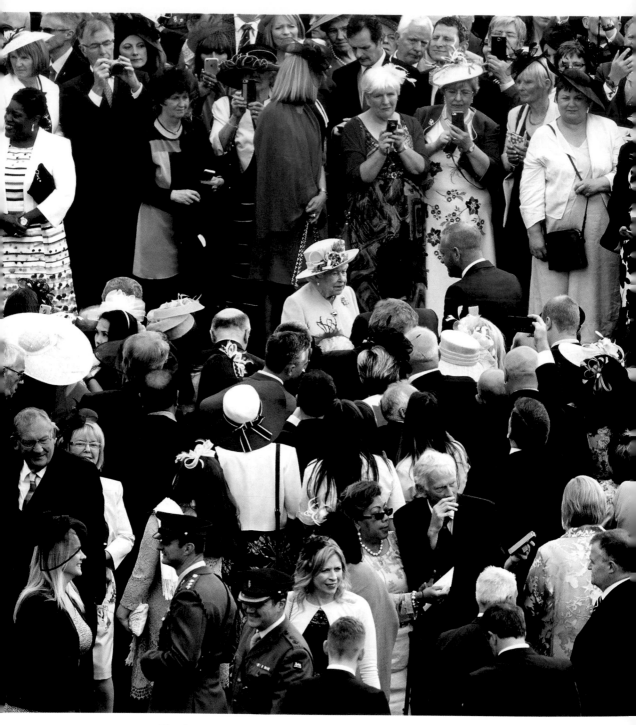

The Queen greeting guests at a Buckingham Palace garden party in 2017, standing out in a bright yellow ensemble

A royal has to work that much harder to stand out because that's who people have come to see.

VICTORIA ARBITER, CNN ROYAL COMMENTATOR

DURING THE SUMMER MONTHS, THE QUEEN HOSTS A trio of garden parties at Buckingham Palace and another at the palace of Holyroodhouse, inviting as many as 30,000 guests to stroll about the grounds and enjoy a spot of tea and a piece of cake. It's among the best chances the British public has to experience the Queen in person and attendees come dressed to impress. Gentlemen wear morning dress or lounge suits, while women often sport a colorful day dress with a hat or fascinator.

Her Majesty's ensembles must be bold enough to be seen from afar among the thousands of attendees, but details matter here, too. The Queen makes her way through the crowds in designated lanes arranged by organizers, allowing many to admire her up close—a great opportunity for an intricate hat.

The unpredictable British summer weather means the skies can be sunny one minute and pour rain the next, so an umbrella must be close at hand. Her Majesty often carries a coordinated clear-domed umbrella by Fulton. The U.K. brand brought back the slow-selling "Birdcage" style at the Queen Mother's request in 1988. Its see-through material doesn't obscure the Queen's face from the crowds. Her dressing team places custom orders with sample fabric swatches to ensure the final products are a perfect color match.

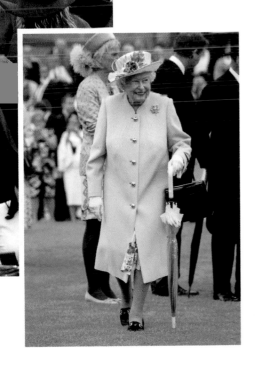

TIARAS COME WITH THEIR OWN SET OF RULES, WHICH FEELS QUITE FITTING, DOESN'T it? The sparkly accessories are typically reserved for brides and married women. Aside from a daytime wedding, they are worn typically at night, more specifically after 5 p.m. The tiaras belonging to the royal family are loaned out by the Queen at her discretion. The base is lined with velvet in a shade to match the wearer's hair. Tiaras can be quite heavy, and are often sewn into place. And just so we're clear: a tiara is not a crown. A tiara is a piece of jewelry that typically goes around the head, while a crown is a circular piece of regalia that sits on top, reserved for the sovereign and female consorts.

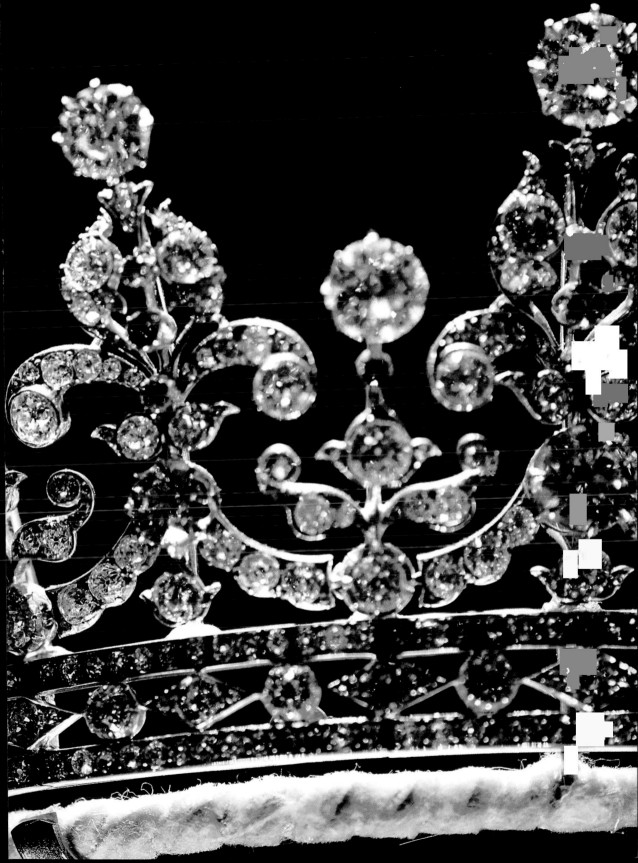

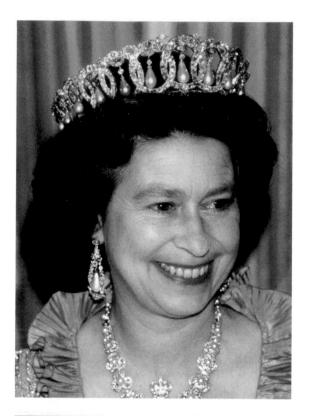

THE VLADIMIR TIARA

The Grand Duchess Vladimir, renowned for her collection of jewels, received this tiara in the 1870s. It was smuggled out of Russia during the revolution. "It's like a James Bond movie," said Stellene Volandes, editor in chief of *Town & Country* and a jewelry expert. Queen Mary purchased it in the 1920s, eventually passing it along to her granddaughter Elizabeth; it has become one of her favorites. The original design has fifteen interlocking diamond ovals with a pearl suspended from each. Queen Mary had a set of Cambridge emeralds fitted as an alternate set of pendants.

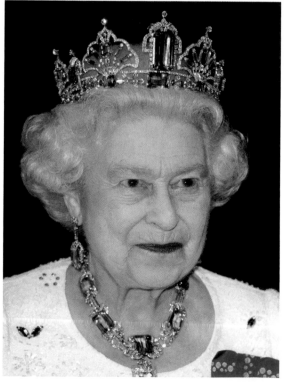

BRAZILIAN AQUAMARINE TIARA

While most of the tiaras the Queen wears are ones she inherited, this sparkler is of her own making. Her Majesty received a diamond and aquamarine necklace and earring set as a coronation gift from the president and people of Brazil. In 1957, she commissioned this tiara to round out the parure. The stunning piece was remade in 1971, with the addition of four scroll designs between the large stones. It is among the tallest tiaras the Queen wears. Who needs high heels when a tiara can give you a few extra inches?

THE GIRLS OF GREAT BRITAIN AND IRELAND TIARA

Made in 1893 with a fleur-de-lis motif, this tiara was a wedding present to Queen Mary. It came with two frames, one in a U-shape and another as a full circle. The tiara was passed down to then-Princess Elizabeth as a gift on her wedding day—and affectionately known as "Granny's tiara." The shadow created by the fleur-de-lis motif looks as though it's a row of girls holding hands. Queen Mary had the bandeau base removed, giving it a lower profile; later, Queen Elizabeth II added it back. The tiara has become part of her regular rotation, perhaps because it is among the lightest in her collection.

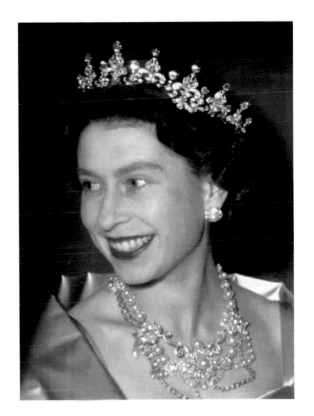

QUEEN ALEXANDRA'S KOKOSHNIK TIARA

This one looks a lot like the Queen Mary Fringe Tiara that Elizabeth wore on her wedding day, doesn't it? Proof of how popular this style of stately spikes is! Queen Alexandra received this tiara as a gift for her twenty-fifth wedding anniversary in 1888. The "Ladies of Society," a group of aristocratic women, had the piece made to match a tiara belonging to Alexandra's sister, Empress Marie Feodorovna of Russia. The style resembles the halo-shaped kokoshnik, a traditional Russian headdress.

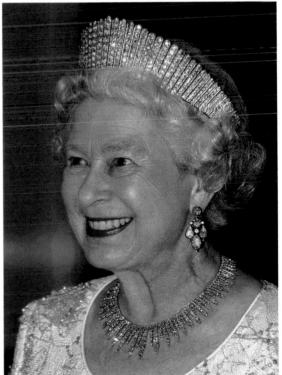

It is inevitable that I should seem a rather remote figure to many of you . . .
But now at least for a few minutes I welcome you to the peace of my own home.

THE QUEEN

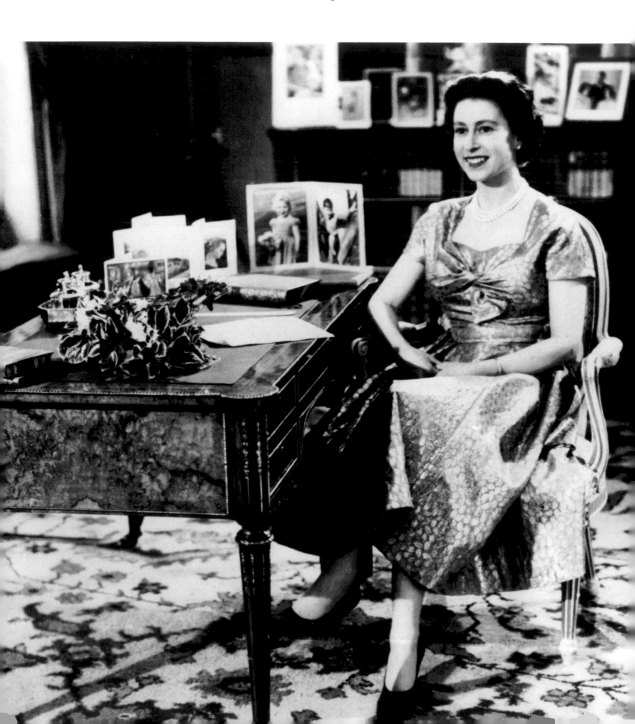

THE QUEEN MARKS THE END OF EACH YEAR WITH HER ANNUAL CHRISTMAS AD-
dress, a brief speech that serves as a recap of the year sprinkled with inspiring sen-
timents for the one to come. It brings Her Majesty into homes worldwide and, since it was
first televised in 1957, gives us a glimpse of hers. What began as a radio tradition with King
George V took on a new level of intimacy when it was broadcast live on television. The
Queen chose a shimmery frock with a sweetheart neckline, perfect to frame her face for the
cameras. She sat at her desk surrounded by framed photographs of her family, with Prince
Charles and Princess Anne by her right arm.

The image of the Queen at her desk has become an immensely calming one, there to steady
a nation with her reassuring presence. In April 2020, as the coronavirus pandemic took its toll
around the globe, Her Majesty delivered a rare state address from her desk at Windsor Castle.
Her bright green dress was simple yet hopeful, the color of spring and new growth; around her
neck hung her signature three-strand pearls. In four and a half minutes, she thanked those who
were following government rules to stay home and offered a few words of encouragement. "We
will succeed—and that success will belong to each and every one of us," she said. "We will be
with our friends again. We will be with our families again. We will meet again."

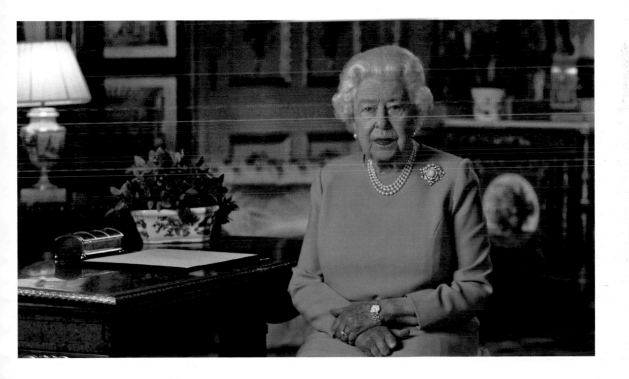

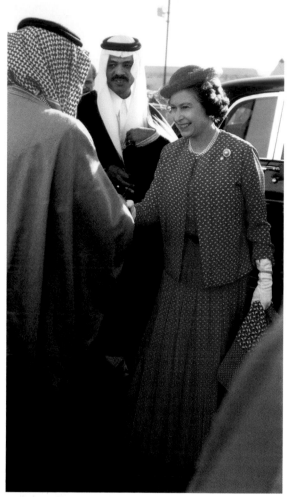

Saudi Arabia, 1979

Japan, 1986

DIPLOMATIC DRESSING

TRAVELING ABROAD BRINGS ROYAL FASHION AT ITS FINEST

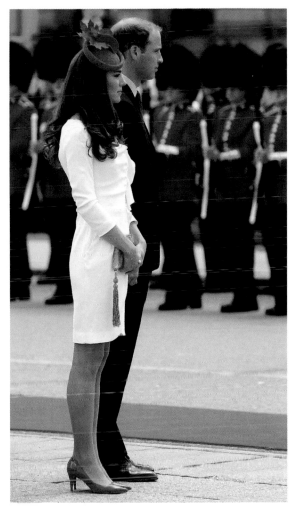

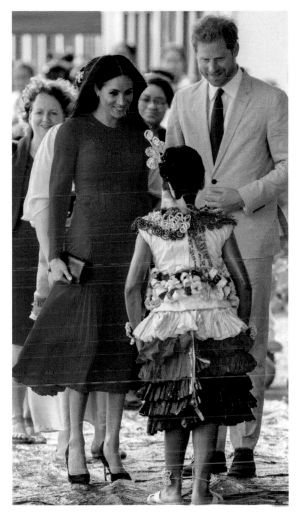

Canada, 2011

Tonga, 2018

THE MOST OBVIOUS SARTORIAL MESSAGING HAPPENS ON ROYAL TOURS, WITH ensembles designed around a host nation's colors, symbols, or traditional attire. It is meant as the ultimate compliment, even if it occasionally looks a bit costumey. Arriving at a racecourse in Riyadh, Saudi Arabia, the Queen wore a print dress and hat inspired by the traditional keffiyeh. Diana referenced the rising sun of the Japanese flag with her red polka-dot dress and with its wide, circular brim. Kate channeled the Canadian flag with her maple leaf hat, while the ruffle of her ivory dress and fan of her red clutch resembled its ripples. Meghan's arrival in Tonga in a bright red dress, the color of that country's flag, had the added touch of pleats, mirroring the traditional skirt worn by the child who welcomed the Sussexes.

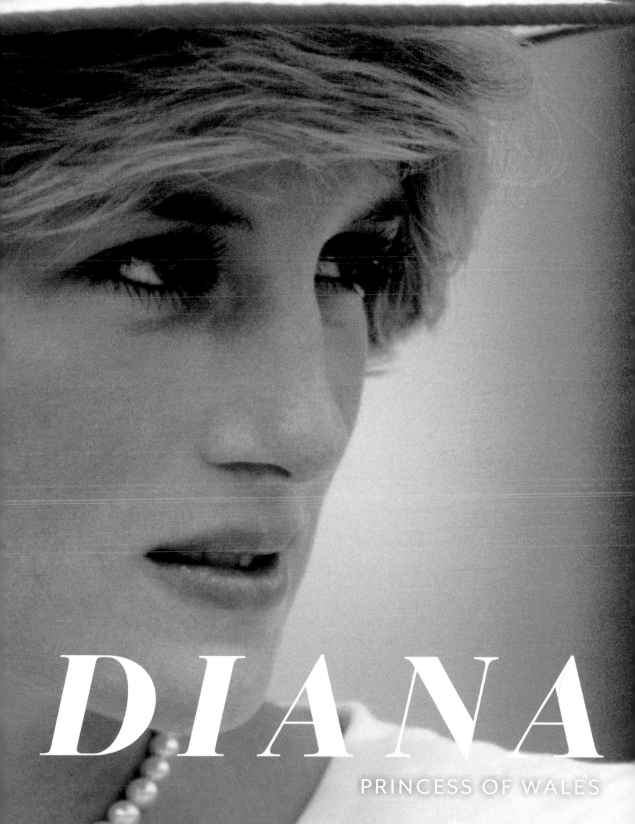

DIANA

PRINCESS OF WALES

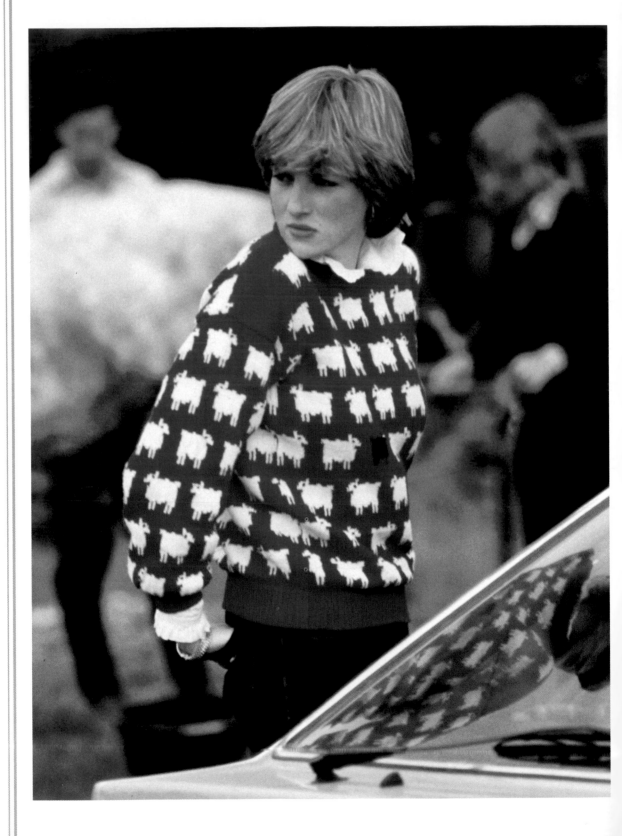

BEFORE THE WEDDING THAT WOULD MAKE HER THE MOST CELEBRATED princess on the planet, nineteen-year-old Lady Diana Spencer turned up to her fiancé's polo match in a kitschy knit. It was the summer of 1981, and the world was enchanted by the soon-to-be wife of the future King of England. Over a ruffled blouse, Diana wore a bright red sweater covered in white sheep. She has a skeptical look about her in the pictures from that day, stuffing her hands in her pockets in one shot and hunched over in the passenger seat of a car in another. She was no doubt aware of the cameras, as the paparazzi had been hounding her for months. But on this day, or perhaps at that moment, she seemed unwilling to perform for them.

I had to look quite closely to spot the sweater's prescient detail, which, in hindsight, is simultaneously subtle and screaming: that single black sheep tucked inside the white flock. It's impossible to know what Diana meant when she wore it the first time. Was it a sign of hesitation about her upcoming nuptials? Or was it simply a young woman who thought a wool sweater covered in sheep was kinda funny? She looked so childlike and unsure of herself, with her long bangs nearly covering her eyes. Nothing about her suggests the sophistication or savvy one might expect from a woman who would become one of the most fashionable figures of the twentieth century.

Fast-forward two years, when Diana turned up in the jumper at another of Charles's polo matches, and it's an entirely different story. Now a wife, mother, and international icon, Diana had evolved from naïve ingénue into savvy cover star. With the help of editors at *British Vogue*, she underwent a dramatic makeover and discovered the power and possibilities of fashion. She knew full well what life was like in the rigid royal fold, and all about her husband's affair with Camilla Parker Bowles. The "black sheep" jumper, as it will forever be known, meant something much

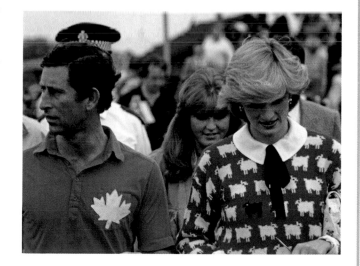

Sporting her famous black sheep jumper at a polo match in 1981 (left) and 1983.

more. Just to punctuate the point, Diana wore it over a blouse with a black bow at the neck. The ribbon tails lead the eye directly down to the black sheep. You can't miss it.

And then there is this intriguing twist: the sweater Diana wore in 1983 does not appear to be the same one she wore two years earlier. It's the same style, but not the same garment. There are noticeable differences in the pattern, including an extra sheep on her shoulder. The black sheep's nose points to her left on the first and the right on the second. Perhaps her dramatic weight loss between those two years meant she needed another size? Whatever her reason for tracking down another sweater, going to the effort to do so makes the message seem that much more intentional.

The black sheep jumper was, like so much of her wardrobe, big, bold, and clever. If you've ever been tempted to write off Diana's style as eighties excess—as I'll confess I have, on occasion—I urge you to reconsider. The People's Princess was a master dresser, tailoring her style not just to what she was doing or who she was meeting but how she was *feeling*. As Patrick Jephson, her equerry, private secretary, and chief of staff, told me, when it came to Diana's wardrobe "there was *always* a message."

LADY DIANA SPENCER WAS ONE HALF OF THE HIGHEST-PROFILE COURTSHIP THE British Royal Family had seen in decades. She and Prince Charles began dating just as the global media landscape was exploding. It was the advent of 24/7 cable news coverage and the early days of weekly celebrity glossy magazines, allowing the rest of the world to follow their relationship in real time.

The phenomenon of Diana, and her fashion, stemmed in part from how visible she was right from the start. As she was plucked from relative—albeit aristocratic—obscurity and presented as a princess-to-be, the cameras were always there. The paparazzi hounded her on the streets of London following rampant rumors of her involvement with the heir apparent. Once she joined the family, Diana was the irresistible new subject of the noticeably expanded royal press pack. The constant coverage catapulted her into a new sphere of notoriety. It wasn't just the people she shook hands with who felt close to her; now anyone enjoying a cup of tea with their morning newspaper could, too. Diana's status as Charles's bride would have earned her a place on the front page regardless. But her clothing kept her there, day after day.

"Even if everyone thought it'd be a dull engagement, we would turn up to see what she was wearing," said Kent Gavin, the royal photographer for the *Daily Mirror*. Working with a team at *British Vogue*, Diana chose clothing that photographed well, in saturated shades and bold patterns. Her dresses offered dimension, with big collars and puffy sleeves, while her hats added texture, festooned with feathers, veils, and bows.

At 5 feet 10 inches tall, Diana was model-like in her stature, at turns demure and dazzling. One moment her chin would be down and to the side, her big blue eyes peering up innocently; the next she would cast a clever smirk. On engagements she would reach into the crowd, enthusiastically embracing strangers. She was expressive, emotional, and available—all the things the royal family had not been. It made for the *most amazing* pictures.

Diana was just twenty when she married Charles and thirty-six when she died, rising from a little-known aristocrat to the most famous woman in the world. In that short time, she cycled through a series of distinct and emotional sartorial phases. Her early looks were demure and romantic, a young girl in love clad in pretty pastels and lots of ruffles. As her husband wandered and her star rose, Diana's fashion grew much more daring, with bold colors and big shapes that seemed to scream: *Look at*

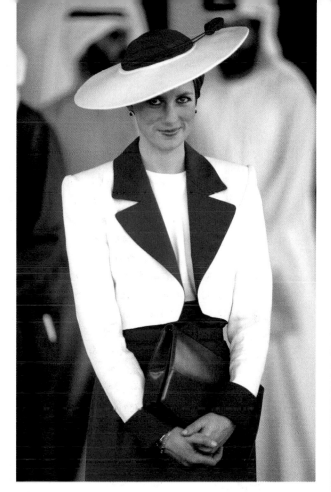

Eyeing the camera on a 1989 visit to Dubai.

me! She shunned fashion as her marriage fell apart; Charles dismissed his wife and her clothes. Her serious and streamlined look centered on blazers and sheath dresses. After her divorce, she emerged anew once again, in sexy short dresses at night and bike shorts at the gym. In the final years of her life, when she wanted the focus to be on her humanitarian work, she auctioned off her gowns and rolled up the sleeves of her button-down shirts.

Throughout it all, the whole world was watching. Photographers found her shortly after she started dating Charles, and stalked her throughout her life. Fans around the globe were intensely interested in her every move. The in-person crowds swelled beyond record, too. In a letter to a friend about the royal tour of Australia in 1983, where tens of thousands of people showed up in Brisbane, Charles lamented the effect the attention might have on Diana: "How can anyone, let alone a twenty-one-year-old, be expected to come out of all of this obsessed and crazed attention unscathed?"

DIANA FRANCES SPENCER WAS BORN ON JULY 1, 1961, QUITE LITERALLY INTO THE royal fold. Her mother delivered her at Park House, which the Spencer family leased from the royals on the Sandringham Estate in Norfolk. She was the fourth of five children born to Edward John Spencer and his first wife, Frances, with two older sisters and one younger brother (an older brother died hours after his birth).

Diana's childhood was tumultuous, marked by her parents' separation and subsequent divorce. After a bitter battle, custody was given to her father, a nearly unheard-of turn of events at the time. As a bridesmaid in her cousin's wedding, she had to choose between dresses from each of her parents to wear to the rehearsal dinner. "They were both so smart, the dresses, and I can't remember to this day which one I got in," Diana later said. "But I remember being totally traumatized by it because it would show favoritism." In 1975, following the death of her grandfather, the family moved to Althorp Estate. Diana's father became the eighth Earl Spencer and she became Lady Diana Spencer.

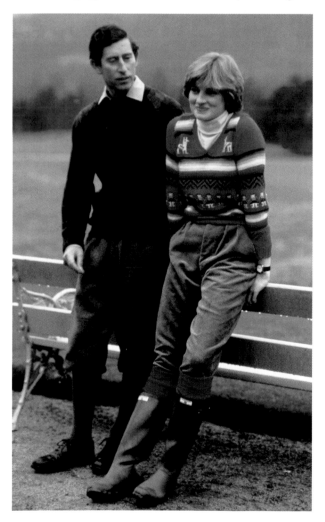

The blushing bride-to-be in a bright jumper and wellies in 1981, just a few months before the royal wedding.

Although Diana's legacy is that of a royal outsider—remember the black sheep?—the aristocratic Spencer family had close ties to the Firm. Diana's grandmother served as a lady-in-waiting to Queen Elizabeth II's mother, and is rumored to have orchestrated (or at least very much encouraged) Diana and Charles's courtship. Diana's father worked as an equerry for the family, a prestigious position as a trusted personal attendant. Her Majesty was a guest at Diana's parents' wedding in 1953 as a young queen. When Charles and Diana got engaged, the *New York Times* carried the news

on its front page with the headline: "Prince Charles to Wed 19-Year-Old Family Friend."

The Windsors had three sons and the Spencers had three daughters, so some flirtatious intermingling was to be expected. In fact, Diana was not the first in her family to date Prince Charles. "My sister was all over him like a bad rash," she recalled of her sibling. "I remember being a fat, podgy, no-makeup unsmart lady, but I made a lot of noise and he liked that." Come Charles's thirtieth birthday dance at Buckingham Palace, Diana was invited, too.

Nearly two years later, in July 1980, both Diana and Charles were invited by a mutual friend for a weekend in the country. Legend has it they sat on a bale of hay at a barbecue and got to chatting. Later, the two went sailing; then came an invitation to Balmoral, the royal family's Scottish home. "I was terrified," Diana recalled. "Shitting bricks." Quite a vivid, if not terribly princess-y, way to sum up one's feelings! I keep coming back to the fact that Diana was just nineteen at the time. She was living in London, working as a nanny and a part-time kindergarten teacher, clad in skirts that fell past her knee and V-neck sweaters. She was a world away from the global superstar she was to become.

After seven months of dating (and by some counts, about a dozen dates) thirty-two-year-old Charles proposed. Later, the prince and the Queen presented Diana with a selection of gemstones from which to make a ring. I guess if your soon-to-be mother-in-law is the Queen, she gets to be part of the process? The future People's Princess chose a twelve-carat sapphire, supposedly the biggest rock of the bunch, surrounded by diamonds. Despite reports that it was inspired by a brooch of Queen Victoria's, the ring was not a family heirloom. The design became available for anyone else to buy via the jeweler's catalog, which earned it a few side-eyes by the elite at the time. It's the one piece of Diana's jewelry we still see all the time, as it's the engagement ring William gave to Kate.

Diana bought an "off the peg" skirt suit at Harrods for the subsequent engagement photocall, the blue hue matching her new ring. She looked every bit like a young woman aching to be taken seriously. Charles, with his hand on her shoulder, looked like a man presenting his chosen bride. In their engagement interview, when asked if they were "in love," Diana blushed and blurted out, "Of course." Charles chimed in with a slightly smug smile: "Whatever 'in love' means."

THE PRINCE AND PRINCESS OF WALES WED AT ST. PAUL'S CATHEDRAL ON JULY 29, 1981, their union celebrated around the globe. What Diana wore wasn't just a dress, it was a DRESS. She didn't so much exit the horse-drawn glass carriage as she spilled out of it, a chaotic swirl of silk taffeta and tulle. It fed every last frantic fairy-tale desire, nearly swallowing her up in the process.

It's impossible to watch the ceremony now and not search for clues of the marriage's demise. But it's important to remember that at that moment in time, this royal wedding was positively magical. The world watched with unabashed delight, and Diana's voluminous gown was built for that spectacle. "We all went through previous royal wedding pictures, and felt we had to outdo those," said Elizabeth Emanuel, one half of the design duo behind the dress. "We'd discover which had the longest train, and say, 'OK, it's got to be longer.'" (It was 25 feet.) The over-the-top design, while intended to prove that Diana could be a princess, revealed her youth and naïveté. It was the kind of dress young girls dream a princess would wear, laden with ruffles, sparkles, and bows.

Fashion was new to Diana as she entered the royal fold. "On the day we got engaged I literally had one long dress, one silk shirt, one smart pair of shoes and that was it," she later said. "Suddenly my mother and I had to go and buy six of everything. We bought as much as we thought we needed but we still didn't have enough." For help, Diana turned to Liz Tilberis, then editor in chief of *British Vogue* (and later the editor of the American *Harper's Bazaar*), and Anna Harvey, *British Vogue*'s senior fashion editor. Diana's "eyes lit up when she saw all the racks," Harvey later recalled. "I don't think she had any idea how many lovely things there were out there—and her enthusiasm was contagious."

Eager to please her new family, Diana devised her own style rules that bucked trends at the time. "Hats give me confidence," she once said. It was an unusually formal choice for a woman of her age, but felt like a page from the Queen's playbook. She kept her heel height to two inches, max, to avoid towering over Charles (many pictures were staged to make him look taller than her, when in fact they were roughly the same height). Her style was modest—making her seem older than she was—and practical. High collars and longer hemlines allowed her to crouch down to talk to children and reach her arm way out into the crowd. One thing she had almost no use for? Gloves. She preferred the skin-to-skin contact.

Diana crafted a much more glamorous image in her first decade of marriage than we see from the royal women today. Forget frugality; the British masses wanted their princess to look like a princess, and, *by God*, she did. Scanning the photo retrospectives, there are so many "tiara moments," the glitzy appearances that thrill royal watchers of all ages. They are Peak Princess, reserved for royalty in a way that not even the most A-list celebrity can replicate. This was less about showboating and more about fulfilling expectations. "She knew that time spent with her, anticipating her, remembering her, was important. It was a comfort, it was a pleasure, it was a break from what might be a very difficult existence," said Jephson, Diana's former equerry and private secretary. "It was also a show of respect. People who met Diana usually got up early, did their hair and put on their nicest clothes," he added. "The least she could do was make an effort as well."

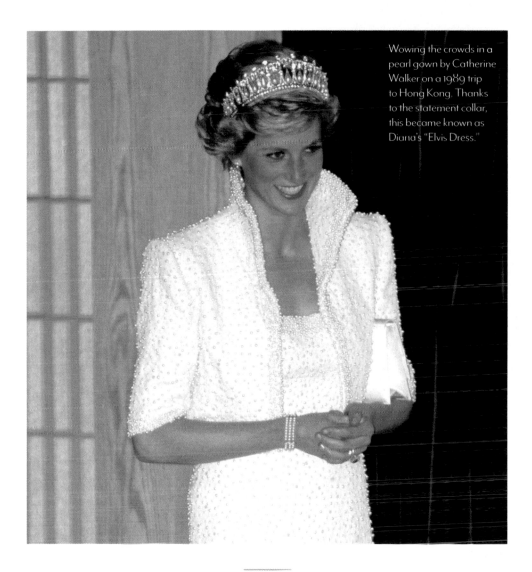

Wowing the crowds in a pearl gown by Catherine Walker on a 1989 trip to Hong Kong. Thanks to the statement collar, this became known as Diana's "Elvis Dress."

DIANA'S STAR REDUCED CHARLES TO A SUPPORTING ROLE, A TREMENDOUS ADJUSTment for the heir to the throne. He was, after all, used to being the center of attention. "Unlike the Queen and Prince Philip, who presented a charming double act of grace and granite, Diana's strengths did not act as a foil to his," wrote biographer Tina Brown. "Instead, they served to spotlight his shortcomings."

Early on, crowds were disappointed if they happened to be on Charles's side of the street rather than Diana's. In a 1983 speech, he joked that he should get a second wife: "I could have walked down the middle directing the operation." (I mean, cringe much?) After Diana danced with John Travolta at the White House in an off-the-shoulder velvet gown, an

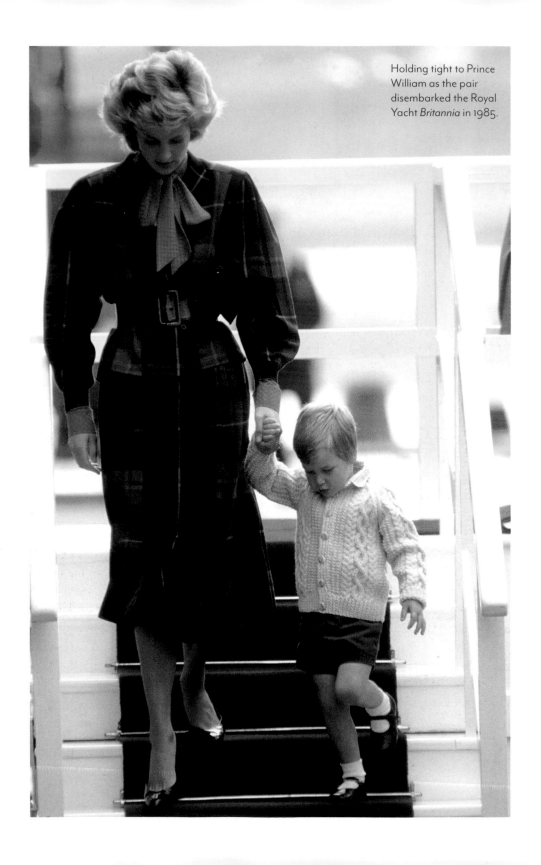

Holding tight to Prince William as the pair disembarked the Royal Yacht *Britannia* in 1985.

annoyed Charles fielded questions about her. "A gentleman of the press asked me rather tactlessly why the crowds in Washington were bigger than when I came a few years ago as a bachelor," he said at a press conference in 1985. "I can tell you why the crowds are bigger," the prince continued, teeing up his own punchline. "They have all turned out to see my new clothes."

Although quite the dapper dresser himself, Charles used Diana's fashion to paint her as shallow and frivolous. On a tour to the Gulf states in 1989, when their hosts asked Diana what she planned to do during her trip—she had a full itinerary, including a visit to a daycare for mentally disabled children—Charles interrupted before she could answer: "Shopping, isn't it, darling?" It's a sad, familiar refrain, dismissing fashion as a purely superficial pursuit.

Meanwhile, Diana was tormented by her husband's infidelity and his emotionally restrained family. "She faced a kind of coldness that would've brought anybody to their knees," said Michelle Green, who covered Diana for *People* magazine for more than a decade. "There's no playbook for the job that she had." She lost a noticeable amount of weight between the engagement and the wedding, but the speculation in the media turned much more sinister following the birth of Prince William. She mostly hid her thin frame underneath wool coats and suits. But a one-shouldered gown by Bruce Oldfield, worn to an evening event in late 1982, put her painfully skinny arms on full display. Diana later revealed she suffered from eating disorders and postpartum depression, which was talked about even less then than it is now.

While the world was clamoring for more of the princess, Diana was often trying to please an audience of one. "No matter what you were making for her," the designer Jasper Conran said, "the question was always, 'Will my husband think I am sexy in this?'" Oof, it makes my heart hurt just to think of it.

The designers the princess worked with became confidantes and friends, and together they styled Diana to keep her in the spotlight. "She really seemed to use [fashion] as good medicine or therapy," said Robin Givhan, fashion critic at the *Washington Post*. People held their breath every time she exited the car, waiting to see what she was wearing. She wore mismatched gloves, one red and one black, and turned a sapphire choker into a headband. "She figured that if people were going to be obsessed with how she looked and what she wore, OK. Embrace it, use it, leverage it," Jephson said. "Diana knew that she was always on parade."

The princess's range was expansive; every print, every silhouette, you name it, she tried it. "Where the Queen can wear every color, Diana could wear every style," said Victoria Arbiter, a CNN royal commentator. One look I keep coming back to is a bold plaid suit with a massive pink pussy-bow blouse underneath and a wide, black belt cinched at her

waist. She took what is usually a formal, stuffy style—does it get more staid than a plaid suit?—and made it into Fashion with a capital F. Sure, you can chalk up some of what Diana wore to the eighties more-is-more trends at the time. But she didn't have to dress so adventurously. The Queen certainly didn't. It makes today's young royals, and their ongoing quest for relatability, seem rather boring by comparison.

In the late eighties and early nineties, when her marriage broke down beyond hope of repair, Diana's style took a hard turn toward the serious. She ditched the puffy sleeves and princess ball gowns and opted for sleeker silhouettes, like simple sheaths, in more mature colors. Perhaps as part of a rebellion, she left some unofficial royal rules behind, choosing red nail polish and short cocktail dresses for evening events.

Andrew Morton's shocking 1992 biography, *Diana: Her True Story*, which we learned after her death was based on secret recordings she had made for him, revealed just how bad things were for the Princess of Wales. Her account from within the walls of Kensington Palace is torturous to listen to now, a kind of from-the-grave retelling of her struggles. Her bulimia and half-hearted suicide attempts, both cries for help as she grappled with Charles's jealousy and affair, made for shocking headlines. Charles and Diana formally separated at the end of that year, and in 1993 she announced she would be withdrawing from public duties. Citing overwhelming pressure from the media, she reduced her appearances in favor of a more private life. She didn't disappear, though, not by a long shot. Some of her most memorable moments, in fashion and in her charity work, came after this declaration. She traveled more freely, too. In January 1995, she attended the Council of Fashion Designers of America awards to present an award. "Move to New York," someone shouted from the gallery as she took the stage. It's hard not to wonder if Harry and Meghan saw their own departure as possible because of how Diana orchestrated hers.

THE PRINCESS'S MOST FAMOUS FASHION MOMENT, THE ONE SO DELICIOUS AND OBVIous it is often cited as proof of her sartorial savvy, came in the summer of 1994. Context here is everything. It was the night a documentary aired in which Charles gave a muddled but definitive confirmation that he had cheated on her.

"Did you try to be faithful and honorable to your wife when you took on the vow of marriage?" the interviewer pressed the prince.

"Yes, absolutely," Charles said.

"And were you?" the reporter asked.

"Yes," Charles responded. "Until it became irretrievably broken down, us both having tried."

Diana was slated to appear that night at a gala and swapped her pre-planned outfit for an

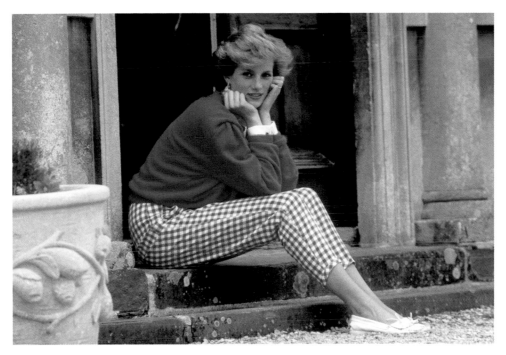

Sitting on the steps of Highgrove in 1986.

off-the-shoulder, above-the-knee little black dress. Now famously known as the Revenge Dress, it was short, tight, and sexy as hell. It scored her a spot alongside Charles on the front page the next day, a sartorial power play aimed at her unfaithful husband.

Charles refused to offer a clear sound bite for the history books; Diana, however, did so dutifully. A year later she appeared in her own television special and served up such a delicious damnation you could embroider it on a pillow. "There were three of us in this marriage," she said. "So it was a bit crowded." Diana rimmed her big blue eyes in uncharacteristically heavy black eyeliner for the top-secret interview, amping up the drama every time she peered up to answer a question. It made her own admission of infidelity feel justified (to this day, her indiscretions are far less cited). Diana supposedly did not want a divorce; she was happy to live her separate life and retain her title. But the interview sealed her fate, with the Queen requesting the couple split.

As the details of her divorce were being finalized, and at the suggestion of then-fourteen-year-old Prince William, Diana organized a massive closet cleanout. She is said to have grown resentful of the focus on her fashion as her humanitarian work ramped up, wanting to be seen as a workhorse rather than a clotheshorse. Together with Christie's, the

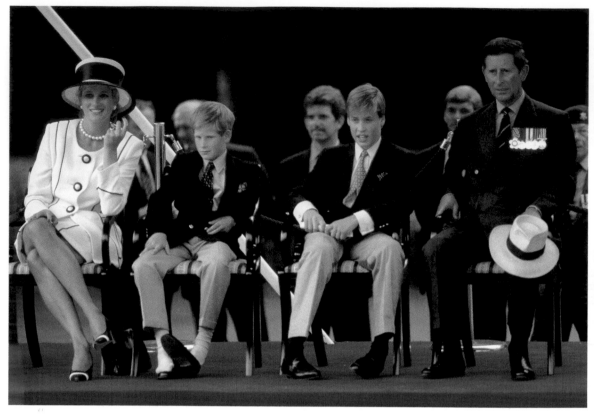

Fulfilling their family duties with a post-separation joint appearance at a parade in 1995. Note Harry's sock feet.

princess auctioned off seventy-nine of her most famous gowns. It took many months to pull together, with Christie's dispatching someone to Kensington Palace to help her organize. "You can see my problem," Diana said, gesturing to a room filled with clothes. She asked that the auction be held in New York, because Americans were thought to have more money and be more fascinated with the royals (and Charles supposedly balked at his ex-wife's old frocks being cast off in his hometown). It was both an admirable charitable pursuit and a dramatic spectacle, with irresistible headlines of Diana discarding her royal past. She raised $3.25 million for charity, an average of more than $41,000 per dress.

Six weeks after the auction, just as Diana's post-royal renewal was beginning, her life came to a tragic end. Shortly after midnight on August 31, 1997, while being chased by the French paparazzi through a tunnel in Paris, her intoxicated chauffeur crashed the car she was riding in. The driver and Diana's companion, Dodi Fayed, the son of an Egyptian billionaire, died instantly. Diana was taken to a nearby hospital, where she was pronounced dead around 4 a.m. She was thirty-six years old.

Thousands of mourners flooded the streets of London, laying a million bouquets outside the royal residences. "There is no doubt she was looking for a new direction in her life at this time. She talked endlessly of getting away from England, mainly because of the treatment that she received at the hands of the newspapers," her brother, Charles Spencer, said in his eulogy. "Of all the ironies about Diana, perhaps the greatest was this: a girl given the name of the ancient goddess of hunting was, in the end, the most hunted person of the modern age." The final images of Diana are of her funeral cortege, her coffin covered in the Royal Standard flag. Amid the white flowers adorning the top was a card labeled "Mummy."

DIANA AND HER FASHION REMAIN OMNIPRESENT TODAY, DECADES AFTER HER DEATH, as a source of inspiration for designers. Tory Burch cited Diana's pre-royal Sloaney style in her spring 2020 collection, while Virgil Abloh based his spring 2018 Off-White collection on Diana's free spirit. *French Vogue* worked with Hailey Bieber to re-create some of those infamous off-duty looks, including sweatpants tucked into cowboy boots, to rave reviews on social media.

To a younger generation of fashionable followers, Diana's legacy isn't weighed down by scandal or divorce. They know a bit about her drama but it doesn't define her. She's a princess who wore really fabulous clothes, clothes that remain vastly more interesting than the wardrobes of the cautious younger royals today. "Diana was a nonfictional Carrie Bradshaw," said Harling Ross, brand director at the fashion website Man Repeller, citing the lead character of *Sex and the City* (which, incidentally, premiered a year after Diana's death).

Diana: The Musical began previews on Broadway in the spring of 2020, a big, bold production dramatizing her royal life and troubled marriage. Fashion was a massive throughline of the production. There were roughly three dozen costume changes for Diana's character, more than double what a typical Broadway leading lady would have. Two songs were focused on the power she derived from her wardrobe. "She used fashion in so many ways, and so many theatrical ways, that we couldn't resist," said Joe DiPietro, who wrote the book and co-wrote the lyrics. "Fashion didn't use her, she used fashion." One of the numbers was devoted to the aforementioned Revenge Dress, a crowning example of Diana's style savvy. "She really was the first great social media influencer, manipulator," DiPietro said. "I always think if she had lived, can you imagine what she would be like on Instagram?" ✦

SO MANY THOUGHTS ON
Diana

A MONG THE FIRST PUBLIC PICTURES OF A YOUNG LADY DIANA SPENCER IS A wardrobe misstep. In September 1980, Arthur Edwards, a photographer at the *Sun* newspaper, heard whispers about Prince Charles's new girlfriend. The pair had begun dating that summer. Edwards went knocking on nursery school doors in the West End, where Diana was rumored to work. "Does Lady Diana Spencer work here?" he inquired. At the sixth or so try, when he got the answer yes, he made his request: "Would you ask if I could take a photograph of her, please?" Diana agreed, posing with a few children at a nearby park. (A)

Edwards took several pictures before other photographers arrived to do the same. Diana didn't smile much in the resulting shots but what I find fascinating is how she actively posed: strolling with the children, sitting in the grass, perched on the arm of the bench. It's wild to think of her willingness to do such a thing. The most famous, lasting shot happened when the sun came out and hit her skirt from behind, revealing it to be semi-sheer. "Charlie's Girl!" read the *Sun*'s front-page headline.

After Diana's spontaneous photo shoot, the press pounced, surrounding her on the streets of London. Photos of her showed a young, modest girl in high-neck sweaters and below-the-knee skirts. (B) Operating without any guidance (or protection) from the palace, Diana responded as she saw fit. Occasionally she was a smidge hostile, with her head down and her shoulders hunched. (C) But she sometimes indulged their requests, occasionally giving a smile or a goofy look. "She was very congenial, she would chat and talk," Edwards recalled. "I knew from the way the Prince of Wales did everything to avoid being photographed with her that she was important."

Hounding her at home. Photographers would congregate outside of Diana's London flat, waiting for her to emerge.

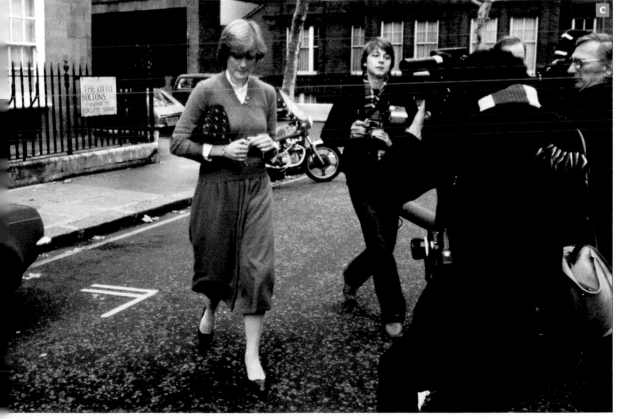

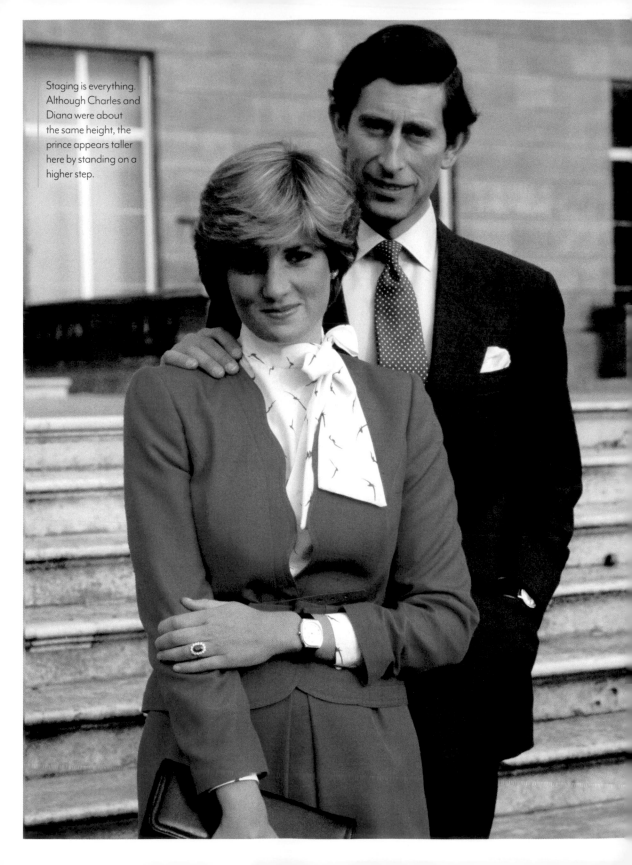

Staging is everything. Although Charles and Diana were about the same height, the prince appears taller here by standing on a higher step.

One minute I was nobody, the next minute I was Princess of Wales.

DIANA

NLIKE WILL AND KATE OR HARRY AND MEGHAN, WHO WERE SNAPPED IN THEIR dating days, the first time Charles and Diana were photographed together was to announce their engagement in February 1981. Nineteen-year-old Diana went shopping for the all-important photo-call on her own, beginning her search at the Bellville Sassoon studio. But she quickly left, intimidated by the disapproving saleswoman who did not recognize her. Brings to mind that famous *Pretty Woman* "big mistake" moment, no? (Thankfully, there's a happier ending to this part of her sartorial story: Diana would later return to the studio and form a lasting friendship with David Sassoon; he designed more than seventy gowns for her.) Instead, for her debut as the princess-to-be, she found a blue skirt suit at Harrods. It was by the British brand Cojana, and she let out the hem herself. The hue perfectly matched her ring.

One can imagine Diana recognized her future mother-in-law wore bright colors for royal engagements, and she began sporting similar hues. The suits gave the teenager a more sophisticated vibe, which was somewhat tempered by her penchant for girlish blouses. She loved an exaggerated neckline, either tied with an oversized pussy bow or a circle of ruffles known as a "pie crust" collar. Her hair was longer then—perhaps she was growing it out for her wedding?—and fell over her famously big blue eyes.

Playing to the cameras on a walkabout in Broadlands, a few months before her wedding. Check out her "pie crust" collar.

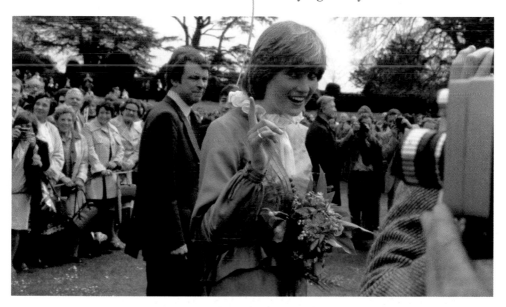

"S O EXCITED," DIANA LATER SAID OF HER FIRST BLACK-tie charity event, a few weeks after her engagement was announced. For the big night out, she chose a strapless taffeta evening dress by David and Elizabeth Emanuel, who would later design her wedding gown. She thought that black was the smartest color a young woman could wear, deeming it "a real grown-up dress." But when she appeared before her future husband, Charles bristled, remarking that black was reserved for those in mourning.

Without another choice at the ready, Diana soldiered onward. The ill-fitting dress proved problematic as she exited the car, revealing her ample décolletage. "I was quite big-chested then and they all got frightfully excited," Diana later recalled. It was an overwhelming evening for the new royal fiancée, without any guidance on how to carry herself. In hindsight, she said she was "terrified" the entire evening. But royal watchers found her novice approach endearing. "To the British public, Diana was every teenager announcing a sweet determination to be seen no longer as a child but as a grown-up, alluring woman," biographer Tina Brown wrote. "The transparency of intent made Diana vulnerable, not vulgar."

The dress is among Diana's most famous ensembles, so when Kate turned up in a similar black frock several months after her own 2011 wedding, the comparison was irresistible. (Like Diana had, Kate wore a dress by the brand behind her bridal gown, Alexander McQueen.) While I do think the connections drawn between their wardrobes can sometimes feel forced, the ruffle along the neckline on both dresses seals it for me.

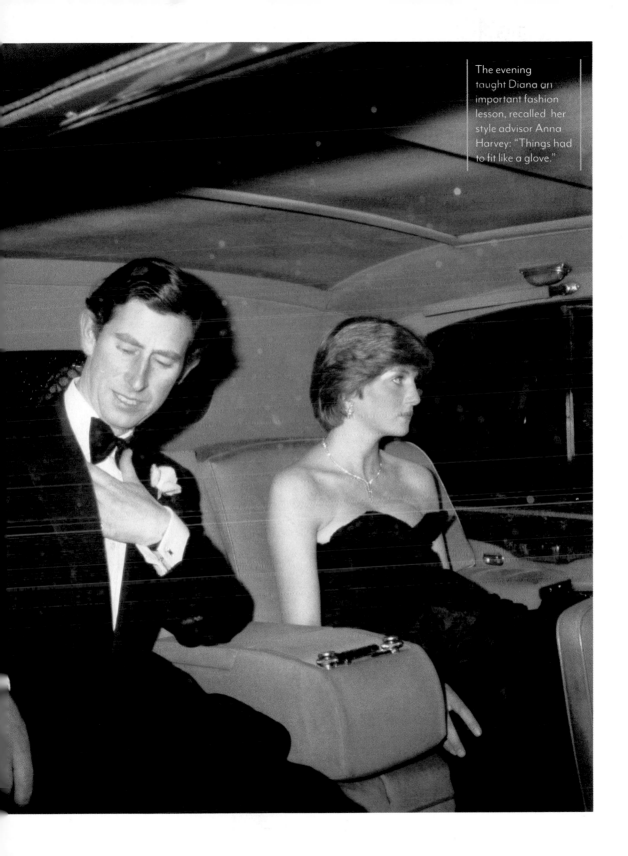

The evening
taught Diana an
important fashion
lesson, recalled her
style advisor Anna
Harvey: "Things had
to fit like a glove."

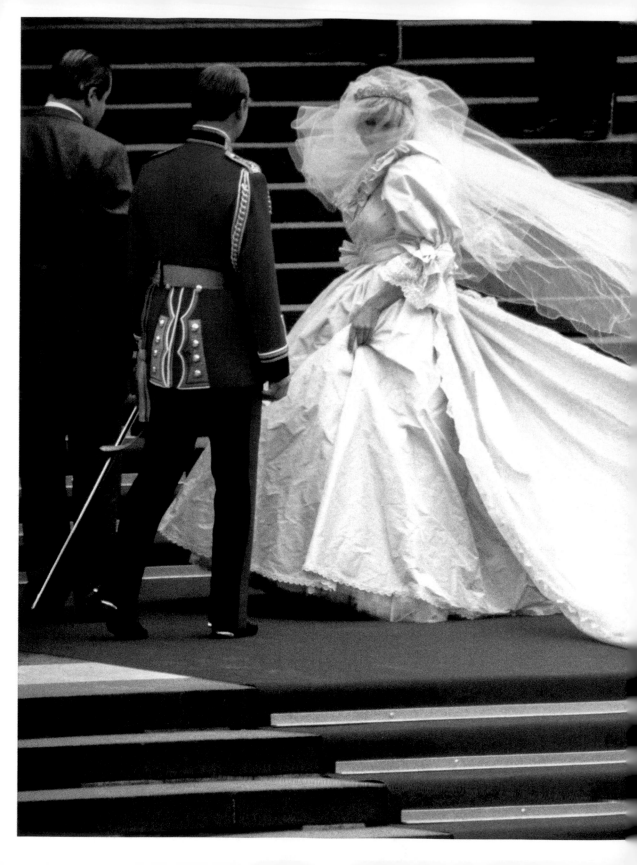

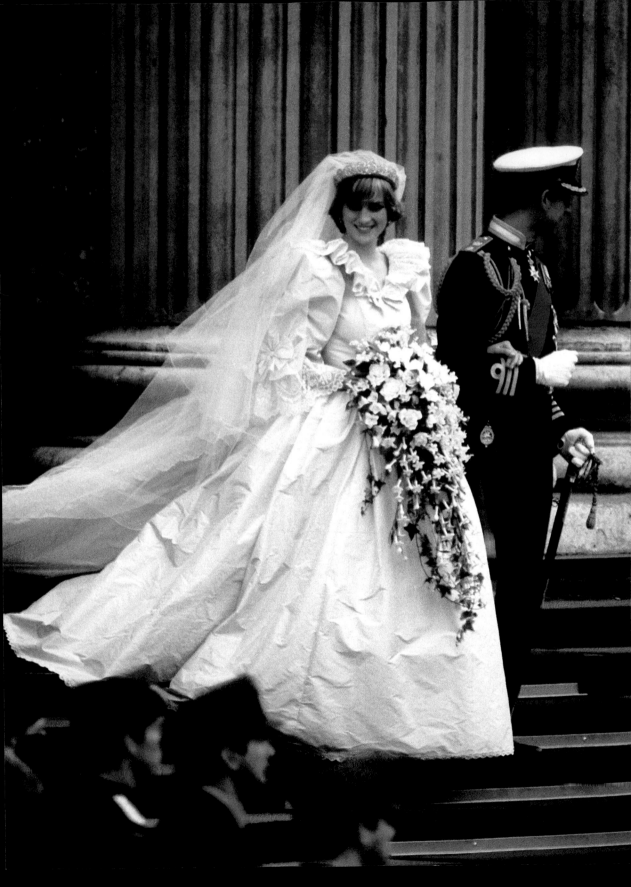

Here is the stuff of which fairy tales are made.

ARCHBISHOP OF CANTERBURY ROBERT RUNCIE

FOR THE MOST ANTICIPATED WEDDING DRESS OF THE CENTURY, DIANA TURNED to David and Elizabeth Emanuel, an up-and-coming husband-and-wife design duo in their late twenties. Diana rang the couple by telephone, a call they did not answer immediately because they were tending to another client in the showroom. "Liz," Diana said when she finally picked up. "Would you and David do me the honor of making my wedding dress?"

Diana, who turned twenty just before the wedding, had high hopes that her dress would fulfill the dream of a princess. "We never had any special instructions about how to make the wedding dress," Elizabeth Emanuel said. "That added a bit to the fun of it all, made it [a] bit of an adventure." The designers did their homework, studying all the previous royal wedding photos they could find, while also turning to favorite old films, including *Gone with the Wind*. "Inspiration came from everywhere," Emanuel said.

She described the process of designing Diana's dress, as well as those of her bridesmaids, as "relaxed and informal." Which is a bit more casual than I would imagine a commission of this gravity would be! And yet, many details of the process would suggest it was just that; Diana reviewed dozens of sketches while seated cross-legged on the floor. At one fitting, the bridesmaids turned up on roller skates. "They were whizzing around with their dresses on," Emanuel recalled. "You hear so much about the Princess's caring side, but she was also great fun."

The team prepared for the worldwide celebration on July 29, 1981, as best they knew how, even measuring the width of the aisle to make sure it could accommodate the train. But a miscalculation on the morning of the wedding came to define their design. They had rehearsed Diana's short ride to St. Paul's Cathedral but not with her father, the Earl Spencer, joining her. "He was quite a large man," Emanuel recalled. Although they had attempted to fold the dress and train "like you would fold a bed sheet," the silk taffeta creased terribly. The heat of the day, coupled with Diana's nervous grip, didn't help. The Emanuels did their best to straighten the creases out before her walk down the aisle, but the wrinkles persisted. In an admirable attempt at reframing, the designers have since spun the technical missteps into part of the magic: "She looked like a butterfly emerging from her chrysalis, unfurling her wings and about to fly," Emanuel said. "It was so romantic. Oddly, the imperfections seemed to make her even more beautiful."

Diana's "something old" was the piece of Queen Mary lace sewn onto the flounces of her "something new" dress. She wore the Spencer family tiara as her "something borrowed" (it belonged to the Earl Spencer, her father). For "something blue," the designers sewed a tiny blue bow on the back of the dress.

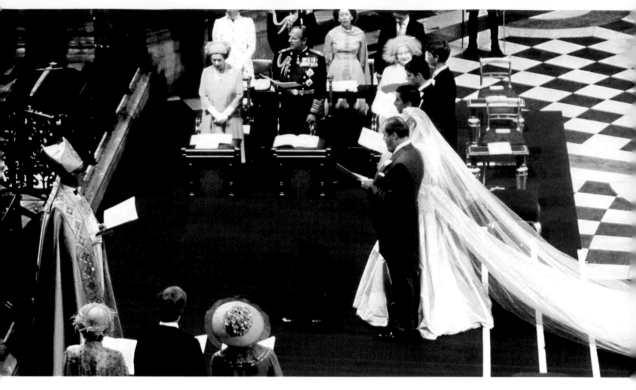

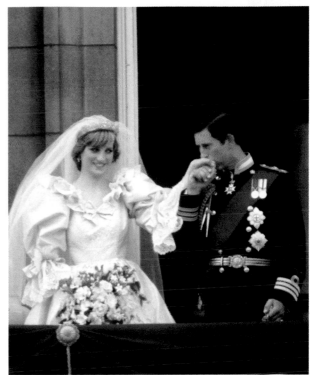

When Diana confided her pre-wedding fears to her sisters, they told her: "Bad luck, Duch"—Diana's family nickname from her pre-royal days, short for duchess—"your face is on the tea towels so you're too late to chicken out." Her dress was not a traditional bridal white but rather "vintage ivory" to better suit her complexion. Following the ceremony and the horse-drawn carriage ride, the newlyweds appeared on the balcony of Buckingham Palace. There were two kisses, the traditional on-the-lips one followed by Prince Charles kissing a shy Di's hand.

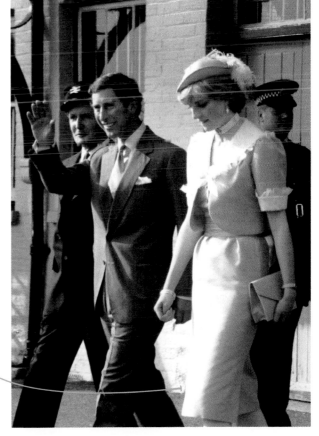

Departing for her honeymoon, Diana wore a peach ensemble by David Sassoon. "It had to have a straight skirt, she felt that was very grown-up," the designer said.

It's a marvelous life.

DIANA

DIANA AND CHARLES EMERGED FROM THEIR HONEY-moon Mediterranean cruise aboard the Royal Yacht *Britannia* to a photo-call at Balmoral, the royal family's Scottish estate. They looked tanned and rested, and very much in love with their hands intertwined. British designer Bill Pashley made two different sizes of the tweed wool day suit Diana wore that day and she chose the larger because the extra shoulder room allowed her to partake in the country pursuits. The slightly baggy fit accentuated Diana's noticeable weight loss in the preceding months. She suffered from bulimia nervosa, a dangerous disorder of overeating and purging. On their honeymoon, as she learned of Charles's continued involvement with Camilla Parker Bowles, Diana made herself sick as often as five times a day.

"She'd transformed completely from the girl I'd met eight months earlier," recalled Anna Harvey, the *British Vogue* editor who advised Diana on her fashion. The change was about more than the weight loss, which Harvey conceded was "dramatic." As low as Diana felt, she was also acclimating to a new high. It had dawned on Diana, and the rest of the royal family, that her popularity after the wedding was not diminishing as expected. "She was amazed at her approval rating," Harvey said. "And this newfound confidence made her blossom." The couple's first visit to Wales made all that abundantly clear. The three-day trip saw massive crowds in five cities, all clamoring for a glimpse of the princess. Diana leaned into the excitement—and proved she could practice sartorial diplomacy deftly. Her red-and-green suit coordinated with the colors of the Welsh flag.

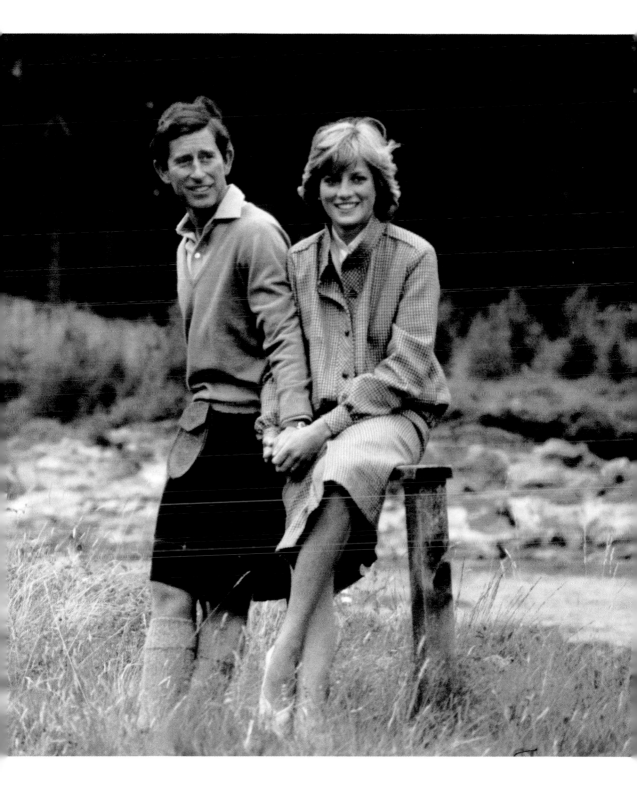

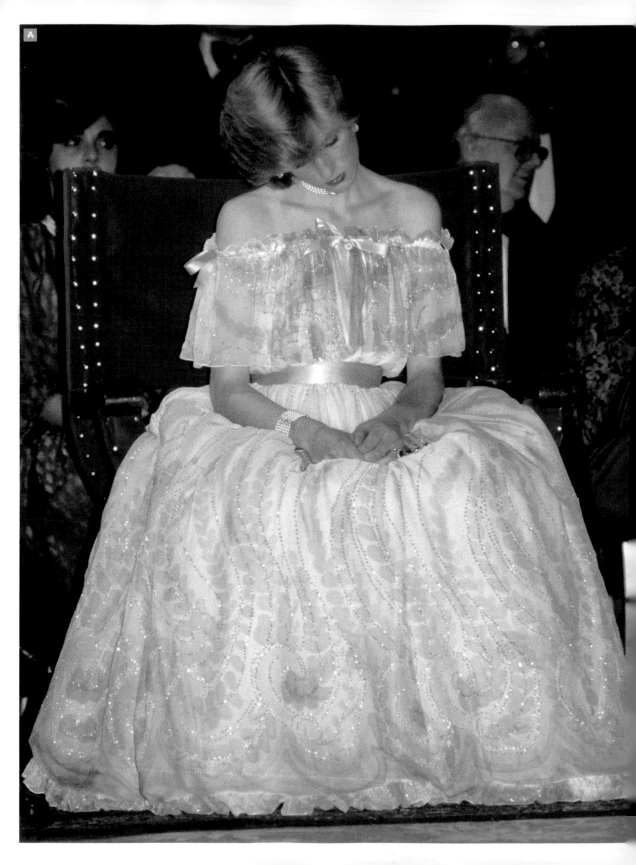

The whole world is watching my stomach.

DIANA

THE PRINCESS OF WALES WAS AN EN-chanting presence on the world stage, her every move taken as the next scene in the ongoing fairy tale. So when she dozed off at a gala on a November evening in 1981, while seated in a throne-esque red chair in the dreamiest off-the-shoulder Bellville Sassoon ball gown, the story wrote itself. (A) Here was Sleeping Beauty, exhausted from her dizzying schedule and the demands of public life. The following day Buckingham Palace, keen to put an end to rumors that she had been disinterested in the event, announced that the princess was pregnant. Her first child was due around the time of Charles and Diana's first wedding anniversary.

Diana's maternity style was composed of mostly voluminous silhouettes known, unfortunately, as "tent dresses." There were no body-con pieces and there was certainly no bump cradling with her hands. Still, it was a novelty to see a pregnant princess. In the summer of 1982, just before the birth of Prince William, Diana and Charles attended a day of Royal Ascot, a special series of horse races. The princess wowed in a soft pink dress and white tights. (B) It appears the couple went from there to one of Charles's polo matches later that same day but—and I love this—Diana didn't change. From one horse event to the next, she simply took off her hat, threw on a cardigan, and carried on. (C)

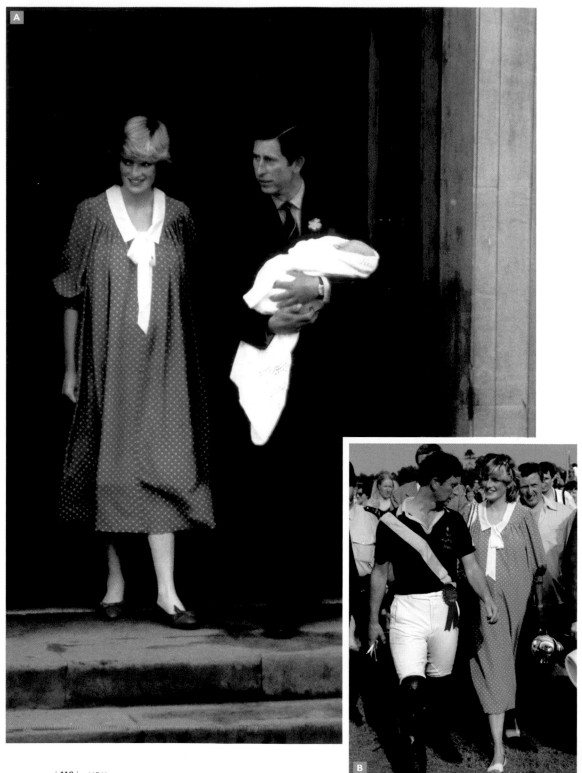

WILLIAM ARTHUR PHILIP LOUIS WAS BORN LATE IN THE EVENING ON JUNE 21, 1982, his arrival securing the next generation. Charles was the first heir apparent to witness his child's delivery since the days of Queen Victoria; William was the closest in line to be delivered in a hospital, rather than a royal residence. Thus began the new tradition of presenting royal babies to the world on the hospital steps. (A) Cradling a day-old William, Diana wore a . . . repeat! She had been photographed in this green polka dot Catherine Walker dress at one of Charles's polo matches. (B) It was long and loose, hiding every inch of her figure. She dressed it up for this historic moment with bright pink flats and tights.

Just six weeks later, William was christened in a private ceremony at Buckingham Palace. The staging of the photographs is glorious, with the Queen and Queen Mother in blue framing Diana in pink. But the strain is obvious. Young William wailed while a flushed Diana soothed him using her pinky finger as a pacifier. "I was excluded totally that day. I felt desperate, because I had literally just given birth," she said later. "And it was all decided around me. Hence the ghastly pictures."

Baby William wore the traditional gown of Honiton lace, which Queen Victoria had commissioned in 1841.

THE ROYAL TOUR OF AUSTRALIA and New Zealand in 1983 changed everything for the Prince and Princess of Wales. The six-week trip was the start of Di-Mania, a critical turning point as Charles realized his wife's star power. The crowd sizes swelled to six figures in some spots. "The adulation of the crowds at first terrified and then empowered Diana. This was something she could do, and do well," wrote biographer Sarah Bradford. *Tatler* declared Diana "Number One, indisputable brand leader."

Diana's dazzling image of youth and beauty took on a new sophistication thanks to her relationship with designer Catherine Walker. As part of the meticulous research, the Walker team studied past British consorts, including Queen Mary, known for her high collars and statement sleeves. "This was an era of grace, which exuded a feeling of calm elegance, symbols we would draw on for the Princess," the late Walker's husband and design partner, Said Cyrus, recalled. The modest silhouettes and long hemlines made Diana look much older than her twenty-two years would suggest. "You'd be amazed at what one has to worry about," Diana said. "You've got to put your arm up to get some flowers, so you can't have something too revealing." Diana rewore many of her the same outfits on a tour of Canada a few months later.

Standing out in the crowd, Diana's bright dresses wow fans in Alice Springs (above) and Perth, Australia.

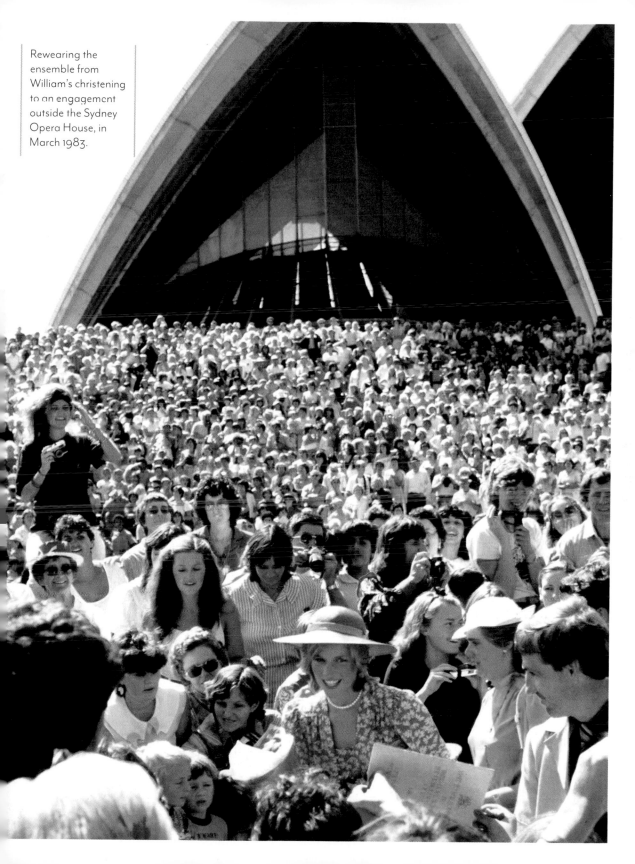

Rewearing the ensemble from William's christening to an engagement outside the Sydney Opera House, in March 1983.

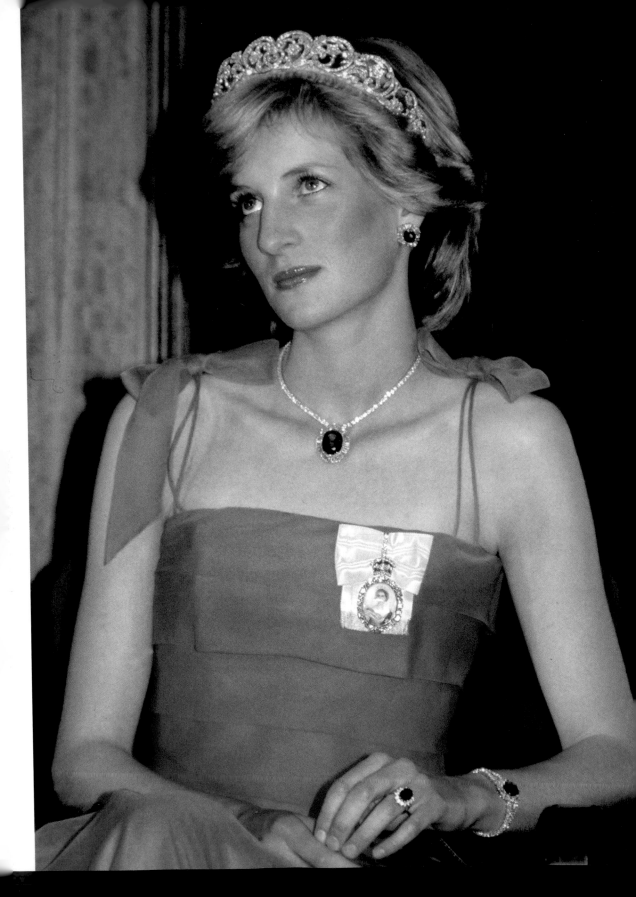

DIANA WORE A TIARA *ALL THE TIME* IN THE FIRST FEW YEARS OF HER MARRIAGE. OK, maybe not all the time, but certainly more than the newer members of the royal family. Black-tie events, in addition to the traditional white-tie ones, were considered tiara moments. Diana also took the sparklers on tour, giving Commonwealth countries an up-close look of some of the family's most-loved pieces.

Her go-to tiara was the Spencer Tiara. Made by House of Garrard, the star-and-flower scroll design has been worn by women throughout the Spencer line, as well as those joining the family. Diana first wore it on her wedding day. It's a patched-together sparkler from the 1930s, in the tradition of creating a new piece with old family jewels. While it has been displayed since Diana's death, it has not been worn publicly since her passing.

Early in her royal life, Diana also wore the Lover's Knot Tiara. Commissioned by Garrard for Queen Mary, it was modeled after a tiara belonging to the first Duchess of Cambridge and made of pearls and diamonds already owned by the royal family. Its name comes from the pretzel-looking knots from which the nineteen pearls hang. It was passed from Queen Mary to Queen Elizabeth II, who issued it on lifetime loan to Diana. Upon her divorce, it was returned to the Queen and stayed out of public view until 2015, when Kate first wore it to a diplomatic reception.

Traveling with her tiaras, wearing the Spencer Tiara in Australia (left) and the Lover's Knot Tiara in Canada.

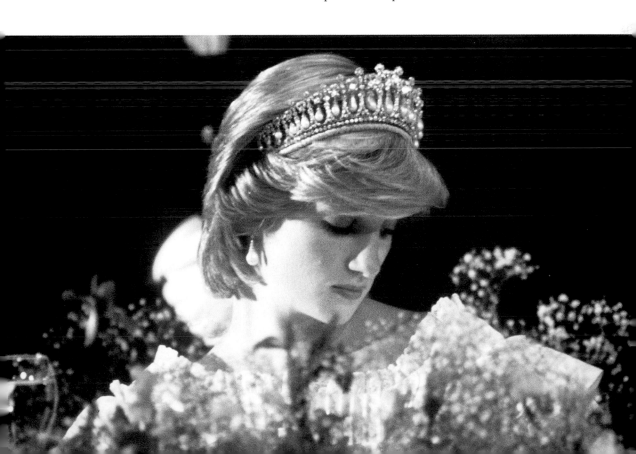

> *It happened before our very eyes, the transformation from this shy teenager . . . into the self-assured woman and mother, confident in her beauty.*

JAYNE FINCHER, PHOTOGRAPHER

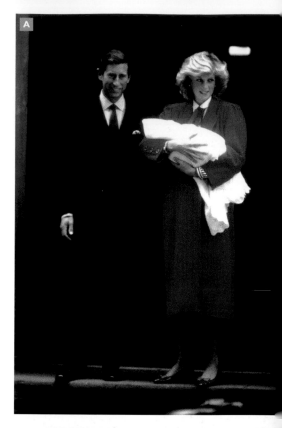

DIANA'S POPULARITY, COUPLED with her burgeoning relationships with British designers, propelled her to new fashion heights. Her bold experiments delighted the press, especially her foray into traditional menswear styles. When Prince Harry was born, in September 1984, she appeared on the hospital steps in a noticeably more glam look than when she had presented William. (A)

The dramatic fashion evolution could be seen on the 1985 tour of Italy. (B, C) Gone were the ruffles and pastels from Australia and Canada, replaced with sharper, tailored pieces. For the seventeen-day trip, it was reported beforehand that Diana packed thirty-two dresses and suits; seven coats; and sixteen pairs of shoes, handbags, and hats (I want to know who shared these details with the press?). It signaled a new confidence in the young mother, revealing both her desire to be taken seriously—nothing says "serious" quite like a suit, after all—and her cheekiness. Her bold clothes in Italy became not just a mention in the story but the story itself. *Never mind Charles admiring timeless art or meeting the Pope, have you seen what Diana is wearing?*

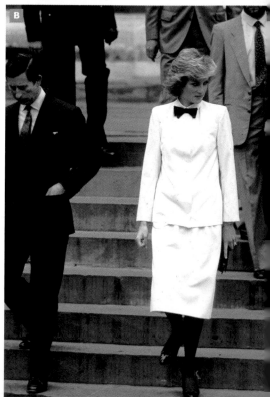

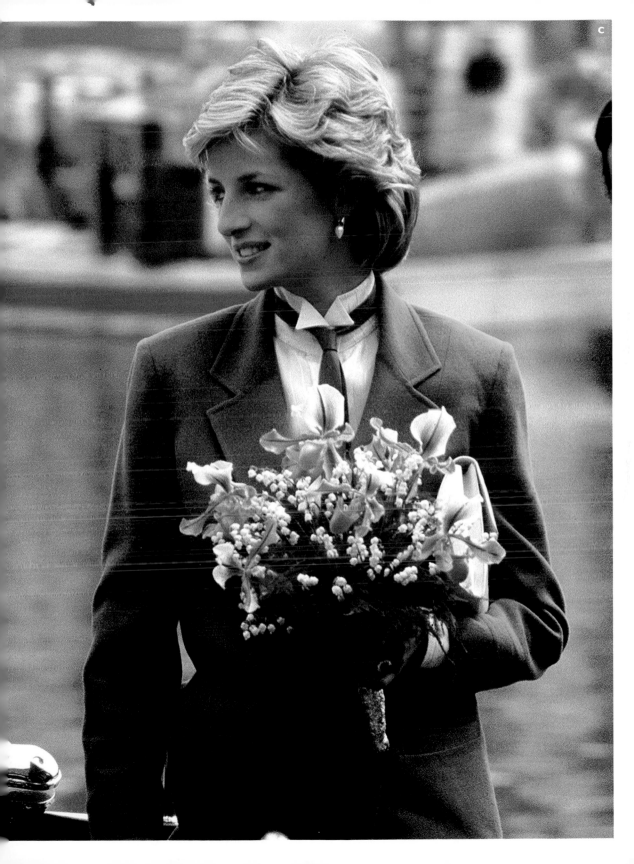

*[It] was one heck of a number
and it thrilled her.*

ANNA HARVEY, *BRITISH VOGUE*

IF YOU WERE TO ASK A LITTLE GIRL what a princess likes to do, I imagine dancing—and, more important, twirling—would be at the top of that list. Diana abandoned her childhood dream of becoming a ballerina because she was too tall. But all that training came in handy in front of the cameras, creating some of the most iconic images of her life. (Think of it this way: Diana loved dancing as much as Kate loves playing sports.)

Her 1985 spin with John Travolta at the White House, while the band played a medley from *Grease* and *Saturday Night Fever*, will be remembered forever. First Lady Nancy Reagan asked the Hollywood heartthrob to take Diana for a spin. "It had to look like a million dollars," Travolta told biographer Tina Brown. "It was history being made."

Photographer Pete Souza, now best known now for his tenure as President Obama's official photographer, was working for President Reagan at the time. He described Diana as "taller than I would have expected," and seemingly older than age twenty-four. The lasting memory he has of the late princess is how aware she was of the cameras. "Most people under the microscope like that are, by that time, so used to cameras being around that they don't even pay attention," Souza said. "Yet I sort of saw her looking at me a couple of times."

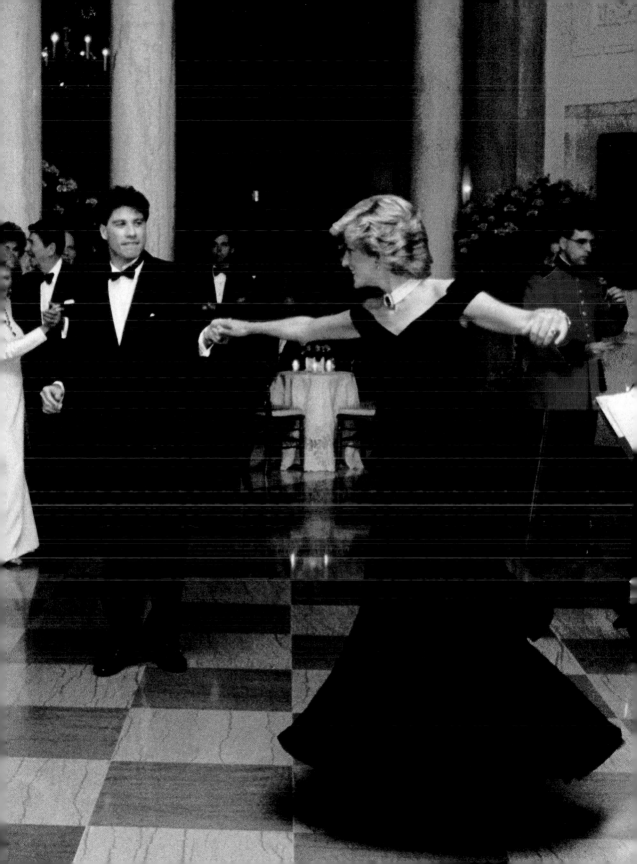

The dinner was closed to the press but news of the dance quickly leaked. Charles was not happy, especially when asked for Diana's reaction at a press conference later. "I think you enjoyed it, darling," he said to her before turning back to reporters. "She'd be an idiot if she didn't enjoy dancing with John Travolta, wouldn't she?" The Queen, in her quest to maintain the glamour of the monarchy, was said to have approved.

As a thank-you, the White House sent one print of the photograph to Buckingham Palace and another to Travolta. A week or so later, it was published in a London tabloid. "We've always wondered, 'How did they get that photo?'" Souza told me.

Diana's deep blue, off-the-shoulder velvet dress by Victor Edelstein became one of the most valuable pieces in her wardrobe, selling at auction in 2013 for £240,000. The dress failed to attract a bidder when it went up again in 2019, a sign of dwindling interest from a younger generation, perhaps? It found its proper home with the Historic Royal Palaces, which snapped up the piece for its Royal Ceremonial Dress Collection.

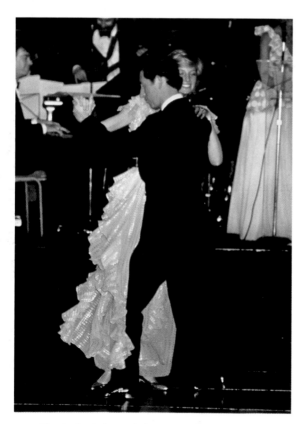
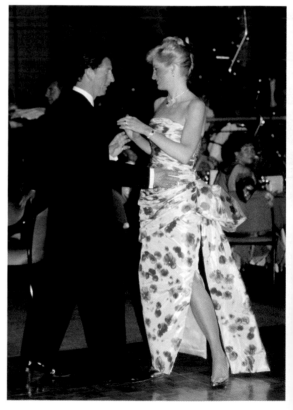

Charles had plenty of chances to dance with Diana, including on tour in Australia in 1983 (far left), 1988, and 1985.

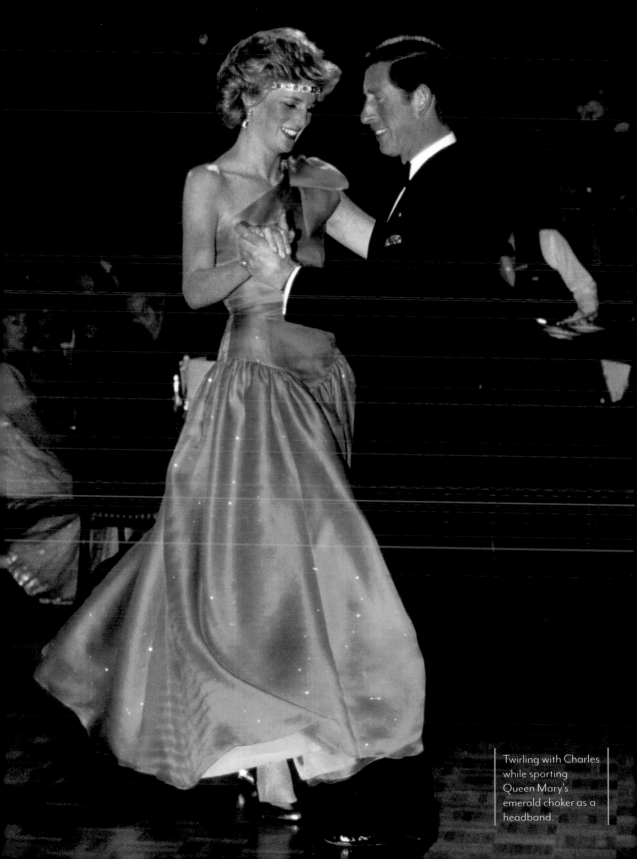

Twirling with Charles
while sporting
Queen Mary's
emerald choker as a
headband.

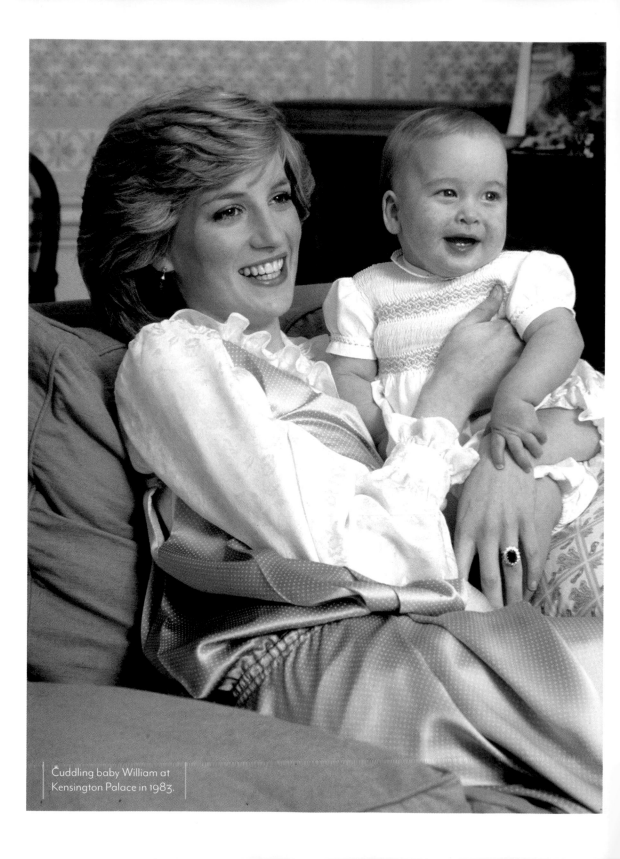

Cuddling baby William at
Kensington Palace in 1983.

CHARLES AND DIANA OFTEN MADE their young family available for photographs, actively putting forth a wholesome image of the next generation. I'm particularly enamored with pictures of the children in their home—we *never* see this sort of thing anymore. After Diana's death, the royal family closed off access to these sorts of moments.

As the princess's fashion star rose, she brought her children along for some high-profile twinning moments. Unlike the Queen's penchant for matching with her younger sister, which could signal an ambivalence toward fashion, Diana's coordination suggests the opposite. She knew the attention would be on her clothing, and making her sons into mini-mes only heightened that interest. Plus, it's the sweetest sign of their bond, don't you think?

Twinning with William for church on Easter Sunday in 1987.

Holding Harry on the balcony at Buckingham Palace for Trooping the Colour in 1988.

She read her reviews and tailored her style so that she could be seen as elegant and glamorous, which she considered part of her job.

ELERI LYNN, CURATOR, HISTORIC ROYAL PALACES

DIANA CAME INTO HER OWN IN THE SECOND HALF OF THE 1980S, AND embraced the over-the-top fashion that was trending at the time. Shoulder pads and sparkles became hallmarks of her eveningwear; dresses like the shimmery red Bruce Oldfield design she wore to a state dinner in 1989 were seen as the height of glitz and glamour. (B) The press nicknamed her "Dynasty Di," after the American television series with its extravagant costumes.

By this point, Diana had taken more ownership of her image and her fashion choices, building on the advice and assistance she received earlier in her royal tenure. She kept close tabs on how her fashion was discussed in the newspapers. The princess listened to her critics, discarding what didn't work and doubling down on what did. For the 1985 London premiere of the James Bond movie *A View to a Kill* she wore a metallic lamé evening gown that was fit for a Bond girl. (C) It was also by Oldfield, one of several designers who became quite friendly with Diana. The princess would spend more time with him than perhaps she needed to, enjoying not just the fashion but the companionship. "She'd get involved, hauling rolls of fabric up the stairs at the studio," Oldfield recalled.

Channeling the glamour of her late mother-in-law, pregnant Meghan wore an all-sequin gown by Roland Mouret in early 2019.

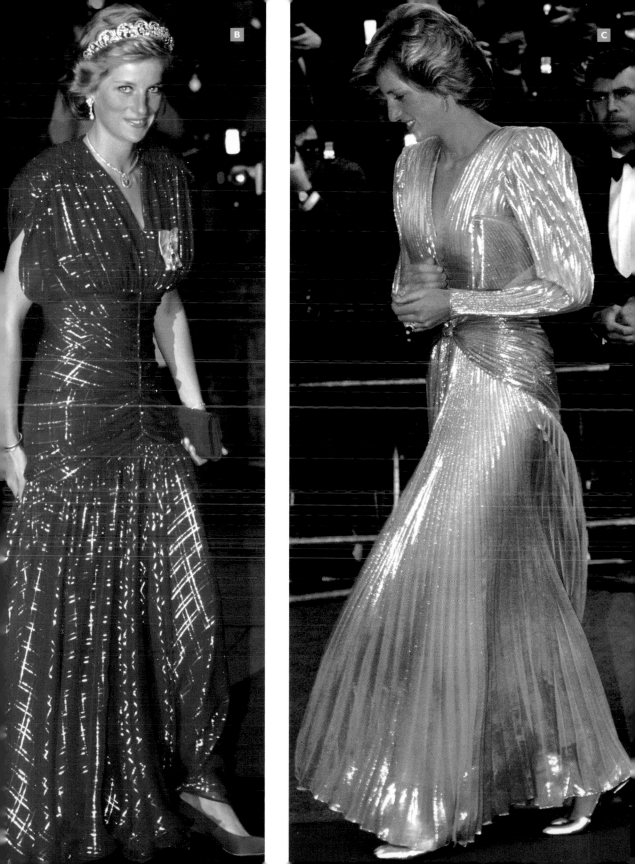

Sometimes I can be a little outrageous, which is quite nice. Sometimes.

———

DIANA

BEFORE THE QUEEN'S TECHNICOLOR MAKEOVER, DIANA PROVED ROYAL FASHION could be bold and bright. Her finishing touches, like red tights while climbing off a red helicopter, made an outfit sing. (C). Diana was in her early- to mid-twenties at the height of her whimsical period, appearing all the more spirited alongside Charles in his serious double-breasted suits.

Diana occasionally missed the mark, even with her closest collaborators. A teal checked coat by the Emanuels, designers of her wedding dress, was dubbed the "horse blanket" when she wore it in Italy in 1985. (B) Is the coat the problem or is it the hat? You tell me. It found a new home in a pile of cast-offs, eventually taken to a charity shop. A Catherine Walker dress resembling a majorette uniform, worn to meet the troops in 1987, "was widely berated," said *British Vogue*'s Anna Harvey, who helped style Diana. "Yet she intended it to be a compliment to them." (A)

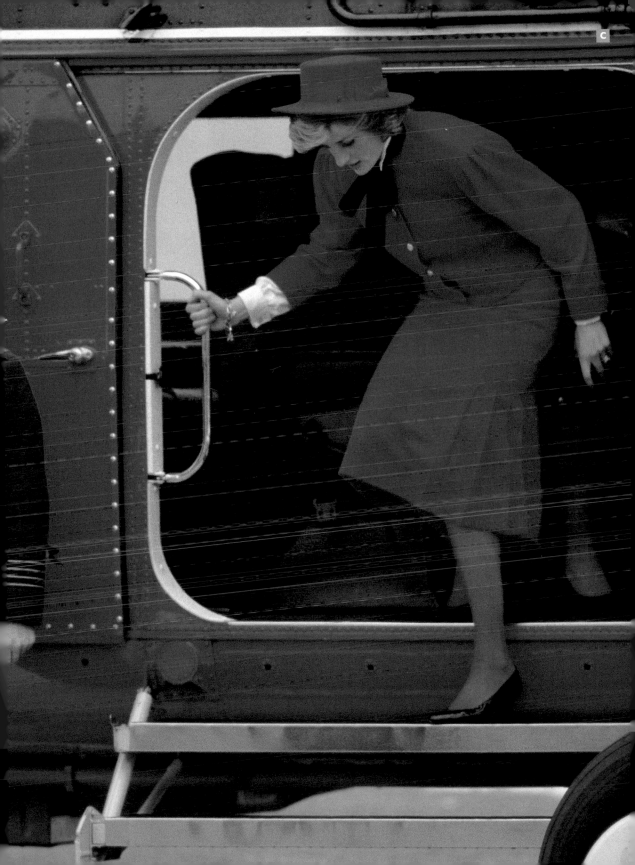

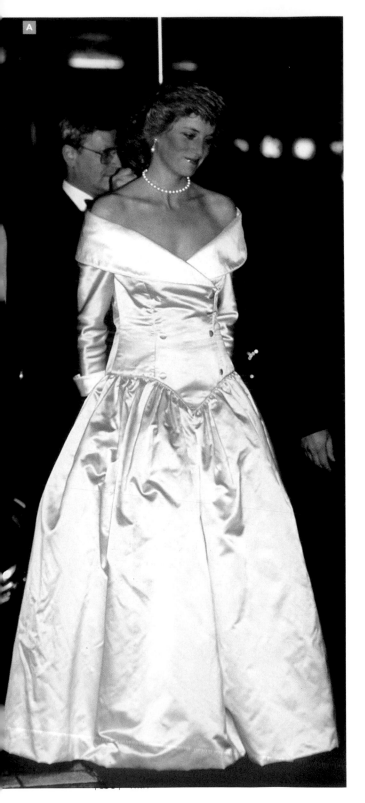
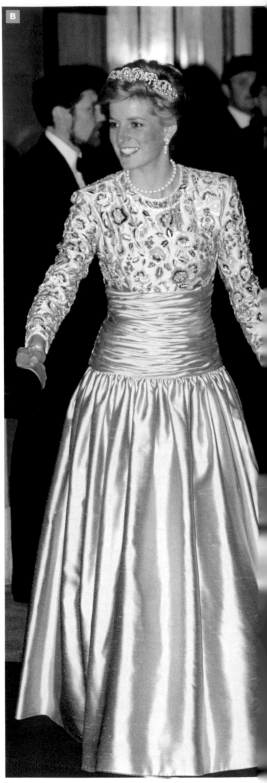

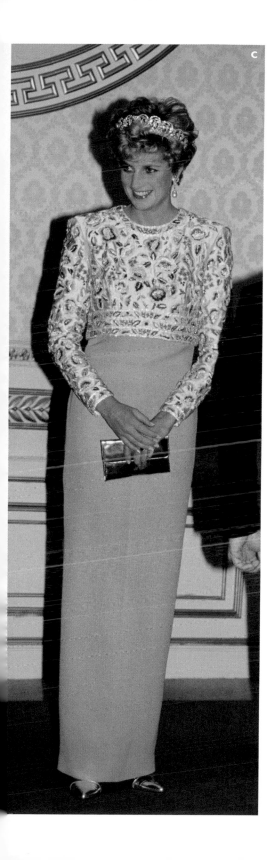

LOST IN TODAY'S CONVERSATION about Diana's fashion legacy is how often she re-wore her clothing. The princess repeated pieces often, and often in rapid succession, even her highly distinctive eveningwear. Diana wore a pink off-the-shoulder double-breasted Catherine Walker gown at least four times in public, including to a ballet performance in Germany in 1987. (A) Perhaps repeats weren't as obvious before the internet began tracking everything or the princess was feeling frugal? Or maybe multiple wearings were a sign she really loved this dress!

Another wardrobe trick of Diana's was to rethink parts of a dress to modernize it. She remade a Catherine Walker gown between a 1989 appearance to meet the president of Nigeria and a 1992 visit to South Korea. (B, C) The sleeker, straighter skirt felt much more sophisticated, in line with where the fashion trends were heading. "Walker would often make two of everything in case something went wrong, and always ordered more fabric than she needed in case she had to alter anything or send something in an emergency," said Eleri Lynn, a curator at Historic Royal Palaces.

Diana wore the full-skirted version of this purple gown twice in 1989.

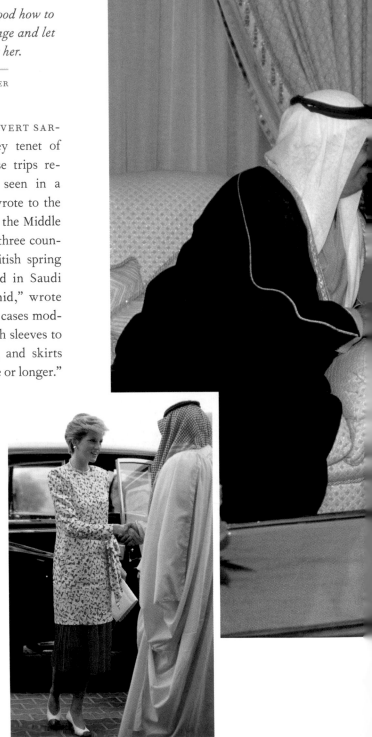

I always felt she really understood how to use fashion as the silent language and let clothes do the talking for her.

JOHN GALLIANO, DESIGNER

IN QUEEN-LIKE FASHION, OVERT SARtorial diplomacy was a key tenet of Diana's tour wardrobes. These trips required careful consideration, seen in a note Diana's lady-in-waiting wrote to the Emanuels before a 1986 trip to the Middle East. "The climate in the first three countries will range from cool British spring to a good British summer and in Saudi Arabia could be hot and humid," wrote Anne Beckwith-Smith. "In all cases modesty is the order of the day with sleeves to the elbow, necklines discreet, and skirts fairly full to just below the knee or longer." Among the designs the Emanuels sketched was a burqa; Diana was not photographed wearing it, but her openness to the idea shows admirable cultural sensitivity. The most memorable look from the tour was a black-and-white gown by the design duo with an oversize hip bow, an obvious callback to her hosts' attire.

A red print Catherine Walker ensemble from the tour was quieter but every bit as thoughtful.

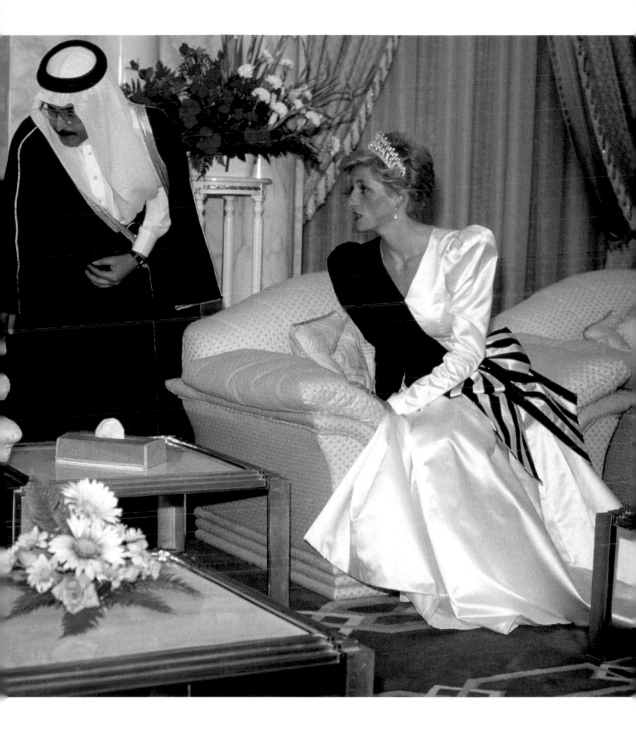

*She knew that time spent with her, anticipating her, remembering her,
was important. It was a comfort, it was a pleasure,
it was a break from what might be a very difficult existence.*

PATRICK JEPHSON, DIANA'S PRIVATE SECRETARY

FOR ALL THE FASHION DIANA DID WEAR, SHE IS PERHAPS MOST FAMOUS FOR what she did not. Gloves, a staple of the Queen's daily attire, had no place in the princess's wardrobe. Her tactile approach was at its most powerful during hospital visits, particularly a new AIDS clinic at a London hospital in 1987. It was at the height of misinformation about HIV, with rampant mistruths about infection through casual contact. Diana, dressed in a simple blue dress, greeted the hospital staff warmly with her bare hands. Most of the patients stayed out of view of the cameras in protest over the media's portrayal of the disease. But one man agreed to a pose for a photograph. (C) It was a simple gesture with enormous implications, instantly dispelling myths about how contagious the disease was.

Working with AIDS patients, and destigmatizing the disease, became a defining cause of Diana's life. She developed a "caring wardrobe" of bright clothing meant to complement or cheer up the people she visited, like on a 1991 trip to Brazil. (A, B) Long necklaces gave children something to play with; she never wore hats because, as she rightly said, "You can't cuddle a child in a hat."

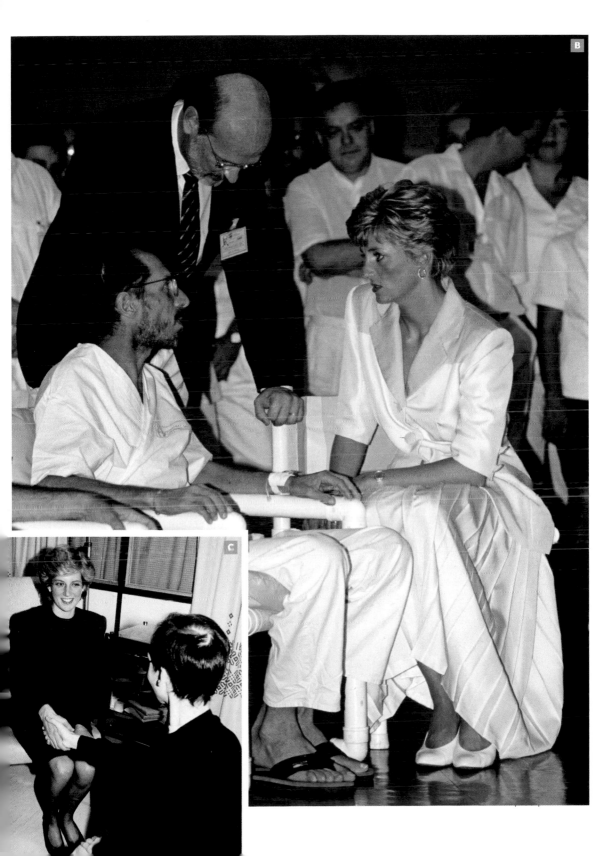

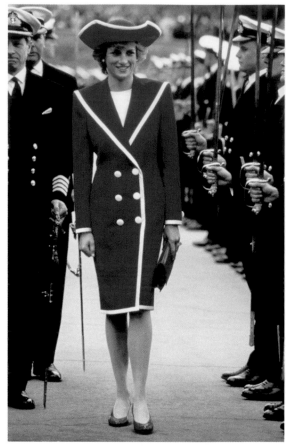

Diana's early Catherine Walker ensembles, like this 1983 polka-dot look, had a modest, feminine vibe (above left). By 1989, the designs were more streamlined.

CATHERINE WALKER WAS THE SINGLE MOST INFLUENTIAL DESIGNER IN DIANA'S life. Diana began working with Walker and her husband, Said Cyrus, the year of her wedding and continued until her death, when Diana was buried in a black Catherine Walker dress. "We saw our role as giving her the tools to do a job," Cyrus said. At the beginning that meant dressing "to match people's dreams of what they expected a fairy-tale princess to be." (Walker died of cancer in 2010, but her husband has continued their business.)

Later in Diana's life, as her marriage fell apart and her work took on more prominence, the princess sought a more sophisticated look. She was still very young—we're talking early thirties here—but determined to present a more serious image. The Catherine Walker label, known for its flawless tailoring, was ideally suited as a brand to help Diana evolve her image. The silhouettes, especially the sleeves and the skirts, became noticeably sleeker. She wore more blazers and suits, or suit-inspired dresses. Her statement coats, too, became slimmer.

The label is known for striking coat dresses, seen on a 1986 trip to
Austria (above left) and a walkabout in Cornwall in 1991.

The established relationship between the Catherine Walker team and Princess Diana
made for an efficient workflow. Whereas in the beginning the designers would send draw-
ings for approval and comments, toward the end they simply sent finished garments. "We
only ever measured her twice in sixteen years," Cyrus said. "Many later commissions were
sent with little design collaboration and often without any fittings." (You can see why Kate
would want to keep working with the brand.) Diana relied on them to do her homework
for her. Before the 1986 tour of Austria, Diana telephoned to say she was leaving in three
weeks and needed a wardrobe. "There was no other brief," Cyrus said.

The Catherine Walker team also executed their designs for the rigors of royal life, de-
livering finished pieces to withstand the elements. Diana knew that if people waited to see
her for hours, especially if the wait was in the cold or rain, that she needed to wow them in
return.

Obviously we are preparing for the volcano to erupt.

DIANA AT THE START OF 1992

CHARLES VISITED THE TAJ MAHAL, A TOWERING TESTA-ment to eternal love, as his courtship with Diana began in 1980. "One day I would like to bring my bride here," he said. Some twelve years later, his bride made her way there—all by herself.

Under the guise of wanting to accomplish as much as possible, Charles and Diana planned largely separate itineraries for their five-day 1992 tour of India. At this point, rumors of their marital discontent had been rampant for years. Much more would come to light in the subsequent months, including the publication of Andrew Morton's blockbuster biography and leaked tapes of Diana's private phone calls. But what teed up this disastrous year was one photograph that would provide the most perfect and painful visual. The princess headed to the Taj in Agra, while Charles stayed behind to prepare for a major speech in New Delhi. "No one was interested in his program that day, only Diana's," Diana's former bodyguard Ken Wharfe wrote in his memoir.

Diana sat alone, squinting into the sun, on the bench in front of the mausoleum. She wore a cherry red jacket and a deep lilac skirt by Catherine Walker that stood out vividly in the wide shots needed to properly capture the monument. It was a repeat ensemble, worn twice before. In *Harper's Bazaar*, fashion journalist Suzy Menkes likened the colors to the Indian sunrise. To me, given that this happened on February 11, the shades read as those of a valentine.

Diana later described the visit as "very healing." When asked to elaborate, she told the press, "Work it out for yourselves." The princess delivered the damning line with a "glint in her eye," Wharfe wrote. "And so the press pack had their story, as well as the picture to go along with it."

Twenty-four years later, William and Kate returned to the Taj, together, on the last day of their own tour of India. Kate donned a dress by Indian-born, American-dwelling designer Naeem Khan. As the color-coordinated pair sat on the famous bench, Kate bent her knees toward William's. The PDA-averse couple were close enough so that their shoulders touched.

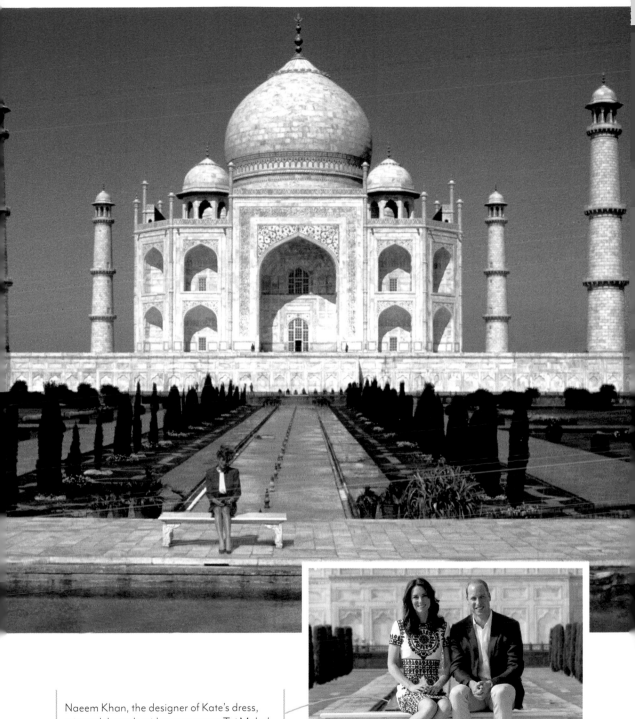

Naeem Khan, the designer of Kate's dress, reissued the style with a new name: Taj Mahal.

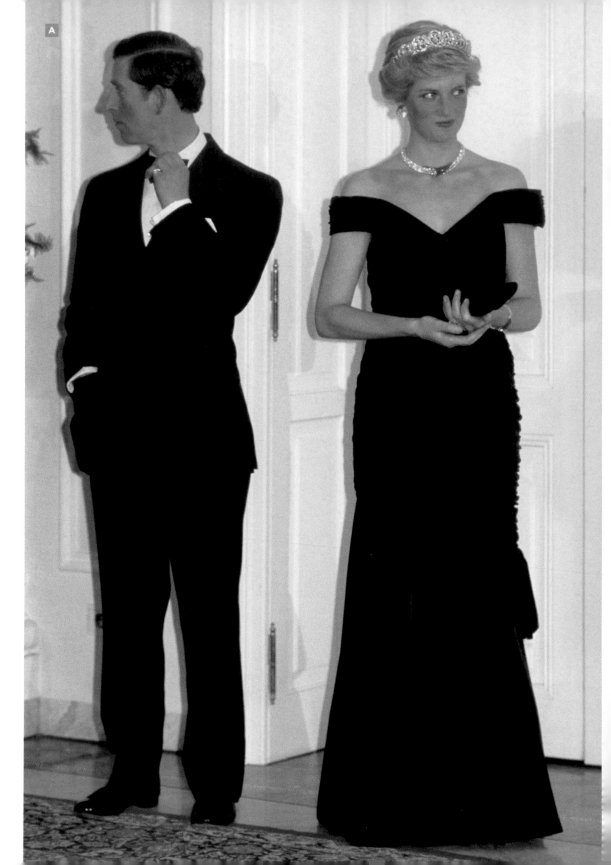

Photos told the story of the Waleses' marital problems without them needing to say a word. A trip to Germany in 1987 came as the media began keeping tabs on how rarely the couple were seen together in public. (A) Diana tried to use a re-wear of her "Travolta" gown to distract from the obvious tension.

The publication of Andrew Morton's explosive biography in the summer of 1992 revealed that the divide was much worse than anyone knew. On Diana's first appearance after publication, to a hospice in Liverpool, she was photographed openly weeping. (B)

Diana hoped the dramatic account would make Charles change his ways; it had the opposite effect, pushing them apart. The Waleses' misery on tour in South Korea was apparent. (C) "In four days, their eyes barely met," read a story in *People*. Come December, they did what had been unthinkable: they separated.

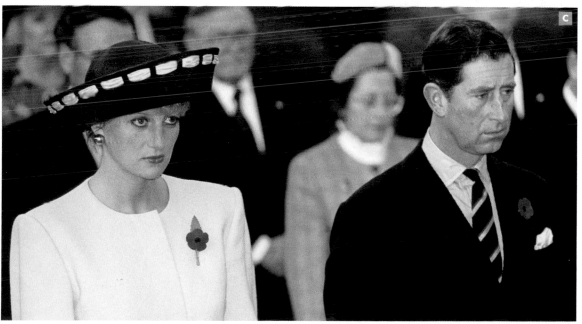

Growing more mature with her style, Diana favored longer skirts. Still, her commitment to color remained.

DIANA AND CHARLES HAD NO INTENtion of divorcing (that was still unthinkable for the heir), but they had no desire to be with each other, either. The Princess of Wales carried out engagements on her own, including a solo overseas tour to Nepal in the spring of 1993. (A)

By the end of the year, Diana shocked the world with a surprise speech declaring her retirement from public life. "I was not aware of how overwhelming that attention would become," she said. It calls to mind Harry and Meghan's break in 2020, amid their treatment in the press. If Diana's path is any indicator, it likely means there is still important charitable work ahead for the Sussexes. Some of the princess's most notable endeavors happened in the years after her speech.

Diana delivered her remarks in a deep green skirt suit by Amanda Wakeley. (B) The jacket had a strong shoulder line, while the combination of twill and velvet gave it an understated glamour. In many flash photographs, it looked black. "She clearly felt confident in it," Wakeley said.

What still puzzles Wakeley is how her name got associated with the look. In those days, designers weren't credited regularly. Any relationship with the Princess of Wales was mostly speculation, since a designer wouldn't want to jeopardize his or her standing with the royal family by publicizing it. A low point for Diana was a career-changing one for Wakeley, who was still up-and-coming at that time. "It was all over every paper," she recalled. "That really was a catalytic moment for me." She had only recently opened her store, with fifteen similar suits on hand. They sold out overnight.

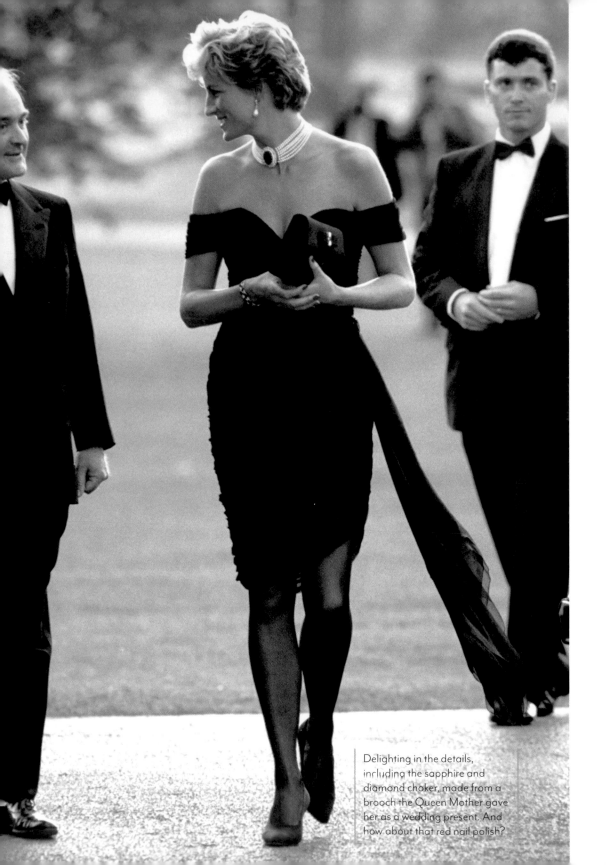

Delighting in the details, including the sapphire and diamond choker, made from a brooch the Queen Mother gave her as a wedding present. And how about that red nail polish?

As she got out of the car, it was impossible not to gasp.

DAME JULIA PEYTON-JONES

I F YOU KNEW YOUR HUSBAND HAD AD-
mitted to adultery in a television inter-
view and that it was about to air for all the
world to see, what would you do? Would
you hole up in some sweats with a pint of ice
cream and a spoon? You could (I would).
Or—hear me out—you could pull a Diana.

In 1994, Charles participated in a
lengthy documentary highlighting his ded-
ication to his charitable pursuits. Buried in
the footage was the bombshell confirma-
tion that he had cheated on Diana with
Camilla Parker Bowles. The evening the
documentary was shown, Diana was slated
to attend a gala for the Serpentine Gallery.
She had originally planned to wear another
dress by a different designer, but decided
against it after the brand released a state-

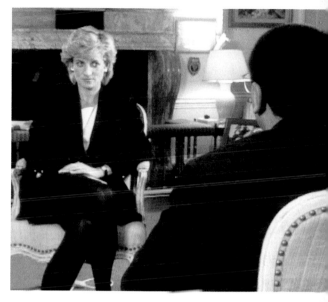

Diana secretly staged the explosive interview
inside Kensington Palace.

ment broadcasting her intent (a royal no-no, then and now). Instead she reached into her
closet and pulled out a dress by Greek designer Christina Stambolian. Her lady-in-waiting
gave organizers a heads-up that Diana would be wearing a short dress instead of the expected
long one, which shows you what a big deal the switch was. The off-the-shoulder form-fitting
dress was sensational—the original Revenge Dress—reframing the narrative entirely.
"The Thrilla He Left to Woo Camilla," screamed the *Sun*.

"Hell hath no fury like a woman scorned. But also: fashion hath no greater thrill than
when being deployed for the purpose of expressing rage," wrote Bethan Holt in the *Tele-
graph* on the twenty-fifth anniversary of the dress. (Note that it is the dress's anniversary
worth marking, not Charles's confession.)

The following year, Diana gave her own jaw-dropping interview, known as her "Pan-
orama moment" for the television program on which it aired. The princess wore a serious
black suit and rimmed her doe-like eyes in heavy black eyeliner, which upped the drama of
her famous chin-down, eyes-up stare. "There were three of us in this marriage," she said. The
Queen wrote to Charles and Diana after the interview and asked them to divorce.

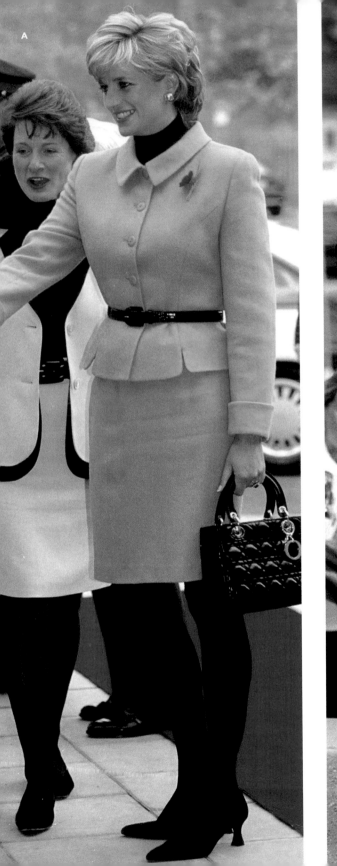

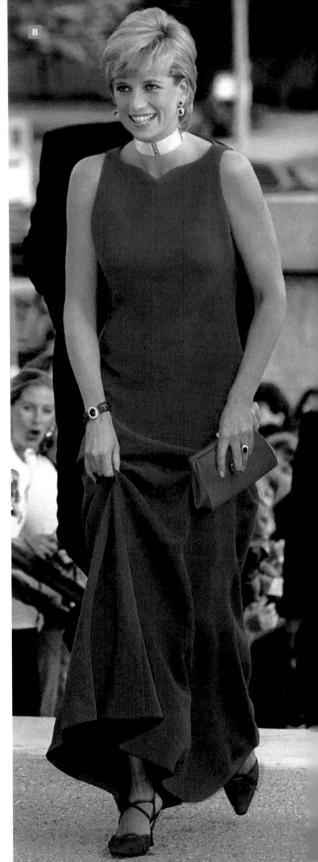

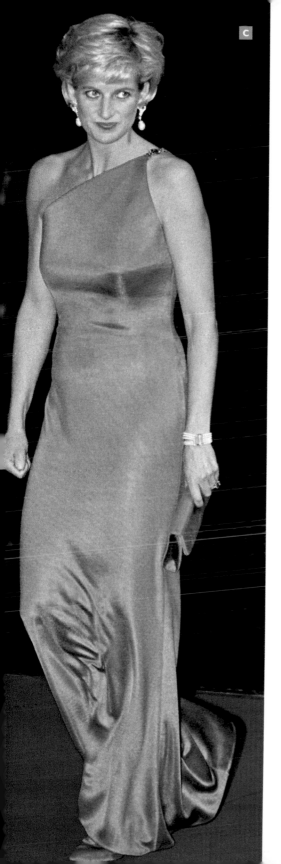

C

*Diana never looked better
than in the days after her divorce.*

TINA BROWN, BIOGRAPHER

ETAILS OF THE DIVORCE TOOK months to sort out, leaving Diana in a kind of uncomfortable personal limbo. Publicly, however, the princess hit her style stride. Freed from the protocol and properness of the monarchy, she emerged, in her mid-thirties, as a confident and composed single woman. She was regaining control of her life and making choices that suited her, like higher heels now that towering over Charles was no longer a worry. She enthusiastically expanded her fashion connections beyond the confines of Great Britain, striking up a friendship with Gianni Versace. A mustard yellow skirt suit for a 1995 visit to Liverpool Women's Hospital was amazing, as was a purple column dress she wore to Chicago's Field Museum of Natural History in 1996. (A, B) The one-shouldered electric blue Versace gown Diana wore that same year was perhaps the best of the best. (C)

"There is a kind of serenity," Versace said in 1997. "I had a fitting with her last week for new suits and clothing for spring, and she is so serene. It is a moment in her life, I think, when she's found herself—the way she wants to live."

DIANA'S NEW ROUTINE INVOLVED WORKING OUT AT THE TONY CHELSEA HAR-bour Club. It was the mid-1990s, early days for the wellness movement, and Diana's frequent visits became prized pics. It was wild to see a princess in this kind of off-duty attire. Surely she could have had any gym equipment she needed installed in Kensington Palace, where she lived. Instead Diana chose to venture out, which gives these pictures a sort of performative quality—and her sweatshirts spoke for her.

It wasn't the first time she used a bright logo to cause a stir. Nearly a decade earlier, at a 1988 polo outing, she wore a British Lung Foundation sweatshirt—a not-so-subtle show of support for the charity. (A) For her workouts, she sported more than one USA-themed top, perhaps as a declaration of independence? (B) What I want to know is where she found these gems! When she didn't feel like being photographed, Diana wore the same Virgin Atlantic sweatshirt, supposedly a gift from Richard Branson himself. (C) Appearing in the style repeatedly made it look like the same picture from one day to the next, decreasing the value. Diana giveth, and Diana taketh away!

Yes, of course it is a wrench to let go of these beautiful dresses. However, I am extremely happy that others can now share the joy that I had wearing them.

DIANA

AS THE DETAILS OF HER DIVORCE were being finalized, Diana made the drastic decision to auction off seventy-nine of her own dresses. "Clothes are not as essential to my work as they used to be," she said. She was shedding her skin—and by skin, I mean couture—to raise money for cancer and AIDS charities. "The clothes themselves speak volumes about a life that was both stimulating and frivolous, rewarding and imprisoning," wrote Cathy Horyn in *Vanity Fair*, calling the auction plan "ingenious." Can you imagine Kate or Meghan doing such a thing?

Christie's organized the auction in New York; Diana attended previews but not the event itself, hanging back home at Kensington Palace. She did ask that the results of the auction be faxed to her overnight so that her butler could bring it on her breakfast tray. As one does.

Laughing during the June 1997 auction preview in London, Diana sported the aquamarine ring that Meghan wore on her wedding day (right). The princess then hopped on the Concorde to attend a pre-auction party in New York (above). The newspaper peeking out of her purse makes it clear this was a work trip.

Surrounded by the crowds at the party in New York, Diana wore a dress (above) that looked a lot like the one she wore to the London event. One of the items up for sale in the auction was the purple gown by Catherine Walker with the remade skirt.

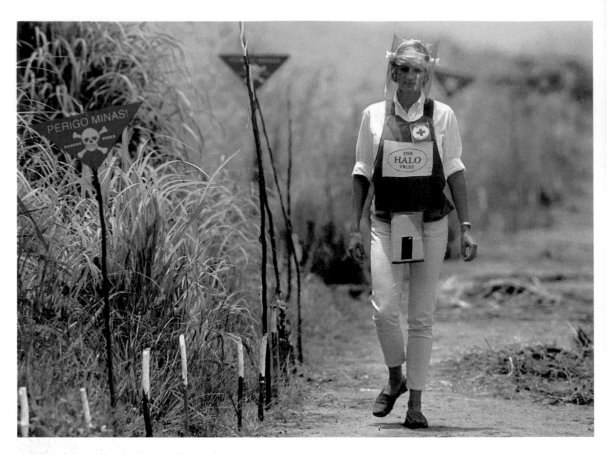

DIANA WAS STRIPPED OF HER HRH STYLING IN THE DIVORCE, BECOMING simply Diana, Princess of Wales. She resigned from more than 100 patronages, too. Eager to redefine herself on her own terms, Diana rolled up her sleeves and dug deep into her own humanitarian work. She went back to basics with her wardrobe, too, favoring tailored skirt suits for dressier day occasions. For her land mine work, she relied on simple slacks with button-down shirts and loafers. She could speak for herself now, and no longer needed to rely on her wardrobe to keep her in the spotlight.

In January 1997, she famously traversed an active minefield in Angola. It was a defining moment in her life—and a long way from the princess fashion that defined her a decade before. Her jaunty hat was replaced with a protective visor, her brightly colored dress swapped out for khakis. The most important thing she wore was the blue safety vest. Twenty-two years later, Harry retraced his mother's steps, taking a similar walk through a partially cleared minefield. "With peace comes opportunity," he said.

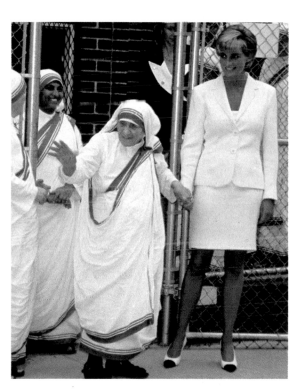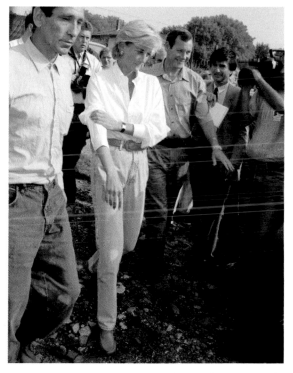

"I know I should preach for family love and unity," Mother Teresa (left) said of Diana's divorce.
"But nobody was happy anyhow." Weeks before she died, in August 1997,
Diana spoke out about land mines on a three-day tour of Bosnia and Herzegovina.

Honoring their mother, Princes William and Harry visit a tribute to her outside of Kensington Palace on the twentieth anniversary of her death in 2017.

All I want to do is make my mother incredibly proud.

HARRY

MORE SO THAN ANY FASHION MOMENT, DIANA'S CHILdren carry on her memory. Princes William and Harry were just fifteen and twelve when their mother died in a car crash in Paris in August 1997. The sight of them clad in black suits, walking with slumped shoulders behind her funeral cortege, forever endeared them to royal family followers. It was a heartbreaking contrast to the images of the family together during her life, which were deeply personal glimpses into their close relationship. Whether it was an official engagement or a personal outing, joy radiated from their smiles. Diana was many things, but first and foremost she was a mother.

As they have grown older, her boys have become confident stewards of the charitable causes she championed. Harry has made HIV/AIDS awareness one of his passion projects, while William became a patron of Centrepoint, which supports homeless youth. Diana, and her ability to connect with crowds, had a profound impact on the royal family we watch today. Every time I see Kate crouch down to talk to a child or Meghan enthusiastically hug a fan, I think of how proud the People's Princess would be.

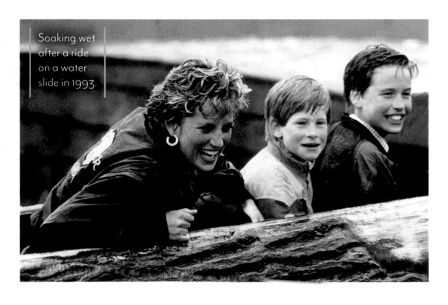

Soaking wet after a ride on a water slide in 1993.

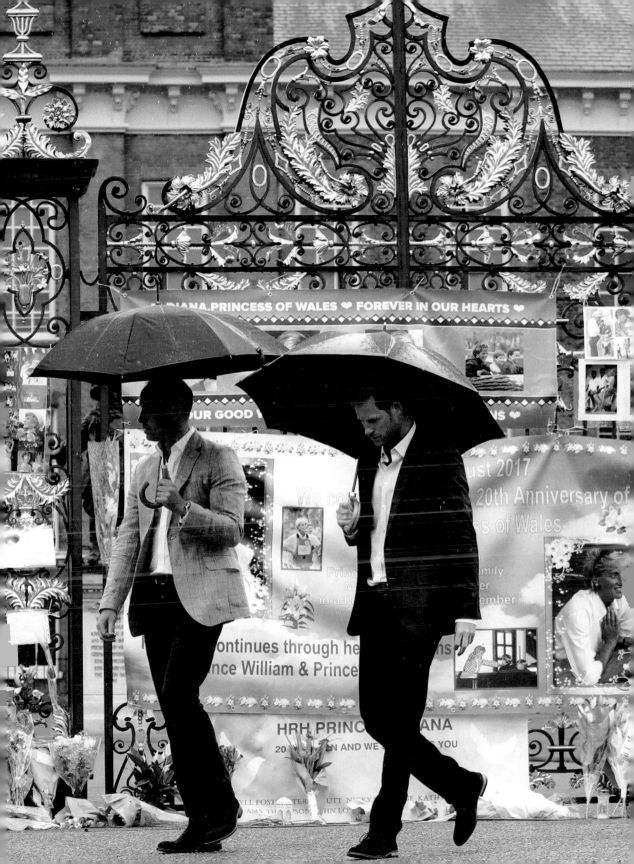

2009　　　　　　　　　　　　　　1990

ROYAL ASCOT

FIVE DAYS OF HORSE RACES ATTENDED BY
THE ROYAL FAMILY IN SPECTACULAR FASHION

2019

2018

A HIGHLIGHT OF THE ROYAL FAMILY'S SUMMER, AND BELOVED BY FASHION FANS, Royal Ascot begins with a carriage procession. The wider Windsor family then mills about on the grass before taking to the stands to watch the horse races from the royal enclosure. The dress code is one of the few written ones made public, requiring women to wear dresses that fall below their knees, shoulder straps of at least one inch, and a headpiece with a base of at least four inches. Men must wear a waistcoat, full tie, and black shoes. My favorite might be the umbrellas the gents carry, doubling as dapper canes. The Queen's hat has become an integral part of each day, with bookies taking bets on what color it will be.

CATH

ERINE

THE DUCHESS OF CAMBRIDGE

ON A BRISK NIGHT IN THE AUTUMN OF 2018, ROYAL FOLLOWERS WAITED for Catherine, the Duchess of Cambridge, to arrive at the Victoria & Albert Museum in London. Kate, as she is widely known, had returned to royal duties a week earlier after taking a few months' maternity leave. Her first engagement back felt deliberately low-key, a casual stroll through a forest school in old knee-high boots to promote early childhood education and outdoor play.

This was her first evening appearance, her first visit as patron, and a chance to return to her sky-high stilettos. As soon as the duchess emerged from the SUV in the dark of night, the flashes from the awaiting press scrum popped—and jaws of fashion journalists dropped.

Known for her preppy sheaths, modest coat dresses, and Breton stripe tops, Kate stunned in an unexpected off-the-shoulder plaid frock by Erdem. The statement piece was made of bouclé tweed with an asymmetrical, shoulder-baring neckline, offering a glimpse of clavicle. It looked as if someone had reimagined a prim day suit as a sophisticated, sultry dress. Even Kate's accessories had an unusual boldness to them, swapping her signature nude heels for a pair of bordeaux velvet pumps by Jimmy Choo. In lieu of her typical small earrings, Kate opted for topaz, crystal, and pearl statement pieces also by Erdem, on display with an über-chic tuck of her signature curls behind her ear.

"Is this Kate Middleton's most fashion-forward dress yet?" headlined the write-up in *Vogue*. "We could get used to this more daring side of Kate," declared *InStyle*.

The look was striking, fashion-wise, but also filled with symbolism. The plaid was the Prince of Wales check, a favorite of the royals and the title of her father-in-law, Prince Charles. But the most clever aspect, I thought, was a nod to the current Queen rather than the future King. The London-based designer Erdem Moralioglu had traveled to Windsor Castle to study the clothing of Queen Elizabeth II before creating the runway collection where this dress first appeared. The pearl-and-crystal embellishment at the gathered neckline held particular significance, its floral motif inspired by similar designs Norman Hartnell had embroidered onto the Queen's coronation gown some six decades earlier. The dress garnered headlines for its flair, more so than for the connections to her grandmother-in-law. It was quintessentially Kate, subtle and sophisticated—a wink if you will—quite fitting of a future queen consort.

Visiting Northern Ireland in 2019. This coat delighted Harry Potter fans with its similarities to the Beauxbatons' capes.

THAT AUTUMN EVENING WAS A BREAK-out moment for Kate, who has long taken a safe approach to royal life and her working wardrobe. When she married William in 2011, the duchess was a novelty, a commoner capturing the heart of a prince. Her clothing reflected her every-girl appeal, with off-the-rack pieces that she wore repeatedly and her admirers rushed to buy. Kate's modest, feminine style allowed scores of women to see themselves in her and, by extension, the royal family. It was a powerful point of connection—but it was not the most thrilling, especially for those who remembered Diana's style. "Kate is not, and never has been, a fashion girl," read a 2014 piece in the *Sydney Morning Herald*, noting she dressed "sensibly and practically." The *Daily Beast* was a bit harsher with its headline: "Why Does Kate Middleton Dress Like She's 50?" To be fair, Kate definitely had some standout sartorial moments early on in her royal tenure—a few super-glam gowns come to mind—but on the whole, she stayed in her lane, favoring the preppy, pretty dresses in her comfort zone.

Fast-forward to the fall of 2018, now a composed mother of an heir, a spare, and another spare, the duchess grew more daring. At a state dinner she stunned again, this time in a dusty cornflower blue ruched drop-waist gown with cap sleeves by Alexander McQueen. Kate was *dazzling*, thanks to a more-is-more Queen-esque accessory strategy, pairing a statement diamond necklace with a megawatt tiara.

The following month, she debuted a more subtle style upgrade, adding a velvet bow to her ponytail, dressing up a repeated skirt suit. It sent me and many others on the hunt

for a spool of ribbon to re-create the look. At the Remembrance Day service the following week, she swapped her fascinator for a padded headband, an accessory that had just been featured on a recent Prada runway. With Kate's seal of approval, hatbands, as I like to call them, were all the rage. Later, the duchess wore a vibrant lavender silk-crepe Gucci blouse backward, an attention-grabbing styling trick I feel like Diana would have appreciated.

What's driving the newly sophisticated look is anyone's guess. Could it be that the addition of her stylish sister-in-law, Meghan, the Duchess of Sussex, sparked a rethinking of Kate's own wardrobe? Or was the duchess feeling newly inspired after returning from maternity leave? Perhaps all these years in the royal spotlight have given her the confidence to experiment more? Whatever the motivation, there seems to be a recognition, at long last, that fashion can be a powerful tool. The sensible styles she is known for are laudable, especially when the taxpayers are keeping tabs. But Kate and the causes she champions, as well as more broadly the Windsor family, benefit from a headline-worthy look and the resulting good press. Whereas once she might have fought the worldwide interest in her wardrobe, now the duchess seems to embrace it.

———

CATHERINE ELIZABETH MIDDLETON WAS BORN JANUARY 9, 1982, THE ELDEST OF THREE children. Her mother, Carole, was a flight attendant and her father, Michael, worked for British Airways before the two started their own party supply business. The well-to-do family lived in the English countryside outside of London, in a village near Berkshire. The Middleton lineage, or lack thereof, has been a source of cutting critiques for years. To a few of William's blue-blooded friends, Kate was known as "Kate Middle-class." (The Middletons had a brush with royalty before Kate started dating William; her paternal grandfather flew alongside Prince Philip on a royal tour of South America in 1962.)

Kate attended a series of boarding schools before enrolling at the University of St. Andrews in Scotland, where she met Will. They were friends before becoming flatmates and, if legend is to be believed, fashion was a part of their meet-cute. Kate wore a strapless dress designed by a friend to a charity fashion show. The ensemble has been described as "sheer" but—and I'm very sorry to say this—"see-through" is perhaps a more accurate descriptor. It clearly showcased the bandeau bra and bikini briefs she wore underneath. "Kate's hot!" William reportedly remarked. (But really: can you imagine having your collegiate fashion missteps preserved in the history books?) Kate was an incredibly good sport about it all. When she returned to St. Andrews in 2012, a year after her wedding, she told students in a speech: "I hope you weren't involved in the fashion show, you never know what you are going to be asked to wear."

Catching the young couple early in their dating days, at a polo match in 2005.

Will and Kate graduated in 2005, about a year after going public with their relationship. University life had afforded them some privacy; it was now time to face the real world (and the press). Kate was regularly snapped at parties and polo matches, as well as weddings of those in royal social circles. She dressed the part of a Sloane Ranger, the Diana-era British moniker for a private school–educated, upper-middle-class preppy woman. It was a slightly less polished version of the classic pieces she would favor as a duchess, with knee-length dresses, blazers, and heels. Her casual style flirted with of-the-moment pieces, like low-rise boot-cut jeans (which, to be fair, got the best of all of us). On the whole it was immensely safe. "You only have to look at pictures of her when she wasn't part of the royal family to see that she's the girl who just wanted to look nice," said Bethan Holt, fashion news and features director at the *Telegraph*. More pointedly, Holt added: "She wasn't exactly a trendsetter." But to the media, eager for a young royal woman to latch on to, Kate's relationship with Will made her irresistible fodder. *Tatler* named her one of its Ten Style Icons in April 2007, and *Vanity Fair* included her in its International Best Dressed poll in 2008.

"She got full exposure to what it can be like to be in the public eye all the time," said Susan E. Kelley, founder of What Kate Wore, which chronicles the duchess's style. "Every single thing tracked, everything discussed, everything measured and written about." The paparazzi tailed her, especially on nights out, getting close enough to catch a shot of her in the back of a taxi. The papers famously dubbed her "Waity Katie," suggesting she was sitting around idly in hopes of a proposal. Even her younger sister, Pippa, was dragged into the coverage. The two were accused of social climbing and nicknamed "The Wisteria Sisters."

Kate developed an impressive level of press savvy that, in hindsight, you wish she didn't have to have. Take the media's obsession with her time spent as an accessories buyer at Jigsaw, a mid-priced High Street brand, from 2006 to 2007. "There were days when there were TV crews at the end of the drive. We'd say: 'Listen, do you want to go out the back way?'" Jigsaw co-founder Belle Robinson recalled. "And she'd say: 'To be honest, they're going to hound us until they've got the picture. So why don't I just go, get the picture done, and then they'll leave us alone.'"

Robinson had given Kate the position after the future duchess called her herself to inquire about work. "She genuinely wanted a job but she needed an element of flexibility to continue the relationship with a very high-profile man and a life that she can't dictate," Robinson said later. As the *Evening Standard* newspaper put it, Kate "mucked in" during her time at Jigsaw, sitting in the kitchen for lunch and chatting with everyone else working there. "She wasn't precious," Robinson said. "I thought she was very mature for a twenty-six-year-old, and I think she's been quite good at neither courting the press nor sticking two fingers in the air at them. I don't think I would have been so polite."

The intense, unwelcome attention is reportedly what led Kate to press Will about the seriousness of their relationship. Not only did she want a commitment from her longtime boyfriend, she wanted the security team that came with it. The future king would provide no such comfort. In the spring of 2007, according to one report, he called Kate on the job at Jigsaw and broke up with her. His military career was intensifying, and reports suggest he wasn't ready to settle down. Kate left Jigsaw shortly thereafter, saying she needed more time to herself. Her loyalty to the brand remains— she still wears Jigsaw pieces on occasion, much to the delight of her longtime fans.

The breakup was short-lived. After a few months, the pair reunited for good. "I, at the time, wasn't very happy about [the breakup], but actually it made me a stronger person," Kate said in their engagement interview. "You can get quite consumed by a relationship when you are younger and I really valued that time for me as well, although I didn't think it at the time." It's crazy that she had to even address it—but you gotta admire that spin, don't you?

The lingering lessons from those years reflect something about Kate's personality that we have seen since in her clothing. She endured a kind of hellish scrutiny, including invasion of her personal space and a painfully public stringing along, with remarkable poise. She spent her twenties under the microscope and yet the worst photos of her are adorably tame, looking slightly tipsy or a bit disheveled after a night out. One of her most "scandalous" outfits (I put that in quotes very much on purpose) was a green sequin halter top, yellow short-shorts, and hot-pink leg warmers at an eighties-themed roller disco for charity in 2008. But under those hot pants, she wore stockings, ensuring even when she fell—which she did, spectacularly and hilariously on the roller rink floor—there was nothing to see.

Posing, back in her royal girlfriend days in 2004 (left) and strolling as a duchess in 2011. Kate swapped her beloved brown boots for shiny nude pumps.

ON NOVEMBER 16, 2010, TO THE DELIGHT OF MOST, AND THE DISAPPOINTMENT OF A few holdout hopefuls waiting for their prince, William and Catherine announced their engagement. It was a new chapter in the royal family's history as the next generation stepped forward. And it was the start of the shopping stampede known as the "Kate Effect."

Like Diana, Kate did not have a sophisticated styling team helping her transition to royal life. For the historic photo-call to announce her engagement, she went shopping at a London department store. She chose a royal blue wrap dress by Issa, a favorite brand of hers at the time, which retailed for £385. William had proposed with his mother's twelve-carat sapphire engagement ring and Kate's silk jersey dress matched the gemstone perfectly. The duchess-to-be coupled the dress with £40 black suede heels by Episode, which she would wear publicly at least two dozen times more. Kate's outfit was familiar to those who had followed her for years. But for that first official moment in the bright lights of the royal fold, she looked just a smidge fancier. Her hair was sleeker and her makeup was more dramatic. Even her nude pantyhose felt a bit shinier.

Her style made her at once accessible and aspirational, changing the course of royal fandom forever. Shoppers scrambled to buy the first dress worn by a future duchess. It sold out in minutes. Fast-fashion retailers rushed to make knockoffs at a fraction of the price. The supermarket chain Tesco made a £16 version. On one of Kate's first official appearances as a royal fiancée, the reporters trailing the couple asked Will's press secretary for details about Kate's outfit. "It suddenly dawned on him—and on us—that we were going to be spending an awful lot of time talking about what she was wearing," said Richard Palmer, royal correspondent for Britain's *Daily Express* newspaper.

Kate's engagement ensembles began flying off store shelves, too. The Whistles blouse she wore was renamed the "Kate" and restocked with a 30 percent higher price. After overwhelming demand, Reiss rereleased the cream dress she chose for another engagement portrait. "At one point, we were selling one per minute," a spokesperson for the brand told *Vogue*. Without the help of a stylist, there was an authenticity to Kate's choices. She "shops in various stores, always pays full price, and we do not have any advance warning of if or when she may wear Reiss," the spokesperson added. Reiss's profits soared that year, with sales up double digits.

Can you fathom what it would feel like knowing what you wore would immediately sell out? The economic power—and burden—of your choices? There are very few people, even A-list celebs, who have that kind of influence. Early on, Kate focused her wardrobe on U.K.-based brands, single-handedly boosting the British fashion industry. Her style also created its own economy among bloggers and social media accounts that began to document her outfits. If the palace didn't share the brands Kate wore fast enough, one of these forensic fashion-minded followers would identify it. Some sites began making money through a commission of sales, both of the exact items Kate wore and the budget-friendly "Repli-Kate" similar styles their editors suggested.

Kate's early fashion wasn't inexpensive, but it was affordable enough. And, perhaps more important, it was available for anyone to buy. It reinforced the story line that Kate was staying true to herself, even as she joined the highest echelon of British aristocracy. Diana had brought the monarchy out of the palace, a glamorous princess mingling with the people. Now, one of those people—albeit a picture-perfect commoner from a well-to-do, tight-knit British family—was joining its ranks.

Kate's presence reignited the fairy-tale aspect of the House of Windsor, too, stoking immense interest in the first royal wedding in decades. The fantasy of marrying a prince was alive and well. "She has done more to modernize and make accessible the royal family than probably anybody in that position who came before her," said Vanessa Friedman, fashion director of the *New York Times*. "That does not make for the most exciting fashion, but it's very smart fashion."

TENS OF MILLIONS OF PEOPLE TUNED IN AROUND THE GLOBE TO WATCH PRINCE WILliam marry Kate Middleton on April 29, 2011. The future duchess arrived not in a horse-drawn carriage but a chauffeured Rolls-Royce, stepping out onto the awaiting red carpet as the bells of Westminster Abbey rang overhead. As the BBC presenter announced her dress was designed by Sarah Burton of Alexander McQueen, her co-anchor let out the most delightful squeal: "Yay!"

It was a wedding gown for the ages, timeless rather than trendy, with a close-fitting corset-like bodice and padded full skirt reminiscent of Victorian styles. Praise was widespread and effusive, the influence nearly instantaneous. Strapless dresses had been the near-ubiquitous choice for brides, but Kate made sleeves chic. The dress also set a new course for the Alexander McQueen label, boosting the house's commercial future a year after the designer's tragic suicide. The ongoing relationship that developed between the duchess and Burton worked in Kate's favor as well, elevating her fashion game.

In the midst of marrying an actual prince, Kate maintained her aura of accessibility—no easy feat. It helped that the couple soon retreated to their rented farmhouse on the Welsh island of Anglesey, some 300 miles to the northwest of London. It was close to where William served as a search-and-rescue pilot with the Royal Air Force. Less than a month after the wedding, Kate was spotted in jeans and flats pushing her own shopping cart at the grocery store. The Queen had agreed to give them a little break from the public eye to find their footing, but they popped up every once in a while to do something fabulous. Photos from this time offer quite the juxtaposition, one minute living a quiet rural life and the next dipping down to London for a black-tie gala. Critics, however, were upset that the star couple wasn't working more, dubbing Kate the "Duchess of Dolittle."

Even with a somewhat slower start to the public-facing part of her job, there was an early recognition by Kate that being a member of the royal family was, in fact, a job. "I don't know the ropes," she said during their engagement interview. "I'm willing to learn quickly and work hard." Part of that was putting together a working wardrobe. Although Kate has not said much publicly about her fashion preferences, the general consensus among those who have followed her is that she is not necessarily interested in fashion for fashion's sake. Her take is more in line with the Queen's, seeing it as a necessary aspect of her duties. Her uniform became a coat dress or a simple shift paired with patent leather nude L.K. Bennett Sledge pumps. (Those heels! She wore them *everywhere*.) For casual engagements, she favored a striped top, dark skinny jeans, and wedges, sometimes with a navy blazer on top.

"She shops where regular girls shop—Topshop, Reiss, Whistles, and L.K. Bennett— and wears looks that regular girls wear—wrap dresses, shifts, and J Brand skinny jeans,"

Showing off her competitive side by joining a game of hockey on a school visit in 2012.

read a piece in *Vogue* following the Cambridges' first tour to North America in 2011. The article, somewhat endearingly, tries to make her style into something exciting: "She keeps her accessories simple and pulls off a look that's straightforward yet somewhat normal. Not normal in a banal way, but normal in a way that it's empirically attractive and universally appealing." There's a fine line between basic and classic, isn't there? Kate's understandable and conventionally pretty pieces inspired a new generation of devotees who adored her choices.

Another major factor contributing to her relatable reputation? Her love of sports. A natural athlete, Kate visibly lights up when given the chance to swing a racket, kick a ball, or run a race. The resulting pictures are full of joy and do wonders to humanize her.

Part of Kate's job has been to introduce a new generation of royal family fans to the Firm's unique traditions. Following in the footsteps of Charles and Diana, the duchess

Touring Germany in 2017 as a family of four, with Prince George and Princess Charlotte.

dutifully dolled up and presented newborn Prince George on the steps of the Lindo Wing Maternity Ward. Many years later, in a podcast interview, Kate described the experience as "slightly terrifying." Which, yes! I cannot imagine the pressure. She wore a pale blue Jenny Packham dress cinched around her upper torso, offering shape to her visible still-there bump. For me, and scores of other women, it was a powerful moment, showing what a woman's body looks like shortly after giving birth.

Critics wondered aloud what sort of unrealistic precedent Kate was setting, with perfect hair and makeup so soon after giving birth? I can understand that, but I also understand why Kate did what she did. As the mother to the third in line to the throne, she gave the public a chance to celebrate this arrival. She pulled it together—with the help of her team, no doubt!—while still high on the adrenaline of giving birth. And you can't discount the privacy element here. The sooner she left the hospital, the sooner she was back in the privacy of her own home, where sweatpants surely awaited.

THE PRESS CAMPED OUTSIDE THE HOSPITAL AWAITING PRINCE GEORGE'S ARRIVAL noticed an important new aide visiting Kate, one who would play a pivotal role in the duchess's image. Natasha Archer was spotted entering the Lindo Wing alongside Kate's hairdresser; Archer had begun working as a personal assistant for the royal family in 2007 and became Kate's stylist in 2014. Archer's roots are not in fashion, she didn't come from *British Vogue* the way Anna Harvey did to style Diana. But she has grown into the role, and now handles researching, ordering, and designer relationships for the duchess.

Archer has mastered the considerable logistics associated with a royal wardrobe, an underappreciated but crucial task. "As much as anything, Natasha is overseeing alterations, cleaning, pressing, all that boring stuff really which can actually make or break whether an outfit is a good one or not," the *Telegraph*'s Holt said. "You can have the coolest designer and you can have the greatest message but if it's still got the label in or if it's creased or doesn't fit properly, then it's not going to work." That flawless execution eliminates any distractions small missteps might cause. When the royal couple's plane got stranded in Lahore, Pakistan, for the night during a 2019 royal tour, Archer was ready with a fresh tunic and trousers on hand. (Archer is married to Chris Jackson, a Getty photographer who covers the royals. Many of his gorgeous photographs are featured in this book.)

Kate's presentation is helped by two of perhaps the unsexiest style aids, which were abandoned years ago by modern women: hairnets and pantyhose. The former is used to secure the chignons in her updos, keeping any possible strays in place. They are the highest quality hairnets, naturally, ones you really have to squint at a photograph to see. But still, for a woman under a certain age, it's not what you might expect. The stockings are slightly more obvious, and at the beginning of her royal tenure resulted in a slew of trend stories about whether Kate could make them fashionable once again. That moment came and went (and that trend did not pan out, *phew*) but Kate still wears them on nearly all of her public engagements. I don't notice them very often any longer, to be quite honest. But when I catch a glimpse I am reminded that royal dressing still has a foot, or rather a leg, in the past.

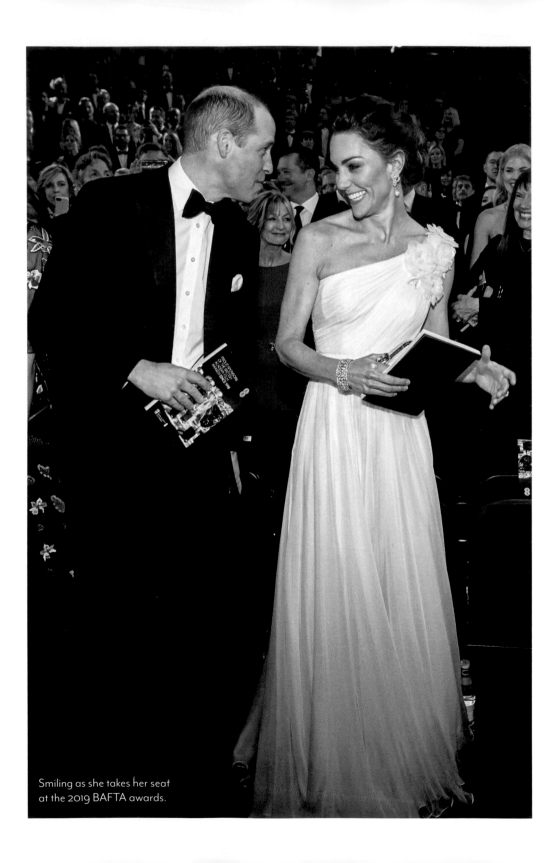

Smiling as she takes her seat
at the 2019 BAFTA awards.

Another key tenet of Kate's sensible wardrobe strategy is her willingness to repeat pieces. It sounds silly, I know, because every normal person re-wears their clothing. The Queen and Diana recycled pieces in their wardrobes, quite often in fact (remember how often Her Majesty wore her coronation gown?). But Kate's willingness to "shop her closet" was a revelation to this new generation of fans, even worthy of headlines. This is a group that came of age in a one-and-done strategy, thanks in part to social media but also the red carpet. Most celebrities would not be caught dead wearing the same dress twice. And here was a duchess, repeating on the regular.

Aside from the practical benefits—re-wearing eliminates the need for time-consuming fittings, for example—the broader effect is quite profound. It positions her as "a simple girl with simple tastes and a simple wardrobe," said Aya Kanai, editor in chief of *Marie Claire*. "It allows you to have the thought: 'Oh, there's a closet with things that hang in her house.'" A royal wardrobe is much more complicated than that, Kanai added, but the appearance of normalcy thrills a certain segment of followers. It also helps quell any public clamoring over the cost of the clothing. "Thrifty Kate Middleton has worn the same Alexander McQueen coat four times," read a headline in the British tabloid the *Sun*.

The continued survival of the royal family in part relies on maintaining the public's general affection for them, which for Kate comes back to being both accessible and aspirational. Motherhood has certainly helped Kate's quest for the former. And her children have given her a new sartorial outlet, an added bonus. The Cambridge kids are often seen in hand-me-downs, and old-fashioned outfits inspired by what young Will and Harry wore. It's a way to uphold a lot of the family's fashion traditions without having to carry the mantle herself.

Perhaps that's why Kate felt a bit freer with her fashion when she returned to royal duties following Prince Louis's birth in 2018. Little touches, like a jaunty capelet on a blue coat or a bright blue fedora for a walk to church, have gone a long way to mixing up her engagements. She has added more trousers into her dressy daywear rotation, too, a relatable shift that gives off more of a Kate-at-work vibe. And for the 2019 British Academy of Film and Television Arts Awards, she delivered on the princess promise in a one-shouldered white Grecian-style Alexander McQueen gown. She sparkled from head to toe, with pearl drop earrings that belonged to Diana, a diamond bracelet from the Queen's collection, and a new pair of glittery pointy-toed pumps. "She understands that one of the biggest parts of the job— whatever you think about this—is that you have to look *really* good," said the *Telegraph*'s Holt. "She's very good at her job, and her job is being a future queen." ✦

SO MANY THOUGHTS ON
Kate

IF CHARLES AND DIANA HAD A WHIRL-
wind courtship, Will and Kate's could be de-
scribed as . . . anything but. They began dating as
flatmates at the University of St. Andrews, which
afforded them some seclusion and privacy. They
went public with their relationship in 2004 and
graduated a year later. (A) Kate moved to Lon-
don, living in a flat her parents owned in Chelsea.
The press dubbed her "Waity Katie," accusing
her of sitting idly for years, hoping for a proposal.
Meanwhile, the paparazzi hounded her. On her
twenty-fifth birthday, in 2007, the police had to
be called because more than a dozen photogra-
phers were trying to get their shot. (B)

After a brief breakup, the couple reunited and
signaled the seriousness of their relationship with
some very public appearances together, including
at the prince's Royal Air Force graduation in April
2008. (C) By 2010, William proposed to Kate on
a trip to Kenya. Before the public announcement
of their engagement, the pair, looking quite smit-
ten with one another, appeared at their friends'
wedding. (D) Kate wore a very large hat and an
electric blue dress, a clever foreshadowing of the
dress she would wear to their photo-call in a few
weeks' time.

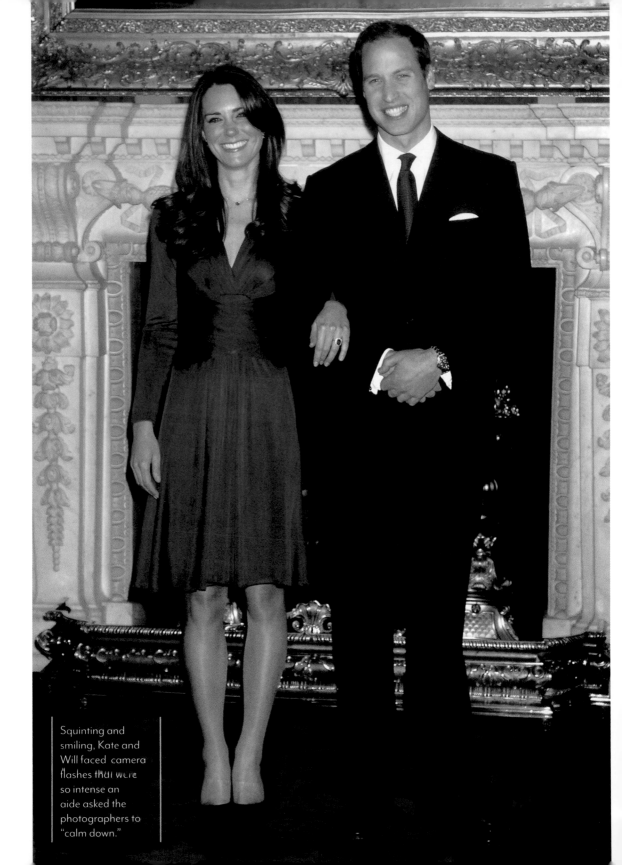

Squinting and smiling, Kate and Will faced camera flashes that were so intense an aide asked the photographers to "calm down."

THE FUTURE DUKE AND DUCHESS OF Cambridge announced their engagement on November 16, 2010, a moment many years in the making. For the photocall, Kate chose a dress by Issa, which perfectly matched the hue of the sapphire engagement ring that had belonged to Diana. To her growing fanbase, it was a familiar style. She had been photographed in a similar bright pink Issa gown just two years prior.

I love the arm-linked, hand-placed pose to properly showcase Diana's ring. It was a stately presentation, and made for a charming contrast to the engagement story they shared afterward in a television interview. The pair had been in Kenya with friends; Will carried the ring in a rucksack for a week, terrified he would misplace it. The banter about the bauble—such a loaded piece, given its history—was quite endearing. When the interviewer suggested Kate was "going to be the envy of many" with it on her finger, the future royal ner-

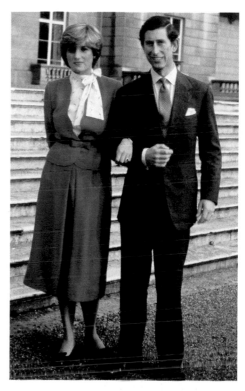

Charles and Diana announcing their engagement in 1981. Same ring, same pose, much different vibe.

vously laughed: "Well, I just hope I look after it. It's very, very special." William raised an eyebrow: "If she loses it she's in big trouble."

At twenty-eight years old, Kate was nearly a decade older than the Queen and Diana when they got engaged. Kate's charm stemmed not from her youth but from her composure, having made it this far. Her color-coordinating off-the-rack dress foreshadowed what would become her signature duchess style, and her shiny nude pantyhose signaled a willingness to follow old-fashioned sartorial norms. The only real difference between Kate the girlfriend and Kate the fiancée? A major hair upgrade. Her glossy blowout, with its full curls, instantly became total hair goals.

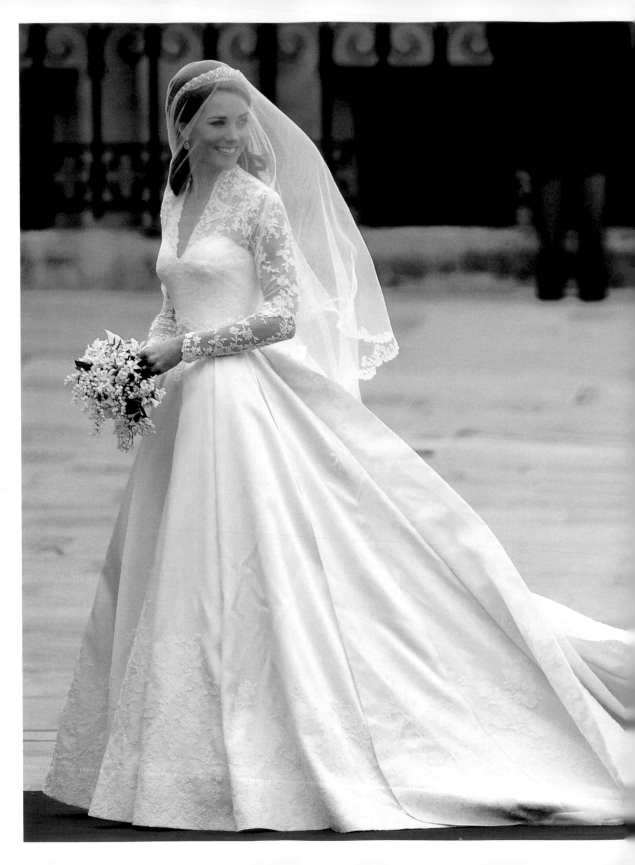

It is good that people in every continent are able to share in these celebrations because this is, as every wedding day should be, a day of hope.

BISHOP OF LONDON RICHARD CHARTRES

WILLIAM AND CATHERINE'S WEDDING ON APRIL 29, 2011, WAS A FRESH START for the House of Windsor. After years mired in divorce, scandal, and tragedy, the monarchy had a fairy tale for the next generation. It proved its worth, and attracted legions of new fans, in an unforgettable display of pomp rooted in relatability. You can see the optimism the Queen felt in the soft, sunshine yellow Angela Kelly design she wore. Her grandson William was in love with a commoner who had weathered prolonged public scrutiny with grace and emerged triumphant. Twenty-nine-year-old Kate's appeal was strikingly, almost impossibly, twofold: she was both a girl next door *and* a fitting future queen consort.

The future duchess's bridal look managed to walk that same tightrope, looking fancy but familiar. Her elegant dress, by Sarah Burton of Alexander McQueen, was big enough to stand up to the cavernous Westminster Abbey, but not so large as to overwhelm her. The full skirt was quite streamlined, save for the bustle in the back; the nine-foot train was sizable but manageable, less than half the length of Diana's. Her short veil felt light and airy; her bouquet fit easily in one hand. The Queen had loaned Kate the Cartier Halo Tiara, dazzling with nearly 900 diamonds but not, by any stretch, large or crown-like, sitting not much higher than a headband.

When Kate reached the end of the 300-foot aisle, William leaned over to his new father-in-law. "It was supposed to be a small family affair," he joked, according to a lip-reader. But there was a ring of truth behind it; this was the new post-Diana monarchy, situated among the people, not above them. The wedding was not a state occasion, given that William was the second in line to the throne. "I think if William didn't have a public role, they would have loved to have gotten married in a little church in Bucklebury," a guest told *People* magazine.

The couple were allowed to shape the day, but ultimately this event was about continuing the centuries-old institution—so the Queen had final say, including on attire. William had eyed a different colorway of the uniform of the Irish Guards, in which he was given honorary rank of colonel. "My grandmother very much decided that the red unit was very smart and the appropriate one to wear for the day," he later said. So red it was.

The Royal School of Needlework made the lace applique for the bodice and skirt of Kate's dress. The craftsmen washed their hands every thirty minutes and replaced their needles every three hours "to keep them sharp and clean," a release from Buckingham Palace said.

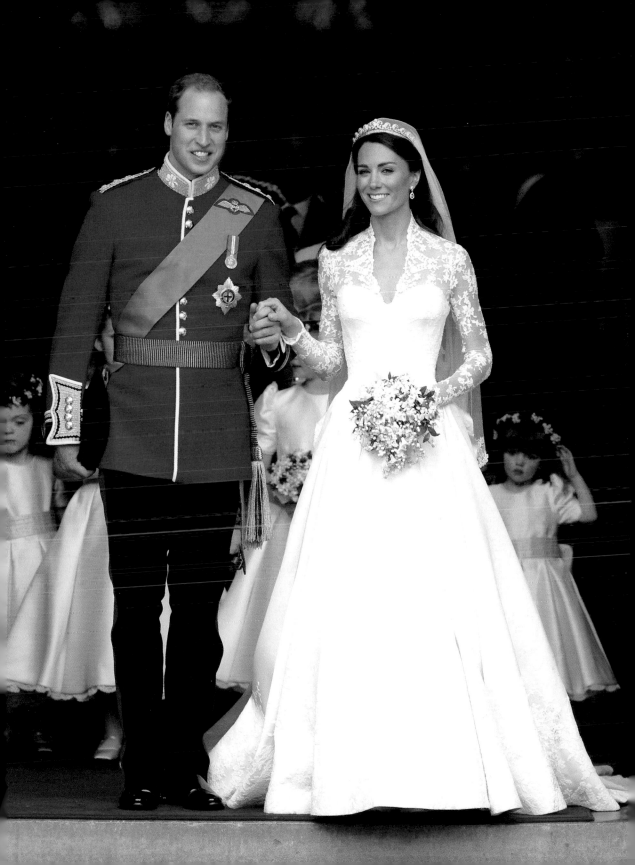

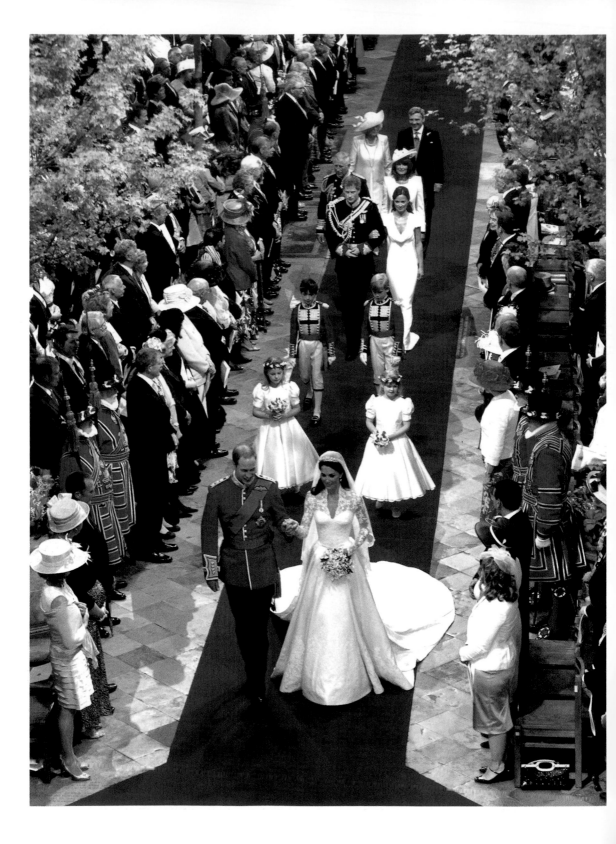

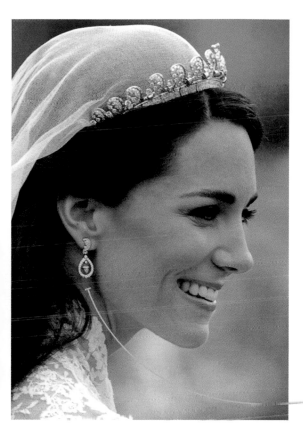

Kate declined advice to wear her hair up for the ceremony, instead compromising with a demi-chignon. The Queen loaned her the Cartier Halo Tiara, which her sister, Princess Margaret, had worn to her coronation. Her earrings were a gift from her parents designed to complement the tiara and symbolize the Middleton Coat of Arms given to the family ahead of the wedding. Field maples lined the aisle, part of a thoughtful foliage plan. "The aim is the abbey looks unpretentious and simple and natural and that it reflects the fact that Catherine is a country girl at heart," the artistic director of flowers told the BBC. After the ceremony, the couple climbed straight into an awaiting horse-drawn carriage for the ride to Buckingham Palace.

The acorn motif was inspired by the oak trees near where the Middleton children were raised.

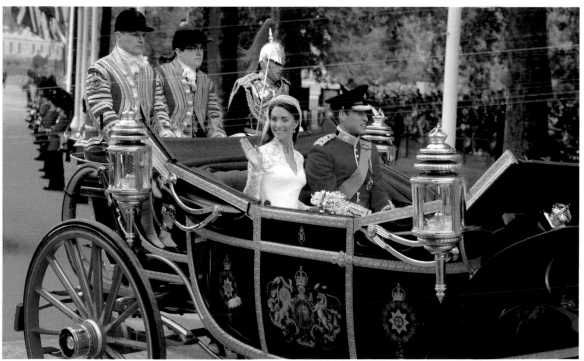

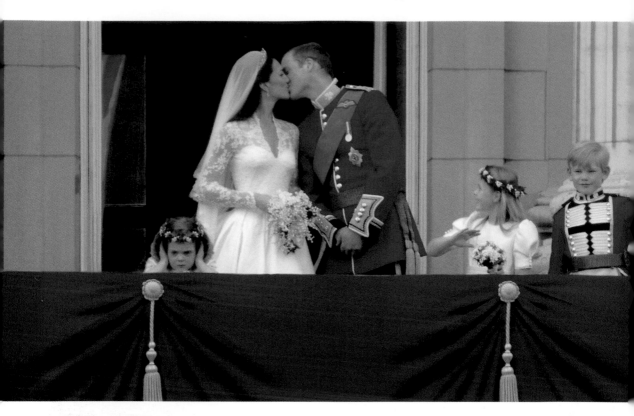

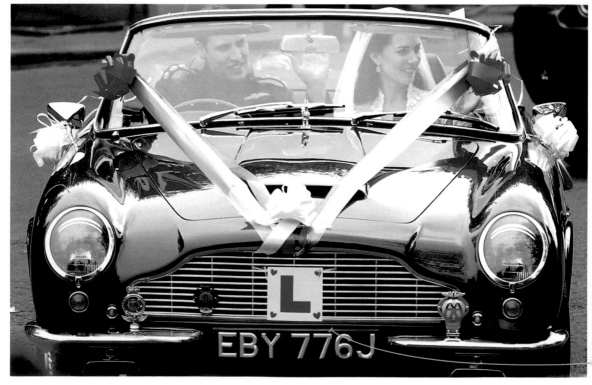

"Oh wow," a lip-reader caught Kate saying as she walked out onto the balcony. The couple kissed twice, a quick peck to start and then an ever-so-slightly longer version at the insistence of the crowd. The couple delighted fans later by driving away from Buckingham Palace in Prince Charles's blue Aston Martin convertible, escorted by a RAF rescue helicopter overhead. For the evening reception, Kate let her hair down in a trademark bouncy blowout and changed into a second dress by Sarah Burton for Alexander McQueen. It is thought to be a strapless dress, although no pictures of her bare shoulders were released.

Prince Harry helped decorate the car, taking a swipe at his brother by adding an "L" learner plate on the front, the symbol for a new driver.

She's pretty—but not intimidating; she looks like someone we could be friends with.

VOGUE

NO REST FOR THE WEARY, AND DEFInitely not for a world-famous couple. Three months after their nuptials, the newlyweds embarked on their first official tour to North America, which meant mostly Canada and a quick dip down to California. Kate was not yet working with a styling team, instead relying on help from her mom and some personal shoppers to put together most of the outfits. She learned a few things the hard way in her early days, like how windy a tarmac can be. Her breezy Jenny Packham dress, at the airport in Calgary, did her no favors. (A)

The nine-day tour was a series of lovely, if often super safe, dresses paired with her nude L.K. Bennett Sledge pumps. It was her first chance to show a bit of sartorial diplomacy, arriving in Ottawa in a navy lace dress by Erdem, a Canadian-born, London-based designer. (C) A fan favorite was the nautical look by Alexander McQueen she wore for a visit to Prince Edward Island, thought to be a nod to Anne of Green Gables' station dress. (B) "She understands that flirty, feminine frocks are always pretty and never fail," read a recap in *Vogue*. The one big break was the cowboy getup in Calgary. The couple received the white hats as gifts upon arrival. Kate packed a coordinating blouse to wear to a rodeo by Alice Temperley called, fittingly, the "Rodeo" shirt. (D) "They are breathing new life into a monarchy grown stodgy and seemingly irrelevant to younger generations," wrote a columnist in the *Calgary Herald*. "It doesn't hurt either that they both look hot in jeans and cowboy duds."

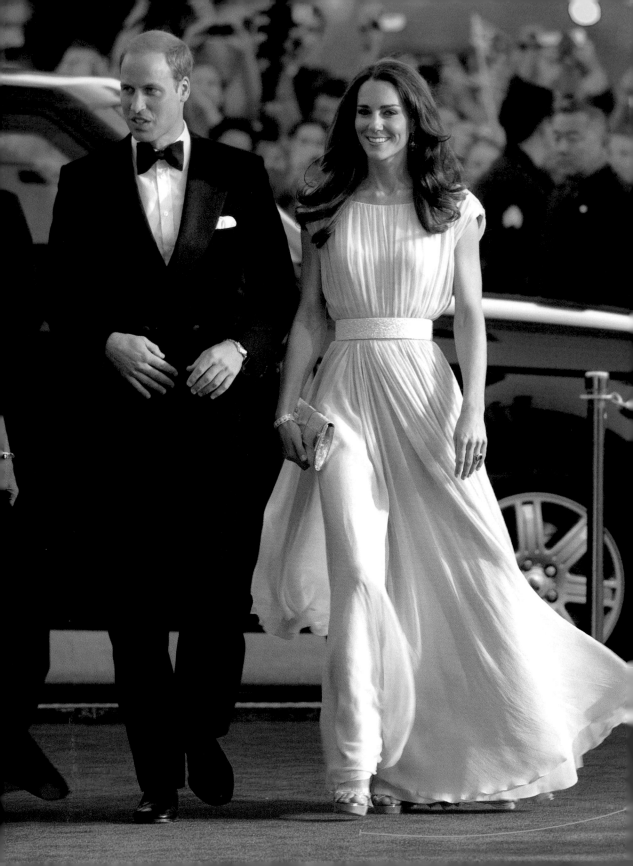

*If you brought back Clark Gable and Marilyn Monroe to life
you could not have had more excitement.*

STEPHEN FRY

THE CAMBRIDGES CLOSED OUT THEIR nine-day tour with a quick stop in Southern California, marking Kate's first visit to the U.S. Hollywood was waiting with open arms and a red carpet. William had been named president of the British Academy of Film and Television Arts, and the organization was holding a "Brits to Watch" gala in Los Angeles.

In what is still cited as one of her all-time most memorable looks, Kate stunned in a lilac gown by Alexander McQueen. The hue was a fresh, softer take on purple, the most regal of colors; the swishy skirt gave a kind of enviable ease to their glamour. The similarities here to the Catherine Walker dress Diana wore at a much swooned-over appearance at the 1987 Cannes Film Festival cannot be denied (especially with the gentlemen in similar tuxedos).

Kate modified the original strapless design, appearing to request a more modest scoop neck and cap sleeves. The sparkles continued with her clutch, bracelet, and enviable chandelier amethyst earrings, on loan from the Queen.

As the pair walked down the red carpet,

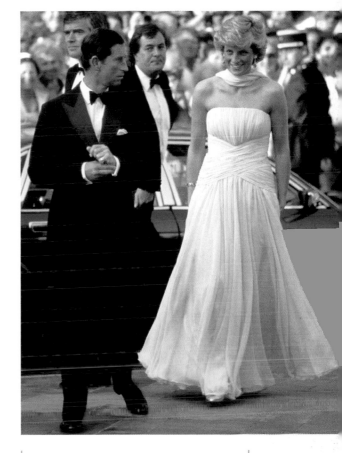

Floating in Catherine Walker, Diana arrived with Charles at the 1987 Cannes Film Festival. The memorable gown was auctioned off a decade later.

The statuesque royal stood even higher than usual thanks to an impressive five-and-a-half-inch heel on her strappy Jimmy Choo sandals.

the skirt of Kate's gown swished dramatically. Behind them, screaming crowds clamored for a better view. The visual was irresistible: the young royals had arrived.

At the Olympics in 2012 (left) and playing volleyball in 2013, wearing her sky-high Stuart Weitzman wedges.

MUCH LIKE THE QUEEN'S SARTORIAL STRATEGY, KATE'S CLOTHING CHOICES CAN feel like something of a uniform. It's not the most exciting, fashion-wise, but it is useful when building one's royal brand (and would help to narrow down the endless choices). A consistent look helped her define her image early on, especially with her casual-wear. The duchess appeared many times in a navy blazer layered over a Breton striped shirt paired with skinny jeans. (A, B) The pieces were both accessible and relatable, wardrobe staples of royal fans everywhere.

From 2006 (above) to 2011, Kate's royal makeover is evident: better hat, better hair, better shoes, better pantyhose.

Another relatable move: repeats, as a way to downplay attention on her and her wardrobe, often when she wants to keep the focus on the cause at hand. This is also true as a wedding guest, because, let's be real, can you imagine having Kate at your wedding? Wouldn't you prefer she arrive in a burlap sack? If a burlap sack could be reimagined as a smart coat dress, then she'd oblige. Kate wore the same piece to both the weddings of Laura Parker Bowles, then her future stepsister-in-law, in 2006 (C) and again for the 2011 wedding of Zara Phillips, the Queen's eldest granddaughter. (D)

THE SUMMER AND FALL OF 2012 were a busy stretch for the royal family, including the Queen's Diamond Jubilee, marking sixty years on the throne. Kate's style had grown a bit more sophisticated a year into her marriage. The lace Alexander McQueen sheath she wore to St. Paul's Cathedral for the National Service of Thanksgiving was blush, which ensured she wouldn't detract from Her Majesty. (A) The dress wasn't flashy, but a fantastic fascinator helped Kate's look feel fancy. She held on to her every-girl image with her pearl earrings, rumored to be $75 from the "Fabulous Fakes" collection by Belinda Hadden.

As part of the Diamond Jubilee, the royal family fanned out around the globe on Her Majesty's behalf. Will and Kate traveled to Singapore, Malaysia, the Solomon Islands, and Tuvalu. Upon arrival in Singapore, Kate wore a pale pink Jenny Packham dress. (B) The orchid is the national flower of Singapore, but the print on the bespoke Packham piece wasn't just any orchid. It was a purple-and-white one with a striking resemblance to the orchid at the Singapore Botanic Gardens being named after the Cambridges, the "Vanda William Catherine." Can you imagine the coordination between the royal tour planners and Packham to pull that off?

A few days later in Malaysia, the Cambridges visited a mosque, the first such visit for them as a couple. (C) Kate's modest attire included a headscarf; her bespoke Beulah London dress fell below her knees.

For an evening reception on the Solomon Islands during the Diamond Jubilee tour, Kate ditched the dress she brought in favor of a colorful strapless piece that had been given to her by her hosts. (A) "She tried it on, she loved it, and she is wearing it," a royal aide said. The quick change proved this sort of spontaneity is never without risk. Kate's dress was not made in the Solomon Islands but rather the Cook Islands some 3,000 miles away. The snafu came to light days later; an excited member of the welcoming committee had added it as an extra gift at the last minute. The government of the Solomon Islands issued a harshly worded statement about the ordeal, disappointed at the missed opportunity to highlight local talent.

Dancing in a dress by Temperley London on tour in Tuvalu. The color coordinates with her headpiece, and the cross-stitch pattern blends with the grass skirt.

For the 2012 London Olympics, Kate stuck mainly to the colors of the Union Jack flag, sprinkling in some official logoed merchandise, too. My guess is that, as a spectator, she did not want to distract from the competitors. Her fashion was restrained, but her cheering was not. When Team Great Britain won gold in the track cycling finals, she thrust her arms in the air. Will wrapped his arms around her hips in an adorable and totally out-of-character PDA. (C) It lasted literally two seconds but <cue the announcer voice> the *fans went wild* for the spontaneous burst of emotion.

Demonstrating team spirit on a pre-Olympics trip to the National Portrait Gallery. Kate wore a blue dress by Stella McCartney, the British designer behind the country's official uniforms, and a Cartier necklace that evoked the Olympic rings.

W HILE KATE'S DAYTIME STYLE IN her first year as a royal was often seen as safe, her evening looks leaned gloriously into her new princess position. The palace appeared to be keen to promote this side of the young royals, filling Will and Kate's diary in the first few years with formal events (although, alas, not many tiara moments).

The Duke and Duchess of Cambridge's first public engagement after their wedding was a black-tie children's charity dinner. (B) Tickets cost a staggering £10,000 apiece. It had been six weeks since the world had seen the blushing bride marry the world's most eligible prince, and Kate wowed in a pale pink pearlescent gown by Jenny Packham. (B) As she ascended the stairs of the purple carpet, she lifted her gown slightly to reveal matching pink, bow-embellished, stiletto sandals.

Another beloved evening look of Kate's was the pleated dress she wore to a pre-Olympic gala the following year. (A) It is a teal version of a bridal gown Packham designed, with something for everyone: Lace! Sparkles! A sheer back! A rhinestone ribbon belt!

The London-based Packham quickly became one of Kate's most-trusted labels, for both evening and daywear, thanks to her über-feminine designs and highest level of discretion. Backstage before one of her runway shows, I once asked Packham what it was like to work with the duchess. Her response? Total silence.

Upping her hair game with what was, in 2012, a rare updo from the duchess.

2013

2015

2018

The Duchess of Cambridge has quickly established herself as the maternity-fashion bar-raiser nonpareil.

VANITY FAIR

THE ONLY THING MORE EXCITING THAN news of a royal engagement is that of a pregnancy (speculation on which often, and unfortunately, begins the moment the wedding ends). Kate has carried three heirs to the throne, and each time her maternity style seemed to push her own sartorial envelope ever so slightly. On the whole, the pregnant duchess favored looser silhouettes. But she dabbled in more fitted pieces and used a strategically placed closure or seam to help shape the top of her abdomen. It allowed a clear outline of her changing shape—a far cry from Diana's tent dresses. In 2013, while she was carrying George, the press was thrilled for the first sight of a visible bump. A few of Kate's usual coats and day dresses were a bit more adventurous, so much so that *Vanity Fair* put her atop its list of "The Top 10 Best-Dressed Pregnant Ladies." The hot pink Mulberry coat she debuted when pregnant with Princess Charlotte in 2015 was a standout piece.

Kate embraced High Street maternity brands throughout her pregnancies, too, prompting the familiar shopping frenzies. A blue lace dress by Seraphine, worn twice when pregnant with Prince Louis in 2018, sold out. Upon restocking, the brand added "Worn by the Duchess of Cambridge" to the online listing.

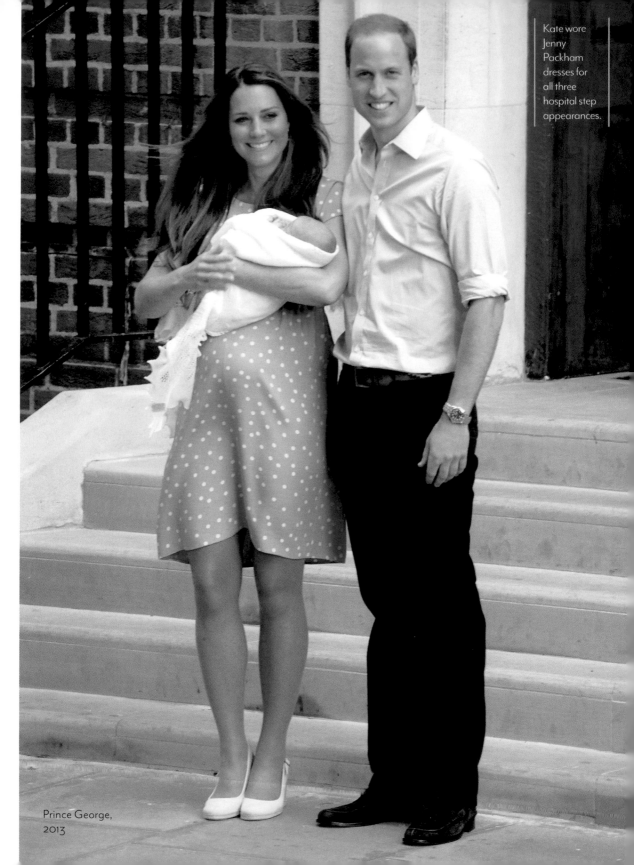

Kate wore Jenny Packham dresses for all three hospital step appearances.

Prince George, 2013

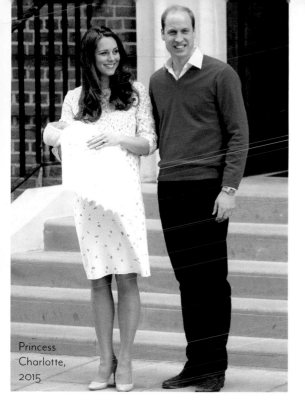

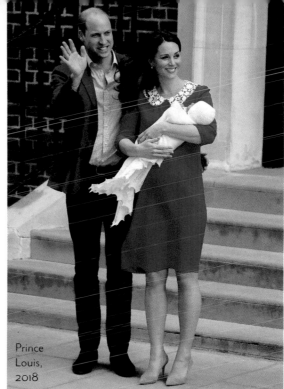

Princess Charlotte, 2015

Prince Louis, 2018

All in a day's work for the ever-fashionable Kate, who made childbirth look like a garden party.

PEOPLE MAGAZINE

THE BIRTH OF PRINCE GEORGE, IN JULY 2013, WAS FILLED WITH FIRSTS FOR A new generation of royal followers. It was the first time we saw the easel announcing the baby's arrival outside of Buckingham Palace, and the first time we witnessed the presentation of the baby on the hospital steps. Kate was glowing in a light blue Jenny Packham polka-dot dress, her summer tan and highlights in full effect. The blue was an adorably obvious tribute to her as-yet-unnamed son and a lovely nod to Diana's polka dots when presenting baby William. The dress was by no means tight, but an elastic band underneath her bust gave it shape. Whether Kate intended to or not, her style choice helped to normalize postpartum bodies.

Much like Diana grew more glam between the hospital appearances of Will and Harry, so did Kate by the time Charlotte arrived in 2015. The duchess's hair is much more coiffed, she swapped her wedge sandals for nude stilettos and her dress was a few inches longer and straighter, lessening the emphasis on the bump. Kate seemed to have found a happy medium for her third baby, sticking with the stilettos but easing up on the blowout and blush when showcasing Prince Louis in 2018.

All three Cambridge children were wrapped in a white shawl by G.H. Hurt & Son. It's a tradition that began with the birth of Prince Charles in 1948.

THE STANDOUT FASHION MOMENT OF A ROYAL CHRISTENING IS THE BABY'S GOWN, an important family heirloom. The original was made of Honiton lace, just like Queen Victoria's wedding gown, and worn by more than five dozen royal babies before it was retired for preservation. The Queen's senior dresser, Angela Kelly, re-created the piece using lace dyed in Yorkshire tea. At Prince George's christening in 2013, Kate's dress by Alexander McQueen nicely echoed that rich cream. (A) But it's her hat by Jane Taylor that made me smile—it's the "Georgie" style. Speaking of hats! Kate debuted one of her most-talked-about pieces at Prince Louis's christening in the summer of 2018. (C) Also by Taylor, it was the first showing of a style I call a hatband, which is a headband big enough to be a hat, or at the very least hat-esque in spirit.

If ever there was a time to lean into a little royal nostalgia, it's at a christening. Kate and Will went all-in with the baptism of Princess Charlotte in 2015. (B) Young Prince George wore red shorts and a smocked shirt that was reminiscent of an ensemble his dad had worn in the 1980s. And the Millson pram Kate pushed had been the Queen's, which she used in the 1960s with her small children.

Getting the most out of this Alexander McQueen coat dress, which Kate wore once before and once after Charlotte's 2015 christening. She wore a similar design to Meghan and Harry's wedding in 2018.

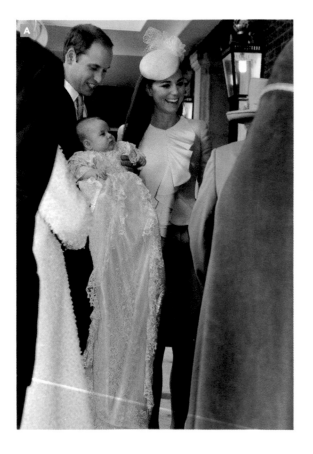

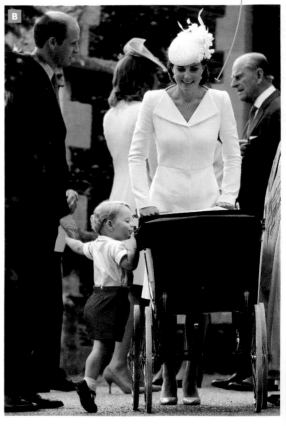

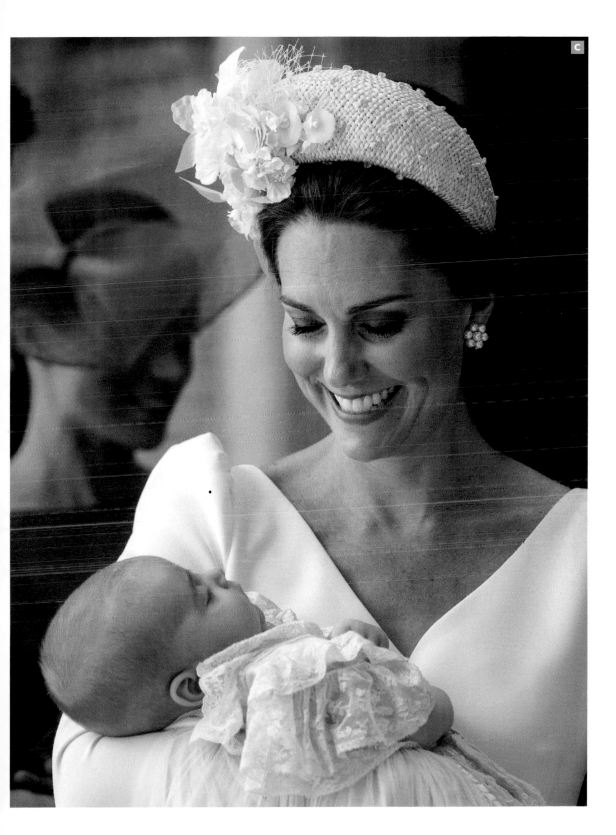

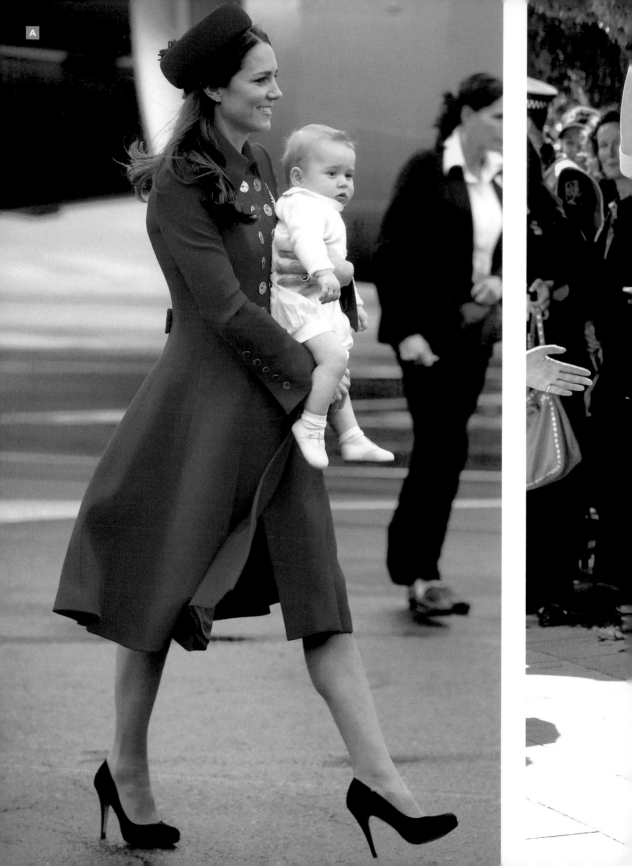

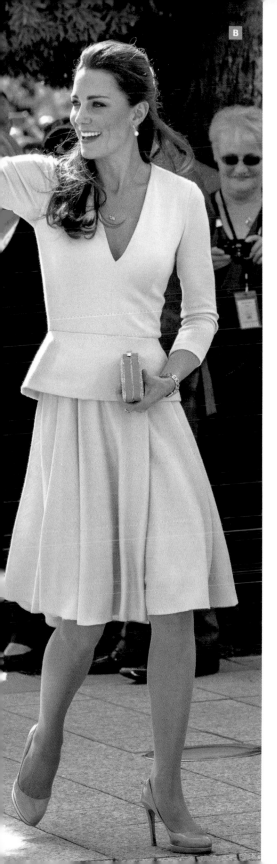

The frilled, girlish frocks she likes have been outlawed in case they detract from the newly grown-up image she needs to project.

THE MAIL ON SUNDAY

AHEAD OF THE 2014 TOUR OF NEW Zealand and Australia, the press predicted a shift in the duchess's wardrobe to a more serious and stately representative of the Crown. Her short High Street hemlines were frowned upon, the *Mail on Sunday* suggested, with the Queen herself prepared to loan jewels from her collection to add more formality to Kate's wardrobe. In reality, the three-and-a-half-week tour was not an obvious departure for Kate but rather a series of subtle shifts.

The duchess stepped off the plane in a stately red coat dress by Catherine Walker, a favorite designer of Diana's, that fell below her knees. (A) She paired it with a pillbox hat and the cutest accessory of them all: Prince George. Kate wore more solid colors, too, allowing the massive crowds to better spot her. A pale pink McQueen dress, with its V-neck, peplum, and full skirt, was a delightful reminder of her wedding dress. (B)

After debuting two dozen new looks on the tour, Kate fended off criticism by wearing mostly recycled ensembles in the subsequent months, as Diana had done following her 1983 Australia tour.

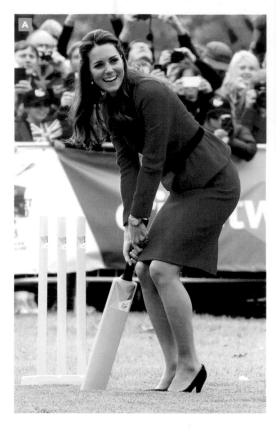

KATE IS A FIERCE COMPETITOR WILLING to pick up any ball or racket in her vicinity. The resulting pictures reveal a spirit and zest in the duchess we wouldn't see otherwise.

On tour, the Cambridges' itinerary often includes at least one sporting moment—it's a guaranteed crowd-pleaser. Her attire runs the gamut, everything from her usual daywear, playing cricket in New Zealand in 2014 in a favorite Luisa Spagnoli suit and heels (A), to a country's traditional dress, trying her hand at archery in a look inspired by a Bhutanese kira in 2016. (C). She has also worn clothing you might expect to see on the field, or that at very least allows for a little more movement, like on a visit to Northern Ireland in 2019. (B) But forget about what the duchess is wearing: I am here for her ear-to-ear smile!

Sporting red and black, the colors of the Canterbury region, on a 2014 visit to Christchurch, New Zealand.

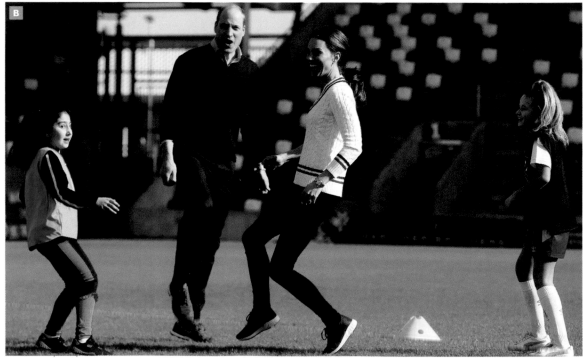

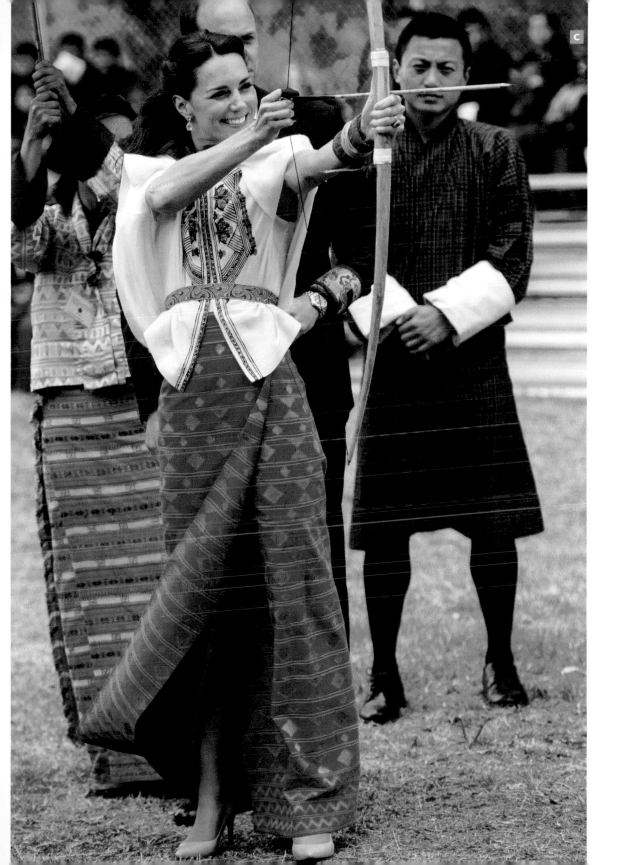

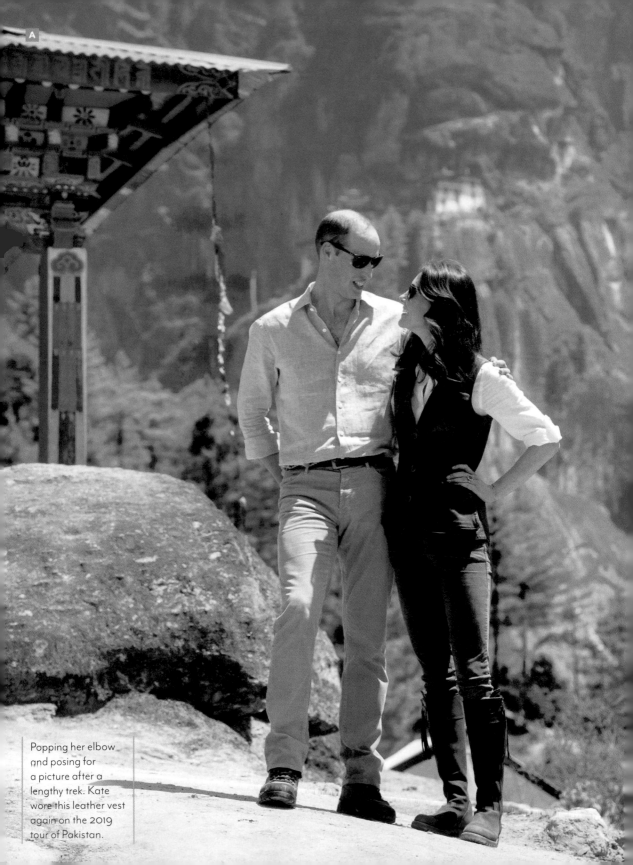

Popping her elbow and posing for a picture after a lengthy trek. Kate wore this leather vest again on the 2019 tour of Pakistan.

BY THE 2016 TOUR OF INDIA AND BHUTAN, KATE WAS WORKING CLOSELY WITH her personal assistant and stylist, Natasha Archer. The additional help added another layer of meaning to her dressing, with the British press taking note of the increased boldness and complexity in her choices. To lay a wreath at the Taj Palace Hotel, Kate wore a red paisley Alexander McQueen dress. (B) Red is an important color in India, used for occasions like marriages and births, while the paisley pattern dates back to the eleventh century in the Kashmir region. For an evening reception, Kate donned a custom gown by London-based Jenny Packham, which featured intricate beading that had been done in India. The shawl and skirt were reminiscent of a sari. (C) But the most thrilling piece wasn't new, it was old—more than a decade old. Kate brought back her Penelope Chilvers boots, first seen while she was dating William, for a hike to the Tiger's Nest Monastery in Bhutan. (A)

IANA AND CHARLES FOREVER changed the precedent for royal tours when they brought nine-month-old William along on their six-week visit to Australia and New Zealand in 1983. The younger royals have since followed suit, and it's one of the few chances we get to see the children in public. The families often dress around a single color—coordinating without matching, it's harder than you'd think!—which projects an air of togetherness. Archie's debut appearance in South Africa was a highlight of the 2019 tour.

Airport tarmac shots have delivered some of the most memorable close-up looks of the Cambridge family. Deplaning in Canada in 2016, Kate expertly held Princess Charlotte in a way that would not wrinkle her dress.

Playing with baby William on the lawn of Government House in Auckland, New Zealand. The twenty-one-year-old princess's informal pose showed off her red heels.

Representing the
sovereign with a
maple leaf brooch,
on loan from Her
Majesty for a 2016
tour of Canada.

2017

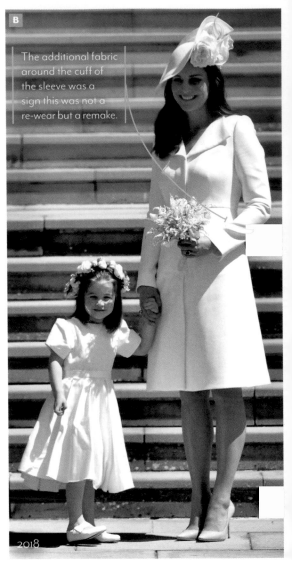

The additional fabric around the cuff of the sleeve was a sign this was not a re-wear but a remake.

2018

ONE OF KATE'S MOST FASCINATING WARDROBE MOMENTS WAS HER CHOICE FOR Harry and Meghan's wedding in May 2018. (B) The Alexander McQueen coat dress was instantly familiar to royal watchers, who had seen it three times before, including on a visit to Belgium. (A) Many fans, myself included, thought it was a repeat designed to keep the focus on Meghan. But upon further investigation, thanks to the savvy spotting of Susan E. Kelley at What Kate Wore, it looked as if it was an entirely new garment. My best guess is that Kate had a new coat dress made to resemble the old one and fit her newly postpartum frame so that it would look like a repeat.

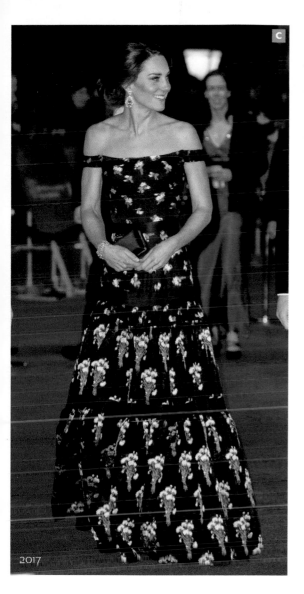

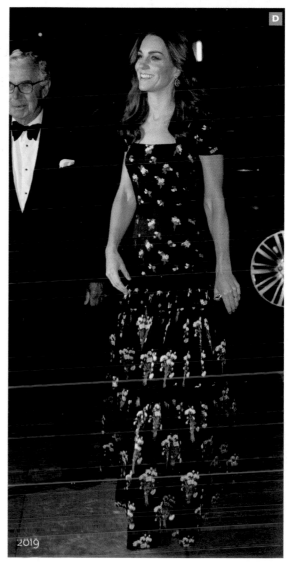

A year later, Kate's reworking was much more obvious. While she had been known to alter some garments—lengthening a hem, for example—this was a noticeable overhaul of a beloved gown. She first wore the black floral Alexander McQueen dress to the 2017 BAFTA Awards. (C) Its off-the-shoulder neckline was seen as ever so slightly risqué. When she re-wore it to a gala at the National Portrait Gallery two years later, it had a much more modest cap sleeve. (D) Close inspection of the dress, including the floral pattern at the neckline and around her hips, suggested she had the top two-thirds redone, not simply the sleeves. Quite Diana of her, don't you think?

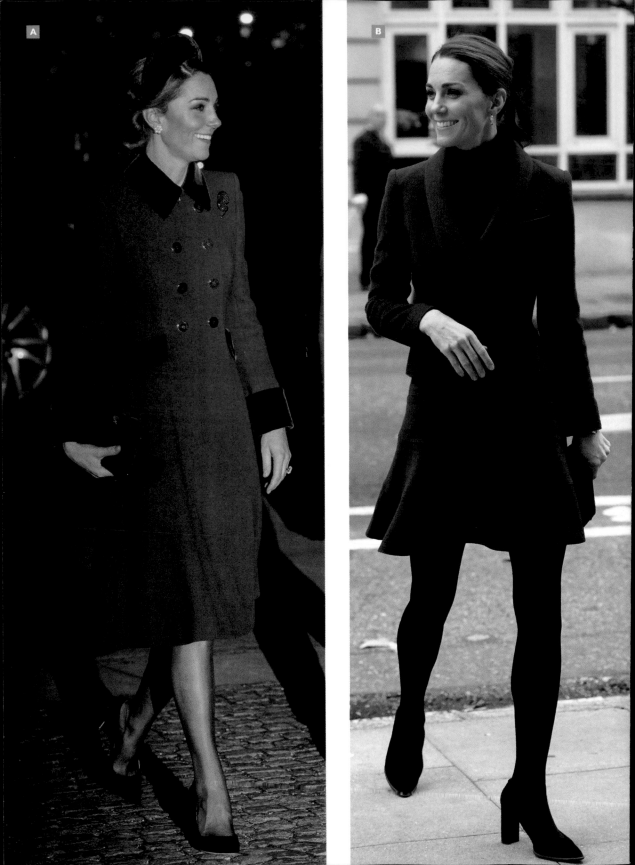

C

Her simple black velvet bow elevates her outfit into one that feels current, cool, and covetable.

HARPER'S BAZAAR

THE DUCHESS'S WARDROBE HAD A NO-ticeable new vibe in the autumn of 2018. It began in some small ways, like the chicest little black bow she wore that November, an exclamation point gathering her swept-back waves. (B) It was a clever way to refresh an oft-worn repeat skirt suit. She must have liked how it looked, because she wore a bow again a week later. (C) You might be thinking: it's just a bow! I would posit the bow is more than that. Not everyone can buy what a duchess wears, and even the accessible pieces can be too pricey or out of stock. But just about anyone can snag a piece of ribbon to tie in their hair. It's an easy way to feel ever-so-slightly royal.

A week prior, Kate attended an evening service on Remembrance Day wearing a black velvet padded hatband. (A) Unlike the ornate one she wore to Prince Louis's christening, this hatband was a sleeker statement piece, much like Prada had shown on its runway. Come spring, padded headbands—and their less intimidating cousins, statement headbands—were all the rage.

Both of these hair accessories signaled a playfulness from the duchess that we hadn't necessarily seen before, adding a youthful vibe to her stately suits and coats.

She looks a lot more confident of late.

RUSSELL MYERS, *DAILY MIRROR*

KATE'S STYLE UPGRADE CONTIN-
ued apace into 2019. On a trip to
Northern Ireland that February, the duch-
ess dazzled in a shimmery mint green Mis-
soni frock. (A) It was a party dress, but not
a fussy one, somehow feeling special and
easy at the same time—perfect for pulling
a pint at a pub.

She also began experimenting a bit
more with styling tricks. On a visit to a
children's center the following month, she
wore a purple Gucci silk blouse backward.
(B) It felt like a page from Diana's fun-
with-fashion playbook. It wasn't obvious
at first glance, but style bloggers quickly
surfaced pictures of the blouse on retail-
ers' websites with buttons down the back,
whereas on Kate they were in the front.

A few months later, the duchess donned
a navy polka-dot Alessandra Rich shirt-
dress for a D-Day exhibition at Bletchley
Park. (C) Scores of celebrities had worn
a version of the distinct piece, includ-
ing actress Abigail Spencer to Harry and
Meghan's wedding the year before. Cue
the side-by-side "Who wore it better?"
collages! It looked demure as Kate stood
still, but a single step in her periwinkle
suede pumps offered a hint of sass.

Confirming the blouse was, indeed, backward,
the buttons on the cuff were on the inside of
Kate's wrist.

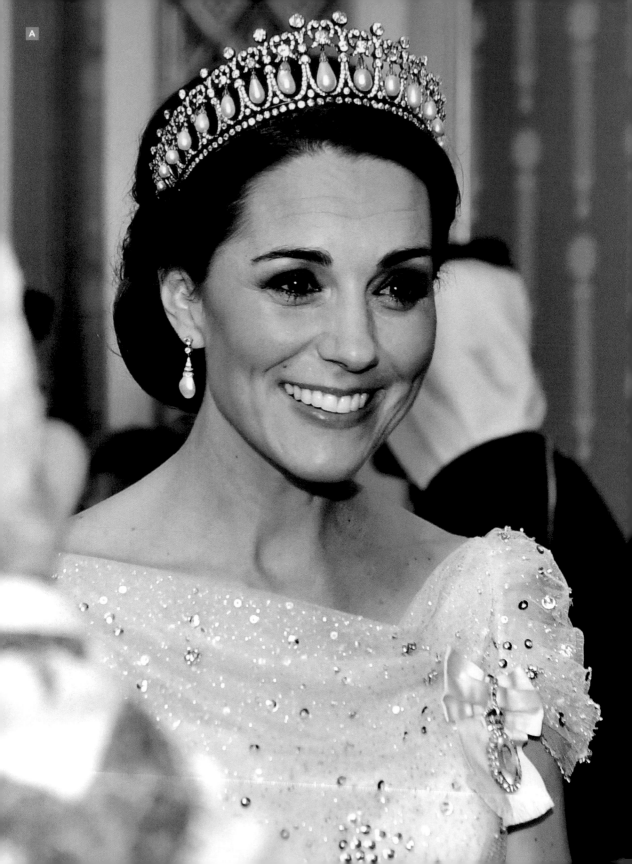

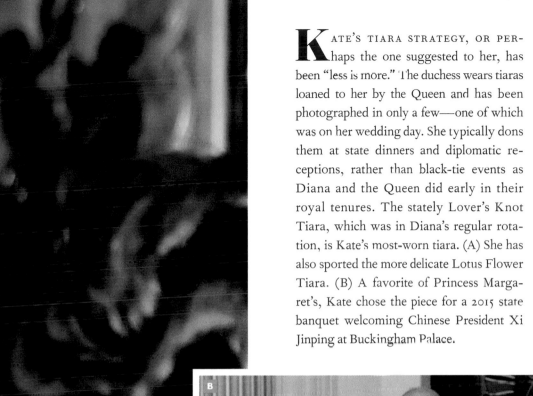

KATE'S TIARA STRATEGY, OR PER-haps the one suggested to her, has been "less is more." The duchess wears tiaras loaned to her by the Queen and has been photographed in only a few—one of which was on her wedding day. She typically dons them at state dinners and diplomatic receptions, rather than black-tie events as Diana and the Queen did early in their royal tenures. The stately Lover's Knot Tiara, which was in Diana's regular rotation, is Kate's most-worn tiara. (A) She has also sported the more delicate Lotus Flower Tiara. (B) A favorite of Princess Margaret's, Kate chose the piece for a 2015 state banquet welcoming Chinese President Xi Jinping at Buckingham Palace.

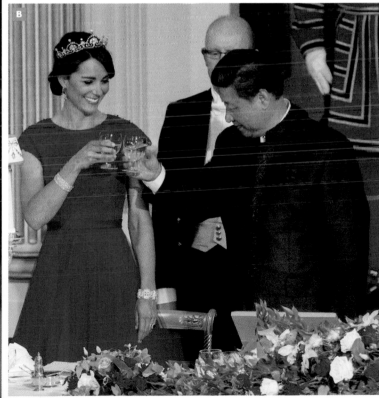

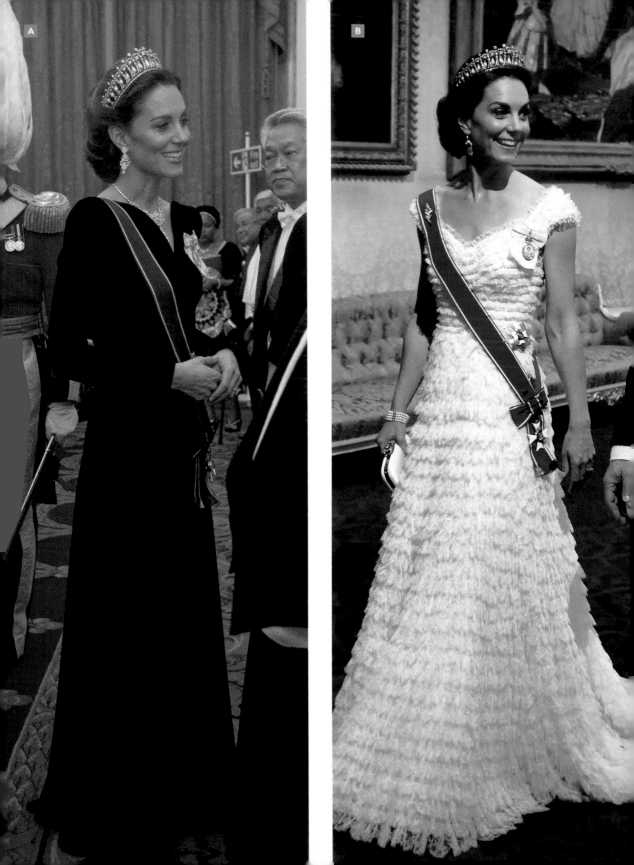

*Awards in the Royal Victorian
Order are made personally by
the Queen, for services to the Sovereign.*

BUCKINGHAM PALACE

REMEMBER THE QUEEN'S APPROACH of showcasing jewels as a sign of power and influence? As Kate continues to prepare for becoming queen consort one day, she has embraced the family philosophy. The duchess has been loaned some stunning pieces from Her Majesty's collection. For a 2019 reception, Kate's Alexander McQueen gown, with its plunging neckline, beautifully showcased the Nizam of Hyderabad necklace. (A) Her Majesty received it as a wedding gift from the wealthy Indian ruler for which it is named. The year before, while attending a state dinner with the King and Queen of the Netherlands, Kate wore Queen Alexandra's Wedding Necklace. (C)

The most special accessories, or perhaps the biggest honors, are the recent ribbon additions. Kate's yellow badge is the Royal Family Order, a diamond piece personally given by the Queen to women in the family. The duchess received it in 2017; it is worn on the left shoulder as if to say "the Queen approves!" Two years later, on her eighth wedding anniversary, Kate was named Dame Grand Cross of the Royal Victorian Order, signified by that blue sash she first wore in the summer of 2019. (B) It's the highest honor the Queen bestows, her way of thanking those who represent her.

*The Queen does not like to tell people
how to do things.
She likes to lead by example.*

VICTORIA ARBITER, CNN ROYAL COMMENTATOR

THE FUTURE QUEEN HAS BEEN A quick study of the current one. The pair made their first "away day" appearance in 2012, as part of the Diamond Jubilee Tour. (A) Kate wore a smart jewel-tone suit by L.K. Bennett; her black accessories paired nicely with the Queen's. Seven years later, when the two stepped out again, Kate wore a similar fascinator and heels. (B) I love how her belt and the skirt of the coat dress by Catherine Walker echoes the peplum of her previous suit. The Queen, whose outfits are famously and carefully tracked by her team of dressers, wore pink both times.

Kate has also embraced Her Majesty's penchant for bold color with, dare I say, a touch more sophistication. The peacock hues she wore to the annual ANZAC Day service in 2019 were a particularly striking combination, pairing a teal Catherine Walker coat dress with navy gloves, as well as an emerald clutch and heels. The whole look was tied together with a fantastic feathered hat. (C)

KATE HAS BEEN ATTENDING WIMBLEDON SINCE LONG BEFORE SHE BECAME A royal (she used to wait in line to get in!). She took her seat in the royal box as soon as she became a duchess in 2011, wearing a Temperley London dress. (A) Its pleated skirt and sleeveless top, coupled with the tennis ball–esque cutouts on the straps and back, looked an awful lot like the tennis whites worn by the players. Attending in 2019, alongside Meghan, Kate blended in once again in her green Dolce & Gabbana dress that matched the stands. (B) It was a repeat and a disappointing one at that, given the brand's racist marketing campaign the year before.

In 2016, Kate became patron of the All England Lawn Tennis and Croquet Club, having been passed the honor directly from the Queen. The duchess awarded the men's championship trophy three years later in a striking blue dress by Emilia Wickstead. (C) The soft shade managed to be both bright enough to be seen against the green turf, but not so bright as to detract from the gold trophy or the players. Her block-heel shoe cleverly protected the turf, not piercing it as a stiletto might.

A WOMAN WEARING TROUSERS IN the twenty-first century wouldn't normally be worth a mention, but when that woman is a dress-loving duchess, it feels noteworthy. Although Kate has always worn pants on her casual outings, she started incorporating more trousers in her dressier daytime looks, too, as part of her fashion-forward makeover.

Kate's styles have run the gamut, from slender and cropped to long and voluminous. It lends a bit of modernity to her appearances; when paired with a blazer, trousers give off more of a serious at-work vibe. (B) As a mom of three, it feels like a practical move, too; wearing trousers on her engagements with small children—or adorable animals!—allows for more bending and crouching. (A)

Trousers are one thing, but shorts—shorts!—are another. The duchess surprised everyone by wearing a navy blue pair to the King's Cup Regatta in 2019. (D) The eight-boat charity race was a much-anticipated event. She had worn a fittingly nautical ensemble for the announcement back in May. (C) It was a dressier version of her go-to casual style, paired with a red clutch. On race day, Kate changed into sailing gear and shorts, throwing her hair into a ponytail and taking to the seas. Again, if we were talking about anybody else, wearing shorts would *not* be a big deal. But to see a royal woman in shorts on an official engagement was hilariously exciting. *Harper's Bazaar* declared, "The internet is shook." Could Diana's bike shorts be next?

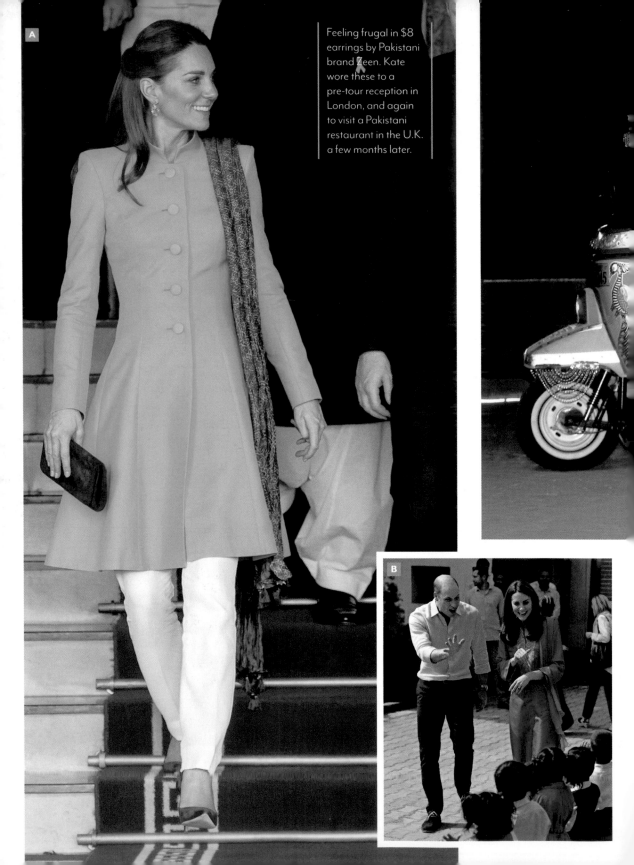

A

B

Feeling frugal in $8 earrings by Pakistani brand Zeen. Kate wore these to a pre-tour reception in London, and again to visit a Pakistani restaurant in the U.K. a few months later.

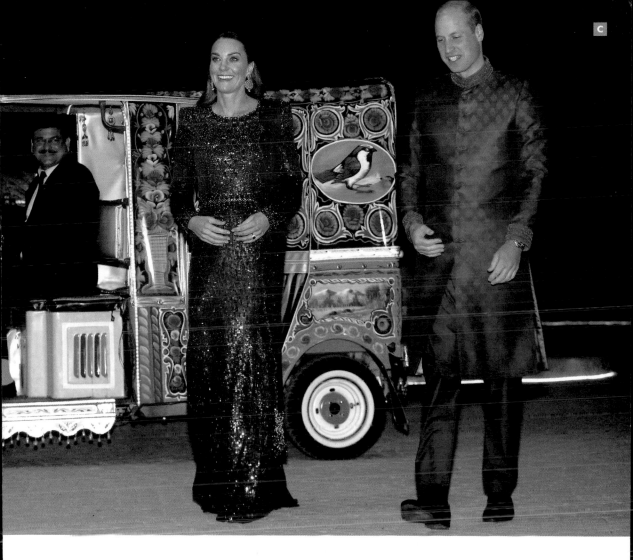

ON A 2019 TOUR OF PAKISTAN, KATE WORE CLOTHES ALMOST EXCLUSIVELY IN-
spired by local attire. She leaned heavily on the team at Catherine Walker as well as
Maheen Khan, a prominent Pakistani designer who had done embroidery for the Walker
brand. The combination of the two, seen in a Walker tunic and Khan slacks, was a fitting
pairing for meeting the prime minister—in colors that coordinated with the Pakistani flag.
(A) On a visit to a local school, the deep periwinkle hue of the Khan kurta and trousers
was a near-perfect match for the students' uniforms. (B) For a black-tie reception, Kate
sparkled in a beaded gown by Jenny Packham. (C) But all eyes were on Will, who served
up the biggest fashion moment of the tour. The prince embraced sartorial diplomacy,
wearing a sherwani by Pakistani brand Naushemian.

THE CAMBRIDGES' TOUR OF IRELAND IN EARLY 2020 HAD A MUCH DIFFERENT sartorial vibe. Given the complicated history between the two countries, and the trip taking place shortly after the United Kingdom formally left the European Union, the three-day visit was less about the couple dazzling on the global stage and more about forging a friendship between neighbors.

Kate's muted fashion followed suit. The duchess arrived clad in green, the country's signature color. (A) The following day Kate wore a cream double-breasted coat, a delightful throwback piece fans recognized from more than a decade earlier while she was dating Will. (B) On the final day, Kate tried hurling at a Gaelic Athletic Association club in an orange sweater. (C) Only in hindsight did the full extent of the duchess's thoughtful dressing become clear. The dominant colors she wore—first green, then white, followed by orange—together made the Irish flag.

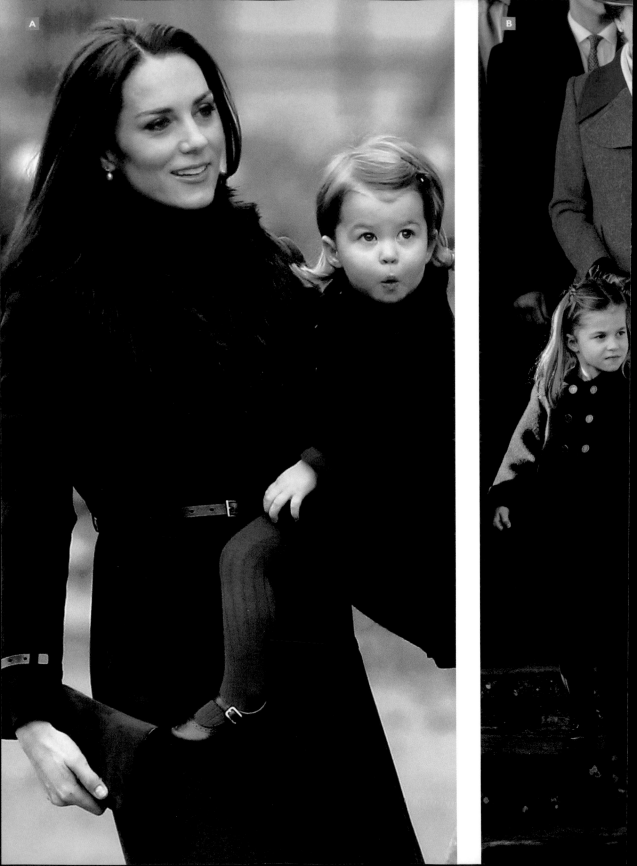

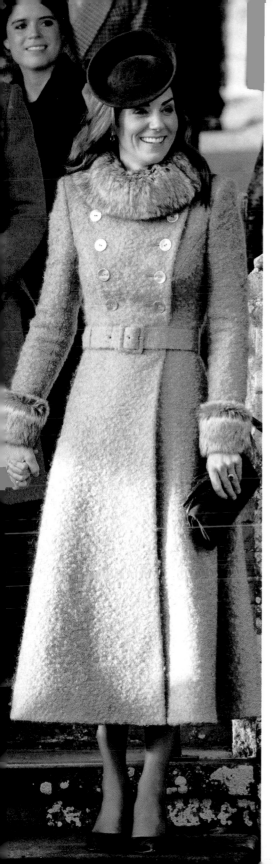

The Duchess of Cambridge may be known as a style icon in her own right, but her children are mini fashion influencers, too!

HELLO! MAGAZINE

THE ROYAL STYLE SPOTLIGHT IS already shining bright on the next generation. The Cambridges' three children, Prince George, Princess Charlotte, and Prince Louis, are getting a master class in strategic dressing thanks to Kate's sartorial savvy. The duchess favors classic British pieces, like double-breasted coats and smocked dresses. She stuck with the tradition of keeping young boys in shorts for many years, and often shared pictures of Charlotte and Louis in George's hand-me-downs.

All eyes will eventually turn to young Princess Charlotte to carry the royal style mantle. She already coordinates with her mother in the sweetest ways. On Christmas 2016, at age one and a half, the young princess wore cranberry tights and a hair bow that perfectly matched Kate's clutch. (A) Three years later, for Charlotte's Sandringham walk debut, Kate chose another fur collar—and again matched her clutch (and her hat, too) to Charlotte's coat. (B)

Waiting to curtsy for the Queen on Christmas Day 2019. Charlotte wore a maroon version of this double-breasted coat for her first day of preschool two years earlier.

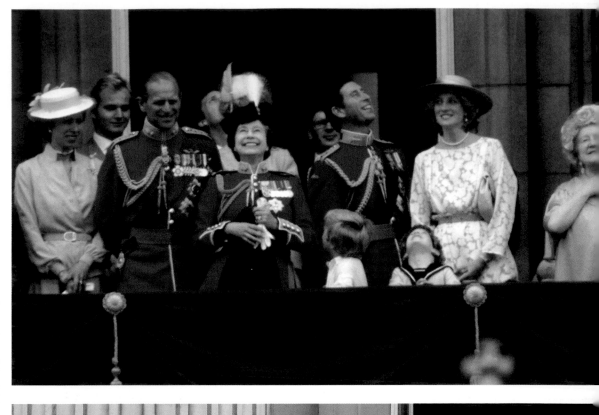

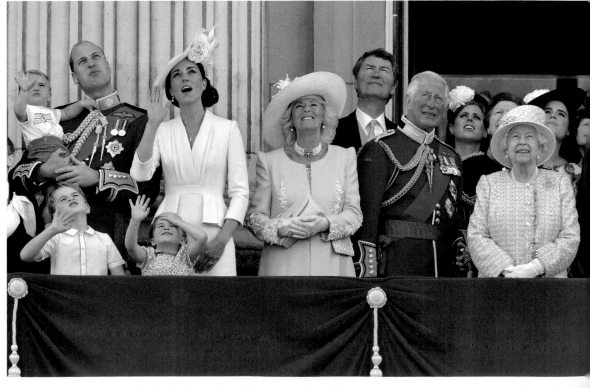

1983

2019

TROOPING THE COLOUR

THE ANNUAL CELEBRATION OF
THE SOVEREIGN'S BIRTHDAY

THE QUEEN'S BIRTHDAY IS IN APRIL, BUT SHE OFFI-
cially marks the occasion with a military parade each
June, a tradition that dates back more than 260 years. Today,
more than 1,400 soldiers, 200 horses, and 400 musicians par-
ticipate in the Trooping the Colour festivities. The Queen and
her descendants then gather on the Buckingham Palace bal-
cony to watch a flyover by the Royal Air Force, resulting in
the iconic group shots. It is the one time of the year we see
everyone standing together, chins pointed up to catch the ac-
tion overhead. The family dresses in delightfully British fash-
ion, with coats and hats that can be spotted from the sizable
crowds. There appear to be loose guidelines, at best, for how
and where everyone should stand based on where they fall in
the family's hierarchy. The Queen's children are often front
and center, with Charles at his mother's side. William, who is
second in line, typically, gets more prominent placement than
Harry. Still, the execution is delightfully chaotic as they crowd
into the space. The one person who is always the most visible?
The Queen, naturally.

M

EGHAN

THE DUCHESS OF SUSSEX

THREE DAYS AFTER MEGHAN MARKLE MARRIED HER REAL-LIFE PRINCE, with millions of people around the globe watching, the newly minted Duchess of Sussex made her first official appearance as a member of the British Royal Family. It had been a whirlwind run for Meghan and Prince Harry, just over seven months between when they first stepped out in front of the cameras as a couple to tying the knot in the chapel of Windsor Castle. The world clamored to know Meghan, to *see* Meghan. A thirty-six-year-old biracial American actress, she was a breath of fresh air for the Britsh royal family and her style was, too. To the Invictus Games in Toronto in 2017, where she first appeared as Harry's girlfriend, Meghan wore an oversize white button-down shirt, pointy-toed flats, and distressed skinny jeans. Two months and a three-stone diamond engagement ring later, Meghan began carrying out royal engagements with a sophisticated take on that same sartorial spirit. She epitomized effortless California-girl style, favoring separates over sheath dresses and pairing oversize coats with luxe scarves. She tended toward neutrals, rather than the candy-colored shades worn by the Queen, and mixed in labels from the United States, where she was born, and Canada, where she lived for many years while filming the cable network drama *Suits*. "Meghan Markle is redefining what it means to be a royal," began a post on *Vogue*, celebrating a "slick suit" she wore to an evening event.

And then Meghan Markle became HRH the Duchess of Sussex. At a garden party on a brilliantly sunny day in late May, Meghan floated down the steps of Buckingham Palace in a blush wool and silk chiffon dress by Goat, a British label favored by her new sister-in-law, Kate. On her head sat a bespoke pink hat by Philip Treacy, a go-to milliner for the royals, and in her hands she carried a metallic clutch by Wilbur & Gussie, also a British label. As the first pictures appeared, the internet lit up: was Meghan wearing pantyhose?

In the weeks that followed, the duchess wore two more pale pink ensembles for high-profile outings. There was the stunning off-the-shoulder top and skirt by legendary American fashion house Carolina Herrera for Trooping the Colour. Later, she wore a two-piece Prada skirt suit in a similar shade for an outing with Harry and the Queen. In between, Meghan chose a white shirtdress and a beige (or was it pale pink?) cape dress, both by Givenchy. The consistency of hues was striking. What was it that had the duchess thinking pink?

Back up just a year and the answer is right there. In a 2017 interview with *Glamour*, Meghan explained the costume strategy for Rachel Zane, the whip-smart paralegal she played for seven seasons on *Suits*. "Rachel's clothes reflect how she's feeling because that's

what happens in real life, right?" Meghan said. "When she and Michael"—Rachel's love interest on the show—"were falling in love, everything was blush tone and it was creams and layers and she was happier."

Meghan, the most-watched newlywed on the planet, seemed to be giving that same thought to dressing for her real life. The American actress had taken on a new, evolving role as a member of the royal family, and she was showing the world just how in love she was.

————

MEGHAN JOINED THE FIRM AS A FULLY FORMED, ACCOMPLISHED CAREER WOMAN. SHE was thirty-six years old when Harry proposed, with an established audience of her own thanks to her recurring role on the television series *Suits*. Unlike Diana or Kate, she had already lived something of a public life, being photographed on the red carpet and interviewed on live television. On her popular lifestyle blog, The Tig, named for an Italian red wine, her musings on travel, food, and fashion were reflections on her rising status and the opportunities it afforded her. "Fashion is the name of the game and on a daily basis I slip into countless bespoke frocks," she wrote in a blog post about her television wardrobe. "This includes everything from a Tom Ford skirt to a vintage Chanel eyelet lace blouse, both of which cost more than twice a month's rent." Her Instagram following reached an impressive 1.9 million followers.

Thanks to a winning combination of talent and hard work, Meghan had some early breaks, on a game show and the Hallmark Channel, in between gigs as a hostess and calligrapher for hire. In 2011, she earned the kind of coveted role most actors only dream of: an ensemble cast member on a cable television drama. She was starting to get a taste of fame, and of fashion—but kept her feet firmly on the ground. "This is still work," Meghan reminded her readers in that same blog post. "At the end of the day, the clothes come off of my body and back into that glorious wardrobe department. My Cinderella moment is done."

I feel like this is where the unseen narrator should loudly whisper: *But her Cinderella moment was only just beginning.* Just a few years later, Meghan would don a glittering tiara, walk down the aisle of a chapel at a castle, and marry an actual handsome prince. She became a global superstar overnight.

But this new life came at a hefty cost. It required her to give up acting and influencing, both of which celebrate using one's individuality and voice for good. She moved to a country that prides itself on a "stiff upper lip" approach and joined an institution that has survived by never complaining and never explaining.

Britain's ruthless tabloid press began leveling racist falsehoods shortly after she began

dating Harry. "EXCLUSIVE: Harry's girl is (almost) straight outta Compton," read a headline in the *Daily Mail* in November 2016. "Gang-scarred home of her mother revealed—so will he be dropping by for tea?" Racism came from inside the royal family, too. After Harry and Meghan announced their engagement in 2017, Princess Michael of Kent, the wife of the Queen's first cousin, attended a Christmas reception with the couple at Buckingham Palace wearing a blackamoor brooch. (She later apologize for the offensive piece of jewelry; a spokesperson said it was not intentional.) Following the birth of their son Archie in 2019, a radio DJ tweeted an image of a chimpanzee with the caption: "Royal baby leaves hospital." The obvious racist vitriol was paired with much more subtle microaggressions; social media gave these negative narratives a platform. It is easy to see why Meghan and Harry made a break for the exit just two and a half years after they announced

Greeting the enthusiastic crowds on a March 2018 engagement in Birmingham.

their engagement. The couple gave up their roles as senior working royals and moved to Los Angeles in the spring of 2020 to seek financial independence and launch a charitable organization.

Looking back at Meghan's time in the royal fold, I see a woman who tried very hard to make it work. Following a very strict royal tradition, she had limited tools at her disposal, but she used them to the fullest—including her clothing. Her time in, and on, television had given her a unique kind of fashion fluency, an extended lesson in how colors, silhouettes, and designer choices can help tell a story. She dressed thoughtfully from the start, choosing brands that matched her personal values and hues that represented how she was feeling. The duchess brought a new, enthusiastic audience to the royal family;

her fashion-forward aesthetic delighted the style world, too, a gorgeous new style star to fawn over. Her short stint hit all of the fashion notes, from bespoke designer gowns to a shirtdress you could buy at the mall. Meghan saved the best for last, carrying out her final engagements in the spring of 2020 with a trio of bold statement dresses. Out with a bang—and better than ever, *thank you very much*—as she and Harry headed into their new life.

———

RACHEL MEGHAN MARKLE WAS BORN ON AUGUST 4, 1981, IN LOS ANGELES, CALIFOR-nia, to parents with experience behind the scenes in Hollywood. Her white father, Thomas, was an award-winning television lighting director; her Black mother, Doria Ragland, was a makeup artist before becoming a travel agent, a yoga instructor, and a social worker. They divorced when Meghan was young. Meghan's first show business credit dates back to 1995, when she was just 14, with an unnamed role on an episode of *Married . . . with Children*. Her father worked on the American sitcom, and Meghan visited the set every day after school for the better part of a decade.

Meghan graduated with a degree in acting and international relations from the prestigious Northwestern University in 2003, and soon made her way back in front of the camera. She landed a series of one-off appearances on well-known American television shows like *General Hospital*, *CSI: NY*, and the reboot of *Beverly Hills 90210*. Among her longest-running gigs was her role as a "briefcase girl" on the game show *Deal or No Deal*.

Suits, the drama the future duchess joined in 2011, became the defining role of her acting career and gave her a new understanding of fashion. Set in a hard-charging law firm, with plots around power and money, *Suits* stars wore the best of the best. Meghan's character, Rachel, was an ambitious paralegal-turned-attorney who wore body-conscious styles from modern high-end designers like Prabal Gurung and Tom Ford. "Playing Rachel opened me up to this entire world," Meghan told *Fashion Magazine*. "In real life I wear clothes, but for work, I wear art." As she grew into the role, Meghan began to infuse her own sense of style into her character, too. "I don't generally wear prints, and neither does Rachel now. Rachel wears a lot of separates, she's really the only character on the show who you'll see mix and match wardrobe basics like a normal person would," Meghan said in an interview with *Glamour*. (Foreshadowing her future pencil skirt style as a duchess!)

Off set, Meghan developed her own signature look, including ripped jeans, a button-down shirt, and flats, or a T-shirt, slim pants, and a long coat. After years of experimenting with trends—there was even a trucker hat moment, if you can believe it—"One day she just nails her look and stuck to it for like ten years," said Christine Ross, creative director of Effervescence Media Group, which runs Meghan's Mirror, a blog that chronicles Meghan's fashion. The neutrals Meghan wore as a royal, the array of white, black, gray, and navy that

everyone was so surprised by? "She's been wearing those four colors for a decade," Ross said. "It's what she likes, it's what she feels comfortable in." Meghan summed up her style on The Tig, describing an aesthetic that was both classic and relaxed. "It can't always be perfect," she wrote. "And yet it can feel remotely pulled together." The easiness of imperfection became a key part of Meghan's look. With age comes confidence, she said. She celebrated the ability to "throw your hair up in that very French way"—previewing the soft chignon that would become her signature royal hairstyle.

Fashion wasn't something Meghan grew up with; in an interview she cites her school uniform as part of why it "wasn't really on my radar" early on. But as an actress and influencer, she came to embrace it fully, seeming to enjoy it as much as Diana had. She appeared as a fashion expert on the *Today* show a handful of times, offering viewers tips on how to mix metallic accents into their wardrobes or the best way

Celebrating the fifth season of *Suits* in 2016.

to style winter florals. Meghan dabbled in design, too, with a capsule collection for the Canadian department store Reitmans. The first release was made up of four dresses, including a sleek little black dress called "The Soirée" and a flirty red mini dress called "The Date Night." She broke down the process on The Tig: "I toiled over design and print, I shared my thoughts on everything (come on, guys, you know I'm opinionated), and I ended up with a limited collection of pieces that reflect facets of my personal style that I think (hope, pray, hold-my-breath-and-wait-for-the-comments-on-Insta) that you'll love."

Just as Meghan seemed to hit her professional stride, her personal life took a dramatic turn. A mutual friend set her up with Prince Harry in July 2016 and the two reportedly hit it off on a pair of dates in London. Within a few weeks, Harry whisked her away to Botswana for some alone time. "We camped out with each other under the stars," Harry shared in their engagement interview, saying it was "crucial to me to make sure we had a chance to get to know each other." They dated for months in private, flying back and

Arriving for an appearance on the *Today* morning show in 2016.

forth between London and Toronto, where Meghan was filming *Suits*. They never went more than two weeks without seeing one another. "We knew we had to invest in the time and the energy and whatever it took to make that happen," she added.

HARRY PROPOSED WHILE MEGHAN WAS roasting a chicken, giving the meme-y lore of the engagement chicken a place in the history books. Before he could finish, she interrupted with "Can I say yes now?" It was a quiet, intimate moment, but by that point their relationship was anything but. A few months earlier Meghan had made her public debut as a royal girlfriend in the grandest of fashions—on the cover of *Vanity Fair* with the headline "She's Just Wild About Harry!" The mere existence of the shoot and accompanying story was, indeed, wild. It was a gorgeous, splashy, public display for what had been an exceedingly private relationship.

The resulting photo spread feels deliciously predictive. The fashion could have come from Meghan's own closet, the chicest mix of tailored pieces in neutral colors, like a white button-down shirt and a long black-and-navy coat. One look, a dramatic strapless black-and-white gown with a full skirt, seemed to wink at what she might look like as a princess. The gorgeous shoot had an intimate, revealing feel to it; her hair was down around her face, her makeup minimal. In the gown, she was seated, barefoot, and laughing. The cover shot showed no fashion whatsoever, just a close-up of Meghan's head and bare shoulders, her freckles on full display and her brown eyes staring

directly at the camera. "That whole shoot was so that we could get to know her on a more serious level," Ross of Meghan's Mirror said.

The *Vanity Fair* spread launched Meghan, and her clothing choices, into the public consciousness—and she was ready for it. She knew how to use fashion to send a message right from the start. For her first official appearance as Harry's girlfriend at the Invictus Games that fall, she set the internet afire by wearing a white button-down style by Misha Nonoo called the "Husband" shirt. After the palace announced her pregnancy, Meghan stepped out on tour in Sydney wearing a sheath by Australian designer Karen Gee called the "Blessed" dress. Also in the spirit of the People's Princess, Meghan appeared to enjoy the fashion aspect of her job, embracing the glamour of her new life. She chose a sheer-topped Ralph & Russo gown for the couple's engagement portraits. The runway dress was a fanciful departure from the off-the-rack pieces her predecessors had worn for similar moments.

The biggest surprise was also her most important dress of all: her wedding gown. Meghan bestowed that honor on Clare Waight Keller, who was at the time artistic director of Givenchy. The palace was quick to note that Waight Keller is British, as well as the first female to lead the storied French design house. It was a strong show of a woman supporting a woman, and of the global nature of Harry and Meghan's appeal. But on that day and in the time since, Brits have voiced disappointed grumblings that such a monumental fashion moment, and all the economic benefits, would be given to a Paris-based brand.

The dress itself was stunning in its simplicity. To Robin Givhan, fashion critic at the *Washington Post*, it signified the confidence of someone who didn't need a gown to make her the star of the wedding. The drama of the design, and the burden of tradition, was placed entirely in the sixteen-foot veil. Embroidered with each of the Commonwealth countries' flowers, it was held in place by Queen Mary's diamond bandeau tiara on loan from Queen Elizabeth II. "It felt very cinematic," Givhan said. "And I have to assume that someone who has spent their life in front of the camera is very aware of how things play on screen."

Meghan's second dress, a jaw-dropper, was by Stella McCartney, a quintessential name in British fashion and pop culture (whose mother, not for nothing, was American). Made of bright white silk, it had a halter top, although the palace described it as "high neck," which I find to be a delightfully proper alternative. As Meghan and Harry left for their evening reception, in a 1968 blue Jaguar convertible that had been converted to electric power, Meghan lifted her right hand to wave. The cameras caught a glimpse of a sizable aquamarine cocktail ring, which had belonged to Diana. *Cue the tears!*

As Meghan tells it, she was exceedingly happy and her friends were happy for her. But early on one British mate issued a stark warning about getting involved with Prince

Harry: "I'm sure he's great but you shouldn't do it, the British tabloids will destroy your life." If dating a prince was a fairy tale, these were the villains, attacking Meghan online and in the media from the outset.

Harry and the palace did their best to stop the abuse from the start, confirming their relationship with an unprecedented statement condemning the harassment. "Some of this has been very public—the smear on the front page of a national newspaper; the racial undertones of comment pieces; and the outright sexism and racism of social media trolls and web article comments," it read. "Prince Harry is worried about Ms. Markle's safety and is deeply disappointed that he has not been able to protect her." It was a fierce defense, done with the palace's support and released on official palace letterhead.

But it did not quell the attacks. In February 2017, the *Sun* issued an apology for a story titled "Harry's Girl on Pornhub," falsely reporting clips from *Suits* had been posted on a pornography website. "We would like to make clear that Miss Markle has never been involved with such content," the apology read. Later that year, the same tabloid ran a story titled: "Meet the In-laws: the VERY un-royal Markle family now set to liven up Windsor family Christmases." The charged critiques continued once Meghan became a working royal, in some truly appalling pieces. "Meghan Markle's beloved avocado linked to human rights abuse and drought, millennial shame," read a headline in the *Daily Express*. It was an absurd story, and part of an emerging, racist double standard. Two years earlier the same publication ran a story titled: "Kate's morning sickness cure? Prince William gifted with an avocado for pregnant Duchess."

The scrutiny Meghan came under while dating, engaged, and finally married to Harry was unsparing. Her admirably ambitious calendar of engagements and charity work was characterized as overreaching; her appearance, including her clothing, subject to coded, racist critiques. Meghan joined the family as a self-made millionaire, familiar with the fashion world and the spotlight. But she wasn't part of the centuries-old British aristocracy, with its myriad rules and funding from the skeptical tax-paying masses. In October 2019, seventy female British politicians issued an open letter to the duchess, condemning the tabloids. "We are calling out what can only be described as outdated, colonial undertones to some of these stories. As women Members of Parliament from all backgrounds, we stand with you in saying it cannot be allowed to go unchallenged," it read. "Although we find ourselves being women in public life in a very different way to you, we share an understanding of the abuse and intimidation which is now so often used as a means of disparaging women in the public office from getting on with very important work. . . . You have our assurances that we stand with you in solidarity on this."

Meghan addressed her critics early, in her engagement interview with Harry. "There was a misconception that because I have worked in the entertainment industry that this

would be something I would be familiar with," she said. As an actress, Meghan had been a regular on *Suits* for years and working for much longer. But that's very different from life as the girlfriend of one of the world's most eligible bachelors. "I've never been in pop culture to that degree and lived a relatively quiet life even though I focused so much on my job." She talked about the "mistruths"—an exceedingly kind way to characterize the awfulness, to be quite honest—and how she decided to stop reading reports about the two of them. "Instead we focused all of our energies just on nurturing our relationship," she said.

The twenty or so minutes Harry and Meghan spoke during their engagement interview was filled with so much joy, so much hope. Beyond seeing two people in love—and *ohmygosh* were these two lovebirds in love—it was what their love signaled. The royal family is a family, after all; Harry and Meghan's union was a new day for the institution. "Meghan Markle can't personally change negative attitudes about race," wrote journalist Tariro Mzezewa in *Vanity Fair* just before the couple's May 2018 wedding. "Britain's cruel and persistent history with people of color around the globe is far from over. But her presence in the royal family is an invitation to have a new conversation."

Meghan's biracial identity is a powerful point of connection for people worldwide—especially Black women. "We see and appreciate her Blackness instantly," said Ericka N. Goodman-Hughey, a style writer and former senior fashion editor at *Ebony* magazine. Meghan's solo walk down the aisle on her wedding day was particularly moving, with a ray of sunlight encircling the soon-to-be duchess like a halo. "She had this angelic look about her," Goodman-Hughey told me. "It felt like the changing of the guard. Meghan was moving this family forward in a way that they had never expected."

As we can glean from Meghan's writing and public remarks, it is a source of both pride and strength for the duchess, too. "Being biracial paints a blurred line that is equal parts staggering and illuminating," she wrote in a 2015 essay for *Elle* magazine. The piece offers painful glimpses into the racism Meghan has faced her entire life. In Hollywood, Meghan was deemed "ethnically ambiguous" and struggled to book jobs. "I wasn't black enough for the black roles and I wasn't white enough for the white ones," she wrote. *Suits* changed that, for Meghan and for all of its viewers. " 'Dream girl' in Hollywood terms had always been that quintessential blonde-haired, blue-eyed beauty," she wrote. "The *Suits* producers helped shift the way pop culture defines beauty. The choices made in these rooms trickle into how viewers see the world, whether they're aware of it or not."

Consider then the enormity of Meghan joining the royal family on the balcony of Buckingham Palace or in the back of a horse-drawn carriage. "Any time you see someone who looks like you in a position of power, especially if you are from an underrepresented group, it means a lot," said Britt Stephens, a writer and a longtime royal follower. On tour in

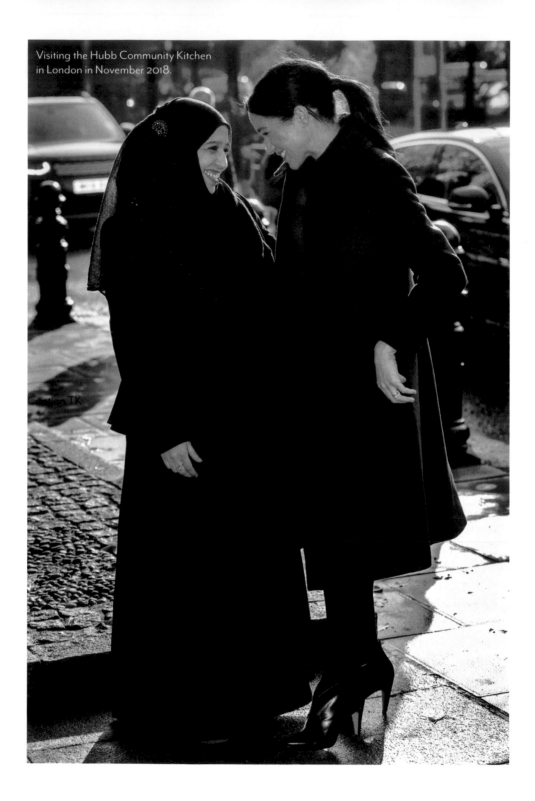

Visiting the Hubb Community Kitchen
in London in November 2018.

Southern Africa in the fall of 2019, Meghan stood before a crowd of mostly Black women in Cape Town. "May I just say that while I am here with my husband as a member of the royal family," she said, "I want you to know that for me, I am here with you as a mother, as a wife, as a woman, as a woman of color, and as your sister." The crowd erupted into cheers.

———

BEFORE SHE MET HARRY, MEGHAN WAS A HUMANITARIAN AND GENDER-EQUALITY activist, traveling to India to destigmatize menstrual health as a global ambassador for World Vision, and speaking at the One Young World Summit as a counselor for the organization that supports young leaders. The royal platform, and its dedication to charity work, was a natural continuation of her work—and she dove right in. Meghan became a patron of four charities and vice president of the Queen's Commonwealth Trust. Some of the projects I admired most benefited local British organizations while giving her fans around the world a chance to participate, too. Her embrace of the Muslim women at the Hubb Community Kitchen, started in the wake of the 2017 Grenfell Tower fire, led to *Together: Our Community Cookbook*, a *New York Times* bestseller. She became patron of Smart Works, which helps outfit women in the U.K. for job interviews, and pulled together four brands to launch a capsule collection of wardrobe staples. For every piece a shopper bought from the collection, one was donated to Smart Works; within just eight days, the effort supplied the charity with a year's worth of clothes. Meghan also guest-edited the September 2019 issue of *British Vogue*, the fastest-selling in its history. "This issue is about the power of the collective," Meghan wrote in her editor's letter. "You will find that spirit of inclusivity on the cover: diverse portraiture of women of varying age, colour, creed, nationality and life experience, and of unquestionable inspiration."

What's more, she did a lot of this while pregnant, and as a brand-new mom, after giving birth to Archie Harrison Mountbatten Windsor in May of that year.

Throughout it all, Meghan had the entire fashion world—quite literally every brand on the planet—at her disposal. Her fashion choices show what a tantalizing, overwhelming, and empowering opportunity that would be. Meghan is said to style herself although she is close friends with Jessica Mulroney, the Toronto-based stylist and television personality, as well as the daughter-in-law of the former Canadian prime minister (and perhaps the reason behind so many Canadian brands in Meghan's rotation).

Aside from some early work with Givenchy, Meghan eschewed the Queen's strategy of relying on a few trusted brands. She spread the designer love and economic benefit around, wearing big names and small. Her fans delighted in the range, thrilled at the fanciest of full-princess moments. Meghan's critics, however, demanded frugality.

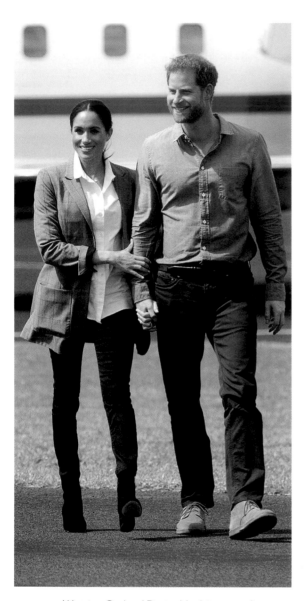

Wearing Outland Denim black jeans and a blazer by Serena Williams on tour in Australia in 2018.

After accusations of leading a lavish lifestyle peaked in the summer of 2019, with an appearance at designer friend Misha Nonoo's wedding in an expensive Valentino gown, Meghan crafted a brilliant response for the couple's ten-day tour of Southern Africa that fall. Her wardrobe was overwhelmingly affordable and casual. She opted for dresses from small or mass-market brands; four of the eleven outfits she wore for public appearances were repeats. The strategy worked. Coverage of the tour was almost universally positive, focused on the causes championed by both the couple and the locals they visited.

The relatable royal also allowed for a deeper connection with fans. A beautiful Givenchy gown is fun to look at, but a chicly styled J.Crew denim dress will send people on a shopping frenzy. That economic power is familiar—remember the "Kate Effect"? But Meghan's bent toward a more minimal style suggested something different, and deeper, to me. Take the black jeans by Australian brand Outland Denim she wore while touring that country in the fall of 2018. A strong show of sartorial diplomacy, yes, but with an underlying female empowerment message, too. The brand employs young women who were victims of exploitation or trafficking and was able to hire as many as thirty more women in its Cambodian production facility because of the increased sales brought on by the duchess. If someone wanted simply to *dress* like Meghan, they could wear any pair of black jeans. But royal fans wanted *those* black jeans from that Australian brand. They wanted a piece of what the duchess supports.

JUST TWENTY MONTHS AFTER THEIR WEDDING, THEIR UNION SIGNALING A NEW
dawn for the House of Windsor, the Sussexes wanted out. In January 2020, the couple
issued a statement declaring their intentions for a new "progressive role" within the mon-
archy. Their hope was for a half-in, half-out approach, continuing to work on behalf of the
Queen while living abroad and making their own money. Although the release came as a
shock to both the public and the palace, internal discussions had been going on for months.

The Sussexes gave the world a glimpse of their pain during the fall 2019 tour of South-
ern Africa. An ITV documentary highlighting the charity work they were doing con-
tained brief but gut-wrenching comments on how tortured they both were emotionally.
Harry confirmed the long-rumored rift with his brother and spoke of how haunted he re-
mains by what he sees as the press's involvement in his mother's death. "Every single time
I hear a click, every single time I see a flash, it takes me straight back," he told presenter
Tom Bradby, who has known Harry for years. "In that respect it's the worst reminder of
her life."

Meghan spoke about how she had tried to adopt the British stiff upper lip sensibility. "I
think that what that does internally is probably really damaging," she said. Her eyes welled
with tears at one point when Bradby asked how she was doing. The most quoted bit, in hind-
sight, predicted the eventual split. "It's not enough to just survive something, right? Like,
that's not the point of life," she said. "You've got to thrive, you've got to feel happy."

Happiness for the couple, it became clear, meant a different path than the one they were
on. They took a six-week break at the end of 2019, retreating from public view to Canada
to spend the winter holidays with Archie, and drew up plans for a split. The Queen issued
a pair of emotional statements showing her support for the couple, but ultimately denied
their request to be part-time working royals. The Sussexes were able to move to North
America and gain financial independence; they retained, but would no longer use, their
HRH styling.

The world was stunned by the news; their supporters were not. Defenders of the couple
were quick to name the abuse the Sussexes had suffered: racism. "Britain is so committed
to her racism that she isn't willing to give it up even if it means losing their princely darling
Harry," Kelechi Okafor, a British actor and podcast host wrote in a January 2020 piece for
Essence. Their departure might have offended some royal stalwarts, but to others it was the
ultimate empowering move. "The fact that you've shown your autonomy by choosing to
distance yourself from the vitriol makes the dissenting British public and the media furious
because, like Diana, they thought you would stick it out for the sake of your family and
their 'good' name," Okafor continued. "We all know what happened to Diana and Black
British women are glad you chose your happiness over their bloodlust."

Before beginning their new life, Harry and Meghan returned to London in March 2020 for a farewell tour. Their triumphant trifecta of appearances showed the world what it would soon miss without this couple in the regular royal fold. Meghan's fashion was her best yet, a sartorial master class in how to dress to be seen. Meghan stood out in every crowd with her trio of tailored dresses by British-dwelling designers in vibrant shades of blue, red, and green. Some of the most iconic photographs of the couple to date, and specifically of Meghan, came from this whirlwind good-bye, projecting poise and confidence as she closed this chapter.

So much remains to be seen. The global coronavirus pandemic sped up the couple's relocation plan; they moved to Southern California as stay-at-home orders were put into place. And it slowed down their own charitable work, requiring them to pause the launch of their new organization.

Meghan and Harry appeared sparingly throughout the spring and into summer, in pixelated video calls with charities and a few paparazzi shots. Fashion didn't have the same effect, nor did it seem to be a focus for Meghan. She was seen in mostly simple, solid tops on official engagements, bringing to mind the dramatic wardrobe shift near the end of Diana's life. The duchess's outfits were covered and credited, but press coverage largely shifted to what she had to say. Her words were what resonated, as she spoke out on Black Lives Matter and gender equality. "Don't be afraid to do what you know is right even when it's not popular—even when it's never been done before," she said in her remarks at the virtual Girl Up leadership summit. "Even if it scares you a little."

Meghan's appearances were not enough to determine what her public style will look like in this next phase, whether she will return to the California cool of her pre-royal days, or if she will carry on with the Firm's sartorial habits.

One thing is certain: Meghan's mark on royal fashion is indelible. ◆

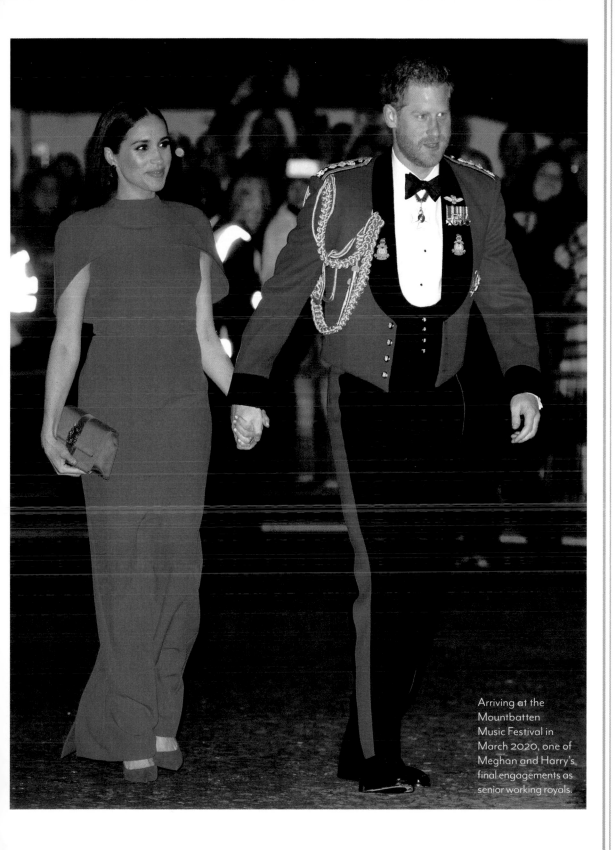

Arriving at the Mountbatten Music Festival in March 2020, one of Meghan and Harry's final engagements as senior working royals.

SO MANY THOUGHTS ON
Meghan

Navigating the fashion world feels as daunting as being the new kid at school.

MEGHAN

THANKS TO A SUCCESSFUL ACTING CAREER, MEGHAN MARKLE SPENT A DECADE in the spotlight before joining the royal family. Back in 2007, she began appearing on the Los Angeles social scene. The early events Meghan attended were small, like a gifting suite for the Golden Globes. (A) But glimpses of her style could be seen in her love of black-and-white ensembles.

Meghan's profile rose when she joined the cast of *Suits* in 2011. She began making more regular public appearances, which gave her a chance to nail the classic red-carpet pose: elbow out, ankles crossed. (B) The lace navy Diane von Furstenberg dress Meghan wore to a network event in 2012 was *the* dress of the moment (I had it, too!). But, by Meghan's own reflection, it was missing a bit of sophistication. "It was too tight, and too short, and my hair was too polished," Meghan later said. "Everything about it was trying too hard." (Which, same.)

As a television series regular, Meghan began receiving invites to New York Fashion Week. It's a highlight on the American fashion calendar and Meghan, clad in designer clothing, took her place in the front row. "NYFW. Even the acronym somehow felt intimidating to me," she wrote on her blog. "The premise of being surrounded by pin thin models, tastemakers who wear socks with open toed shoes, and designers—the fortunate few whose work would be paraded down runways—who likely said words like 'fierce' just because." But after a few seasons, Meghan hit her stride: "I was relaxed," she shared with her readers in the fall of 2014. *"I actually enjoyed myself."*

And she picked up some fashion tips! At the Herve Leger show earlier that year, she draped her studded moto jacket over her shoulders. (C) It's something runway stylists do, in part to show off more of the outfit underneath. It's less about function and more about fashion, giving the ensemble a cape-like effect.

Standing on the runway before the 2014 Herve Leger show with her *Suits* co-star Sarah Rafferty.

WORKING WITH A COSTUME DESIGNER ON *SUITS* GAVE MEGHAN A YEARS-LONG lesson in high fashion, which upped her off-set style, too. She developed her own visual brand, repeating looks that, ahem, *suited* her. Among my favorites are the two uber-chic short suits Meghan wore in 2016 on *Today*, where she appeared as a fashion expert. (A, B) Her sartorial influence earned her invitations to some exclusive fashion industry celebrations, too, with designers like Misha Nonoo. (D)

Among her most famous pre-royal moments was a speech at a 2015 UN Women's event. (C) In her remarks, Meghan recounted how a soap commercial upset her as a child because it implied that only women did dishes. Eleven-year-old Meghan wrote a series of letters expressing her frustration to then–First Lady Hillary Clinton, as well as the manufacturer, which ended up changing the tagline. "Women need a seat at the table," Meghan told the crowd. "They need an invitation to be seated there, and in some cases, where this is not available, well then, you know what, they need to create their own table." The custom Preen by Thornton Bregazzi dress she wore for the speech featured an off-the-shoulder neckline, beautifully framing her face to make it the visual focal point on stage.

A statement V neckline became a signature style for Meghan's evening looks.

Marking the first of many Sussex-inspired shopping sprees. The Everlane tote Meghan carried that day sold out.

We're a couple. We're in love.

—MEGHAN

Chatting with Violet von Westenholz in the Ralph Lauren VIP area of Wimbledon in the summer of 2016. Note the Ralph Lauren logo on Meghan's bag.

IN WHAT MIGHT BE THE MOST EPIC blind date of all time, Meghan was set up with Prince Harry by a mutual friend in the summer of 2016. And fashion played a part! Although the couple declined to name their matchmaker, one rumored contender is designer Misha Nonoo. Another is Violet von Westenholz, a friend of Harry's family who met Meghan while working in public relations for Ralph Lauren. (B) The timing of Meghan and Harry's first date lines up with an appearance Meghan made that summer at Wimbledon as a guest of the American luxury brand.

"It was hugely refreshing to be able to get to know someone who isn't necessarily within your circle, doesn't know much about me, I didn't know much about her, so to be able to start almost fresh," Harry said in their engagement interview. After confirming their relationship later that fall, the pair kept their romance private, not making any official appearances together (although they were spotted by the paparazzi a few times). That all changed in the fall of 2017, with Meghan making a splashy debut as Harry's girlfriend on the cover of *Vanity Fair*.

A few weeks later, the very happy couple stepped out together at the Invictus Games in Toronto. Tying this major relationship moment to the sporting event for wounded veterans that Harry founded exponentially increased interest in the games. I still smile at Meghan's super casual look. From the ripped knee on her skinny jeans to the rolled cuffs of her button-down shirt, the sag of her cognac tote and the ease of her matching flats, she looked chic and comfortable, in herself and her relationship. Meghan chose pieces most women could buy, if they didn't own them already. And she subtly conveyed just how serious this relationship was. Fashion sites quickly discovered that Meghan's shirt was by her designer friend Misha Nonoo, an oversize style cleverly called the "Husband" shirt.

I know at the end of the day, she chooses me and I choose her.

HARRY

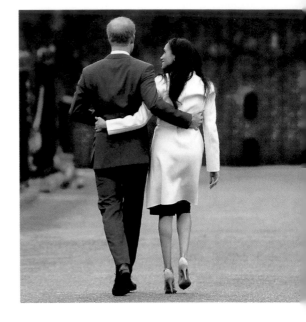

THE "HUSBAND" SHIRT TURNED OUT to be quite the prescient choice! Within two months of that first public appearance, Harry and Meghan made their way down the steps of the Sunken Garden at Kensington Palace to announce their engagement. Their hands were so intertwined that a photographer yelled: "Meghan, can you show us the ring, please?"

According to one report, Harry proposed months earlier, before the Invictus Games. The prince got down on one knee at their cottage on palace grounds; his bride-to-be said yes before he could finish asking her. Harry designed the ring himself with yellow gold as the base, "her favorite," he recounted in their engagement interview. The center diamond came from Botswana, where the two had traveled early on in their courtship. The two smaller diamonds on either side were from Diana's collection "to make sure that she's with us on this—on this crazy journey together," Harry said.

For the photo call, thirty-six-year-old Meghan wore a green dress by P.A.R.O.S.H. and nude heels by Aquazzura, both Italian labels. But it was her coat, by Line the Label, that stood out. The small brand is based in Canada, a Commonwealth country where Meghan lived for years while filming *Suits* (and dating Harry). "She's bringing a little bit of Canada with her to London," the Line's co-founder told WWD. The $750 piece sold out within minutes, crashing the brand's website. It reissued the style with a new name: the "Meghan" coat.

With her look, Meghan managed to appeal to both her preexisting fans *and* to royal watchers, an impressive hybrid of two aesthetics. The pieces—a trench coat, a shift dress, and nude heels—were familiar and plenty formal for fans of the monarchy. But they were a tad trendier, and a little less stiff. Look at the robe-esque collar of the wrap jacket, or the crisscross lacing on the shoes. The coat was a bright cream, or one might say a modern version of bridal white.

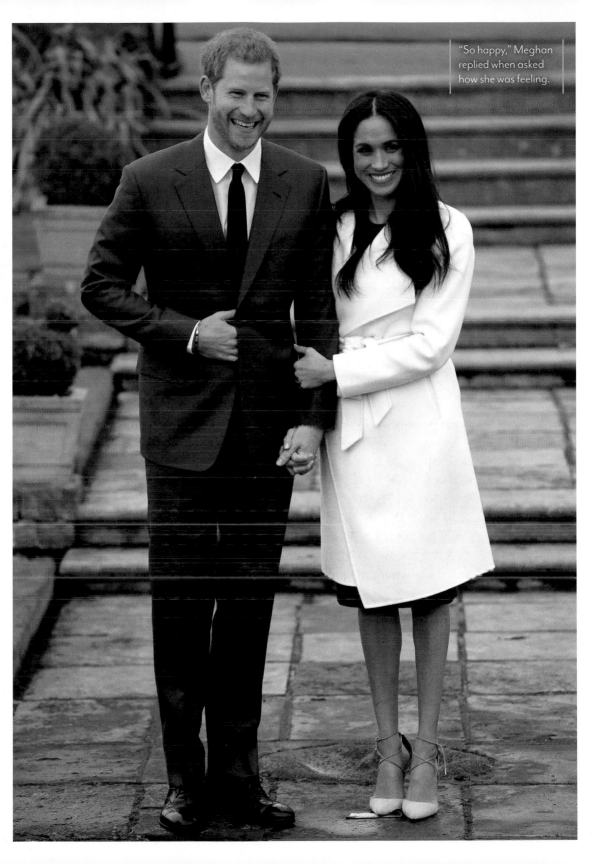

"So happy," Meghan replied when asked how she was feeling.

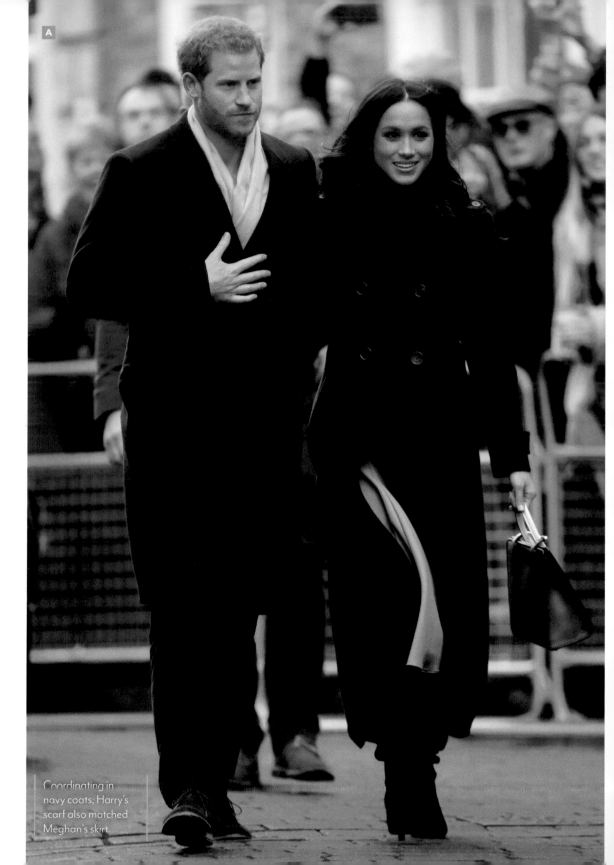

Coordinating in navy coats; Harry's scarf also matched Meghan's skirt.

ROM THE OUTSET, MEGHAN DEBUTED A working wardrobe that was a fresh take on traditional royal style. She steered clear of the expected pieces, like shift dresses and skirt suits, opting instead for menswear-inspired separates. Her coats were among her many standout pieces, and were very true to her personal style. For the couple's first official engagement in Nottingham in December 2017, she pulled out a Mackage coat from her pre-royal days. (A) Later, she wore coats by beloved British labels Stella McCartney and Burberry (B, C). Throughout the winter and early spring, Meghan favored boots, not pumps, and carried small satchels instead of clutches. The vibe telegraphed a new, enviable ease.

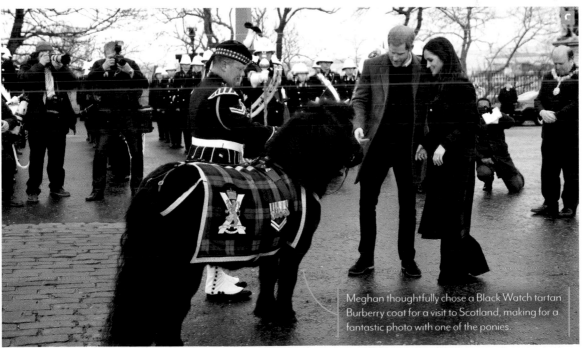

Wearing black jeans by Hiut, a Welsh brand, on a visit to Wales. The small label subsequently had a three-month wait-list for the style.

Meghan thoughtfully chose a Black Watch tartan Burberry coat for a visit to Scotland, making for a fantastic photo with one of the ponies.

ANTICIPATION WAS HIGH FOR MEGHAN'S first evening engagement—because, let's be honest, those are some of the most fashion fun. Journalists and royal fans wondered aloud what kind of cocktail dress the future duchess would choose.

She surprised everyone with a stunning black suit by Alexander McQueen, the British design house favored by Kate. (A) Meghan paired the chic slim cropped pants with a coordinating tailored-to-perfection blazer. In keeping with her elevated-but-relaxed aesthetic, Meghan tied the bow of her white silk bodysuit blouse loosely under her clavicle, rather than firmly at the neck. It was a look you would expect to see in a boardroom, not a ballroom, and sent "a very strong message that she was here to work," said Victoria Murphy, a longtime royal journalist. More broadly, Meghan's choice made it clear that "just because she was a woman, it didn't mean she should be turning up in a dress and that's what we should be talking about," Murphy added.

The celebrated look became a signature style of Meghan's. She wore a black Givenchy suit with a cropped jacket and simple white T-shirt on tour in Ireland a few months later. (B) That fall, she opted for a black suit by Altuzarra with a silk black camisole for the WellChild awards. (C) Fashion magazines were quick to note how reminiscent Meghan's choices were of the menswear styles Diana wore so well.

A

Repeating a cream Victoria Beckham sweater from her engagement portraits.

B

I N THE SPRING OF 2018, MEGHAN'S looks had an editorial-like quality to them, pieces styled as you might find in a magazine spread. She let her coats hang open, or wore them draped over her arms. (A, B) The cape-like effect gave way to cape dresses, which became a hallmark of Meghan's royal look. I loved this on her, such a regal touch to make a dress exciting, like the navy Stella McCartney style she wore to the Queen's birthday concert. (C) Meghan's bags were a welcome pop, sartorial eye candy if you will. To the thrill of American fashion fans, she embraced U.S. designers, too. "When somebody like Meghan wears something of mine, the brand is instantly exposed to every corner of the globe and all eyes are on her. It's really incredible," designer Jason Wu said after Meghan wore his blue satin wrap dress. (D)

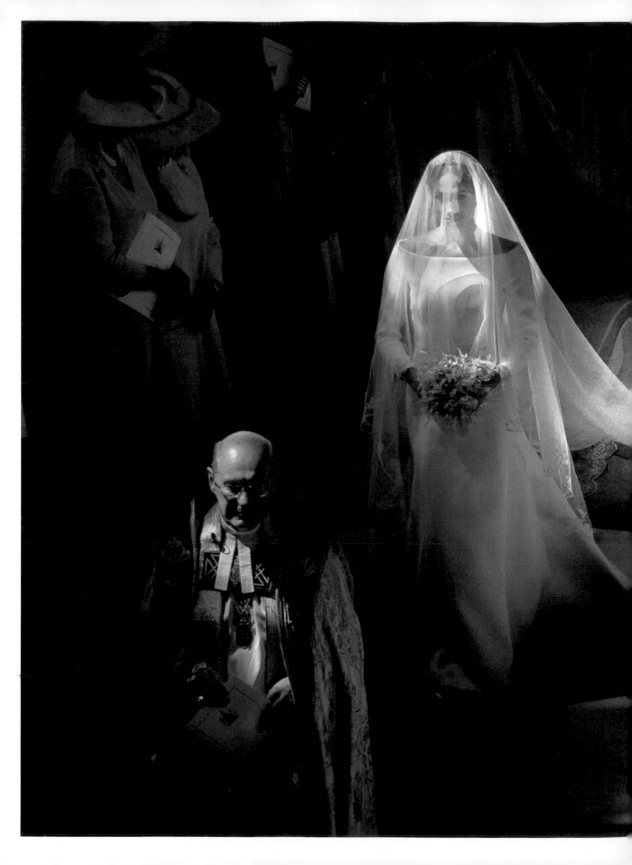

There's power in love. Don't underestimate it.
Don't even over sentimentalize it. There's power, power in love.

BISHOP MICHAEL CURRY

HARRY AND MEGHAN'S WEDDING ON MAY 19, 2018, WAS A GLOBAL CELEBRATION of a modern and adored couple. They were the fresh, diversifying force in a centuries-old institution, a unique combination embodied by the bride's stunning look. Unlike Diana's dress, which nearly swallowed her whole, Meghan's gown was striking in its simplicity. The silk cady gown had just six seams; its distinguishing design element was a simple, graceful bateau neckline that gorgeously framed her face. The drama, and the symbolism, was hand-embroidered into Meghan's sixteen-foot veil. It featured flowers from more than fifty Commonwealth nations (reminiscent of the Queen's coronation gown), plus two special, personal additions: winter sweet, which grew near Meghan and Harry's cottage on the grounds of Kensington Palace, and the California poppy, the flower of the bride's home state.

Both the veil and the dress were designed by Clare Waight Keller of Givenchy, the first British woman to lead the famed French fashion house. The surprise selection of Waight Keller signaled a wedding that was "about more than just the U.K., it was an international affair," said Robin Givhan, fashion critic at the *Washington Post*. Givenchy is known for its pared-down, woman-first style (think: Audrey Hepburn). Givhan added: "To me, that was Meghan's version of her princess idea."

"We have a deep connection to what we wear," Meghan said many months later when announcing Waight Keller as a winner at the British Fashion Awards. "For me, this connection is rooted in really being able to understand that it's about supporting and empowering each other, especially as women."

On her wedding day, after her father's illness prevented him from traveling to the United Kingdom, Meghan walked herself halfway down the aisle. She took Prince Charles's arm for the final stretch and met her misty-eyed groom at the altar. The ceremony represented the modern couple, and celebrated Meghan's African-American heritage. Michael Curry, the first African American to serve as presiding bishop of the Episcopal Church, delivered a stirring address inspired by the words of the late Martin Luther King, Jr., on the "redemptive power of love." Nineteen-year-old cellist Sheku Kanneh-Mason, the first Black musician to win the BBC Young Musician award, performed three songs. The Kingdom Choir, a British gospel choir, sang an emotional rendition of "Stand by Me." As the newlyweds exited the chapel to their awaiting horse-drawn carriage, the choir provided the joyful soundtrack: Etta James's version of "Amen / This Little Light of Mine."

The bridal bouquet featured forget-me-nots, a favorite of Diana's, as well as sweet peas, lily of the valley, and jasmine. Prince Harry helped pick some of the flowers himself from the garden near their Kensington Palace home.

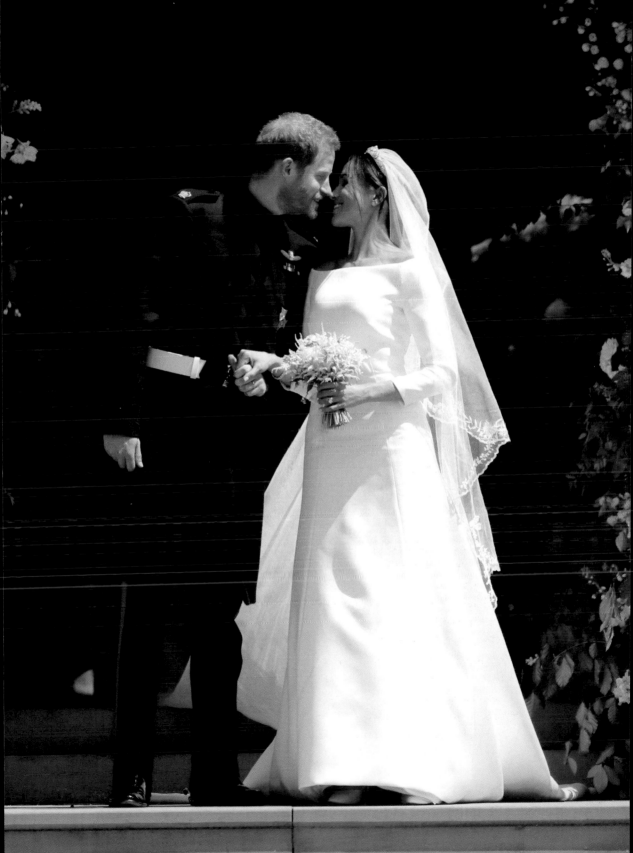

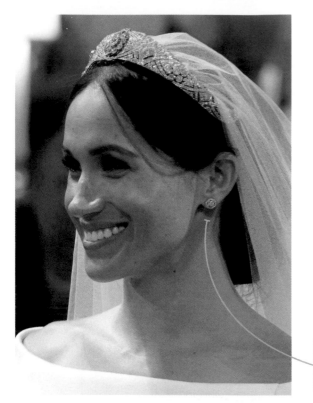

Meghan sparkled in Queen Mary's Bandeau tiara, on loan from Queen Elizabeth II. The bride's hair was swept up in one of her signature chignons. "We wanted something that was effortless and really timeless—as long as it didn't look contrived," hairstylist Serge Normant said. Her makeup, by close friend Daniel Martin, had a similarly light touch to it. "She wanted to look like her best self," he said. After the ceremony, the couple took a horse-drawn carriage ride through the streets of Windsor, filled with tens of thousands of fans.

A royal repeat! Meghan wore these Cartier diamond earrings on an official engagement the month before her wedding.

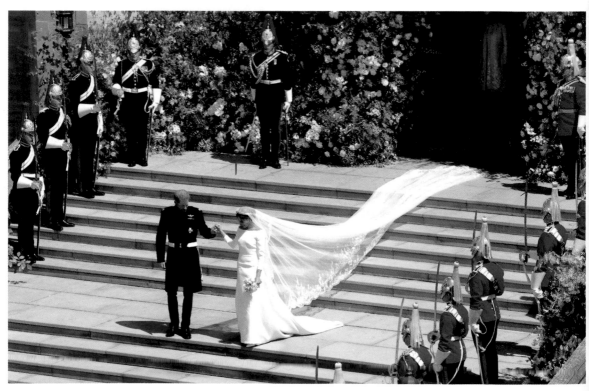

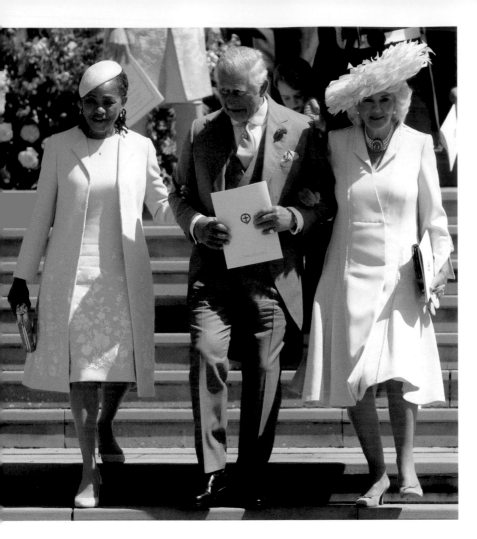

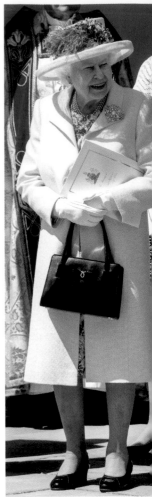

After the ceremony, Prince Charles escorted his wife, Camilla, and Meghan's mother down the steps of the chapel. Doria Ragland wore a pastel lime green coat and dress by the creative directors of Oscar de la Renta, with floral detailing reminiscent of Meghan's veil. Queen Elizabeth stuck to her stand-out sartorial strategy in a vibrant neon green coat by Stewart Parvin, her British dressmaker. That both the mother of the bride and the Queen wore the same hue felt like a powerful message of family unity.

Fashion fans, myself included, swooned hard when Harry and Meghan emerged later that day for their evening reception. The bride's second dress, by Stella McCartney, with a halter top and swishy skirt, upped the va-va-voom factor. Harry swapped his Blues and Royals military uniform for a James Bond—worthy black velvet tuxedo.

Waving as the pair sped off, offering a glimpse of Diana's beloved aquamarine statement ring.

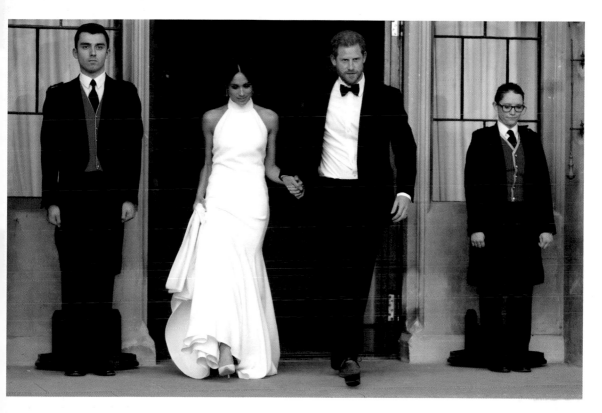

AS THE NEW DUCHESS OF SUSSEX, MEGHAN underwent a noticeable makeover, choosing clothing and accessories that veered much more closely to a "traditional" royal look. When appearing with the Queen, she wore stockings and black shoes, and carried a black handbag, just like Her Majesty.

What was most striking in these early months was Meghan's consistency of color, favoring romantic pink tones, pale blush shades, and beigey creams. Commentators suggested the low-key hue was designed to avoid upstaging or outshining anyone. I think it also revealed how Meghan was feeling; on *Suits*, it was a color her character, Rachel, wore when she was in love.

The duchess also opted for garments with similar style details, making for a visually appealing progression. Style sites breathlessly chronicled each and every outfit; the consistency of her pieces made for the most beautiful online slideshows and montages. Meghan gravitated toward dresses and skirts that fell just past the knee, as well as wider necklines and strong shoulders. Look at how the buttons of her Carolina Herrera suit for Trooping the Colour (B) mirrored those of her Prada ensemble a few weeks later. (A)

Was the Queen employing her own color strategy here? She wore lime green twice when appearing with Meghan in June, as she had to Harry and Meghan's wedding the month before.

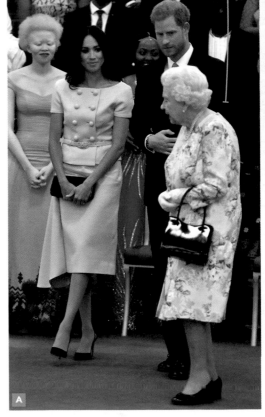

A

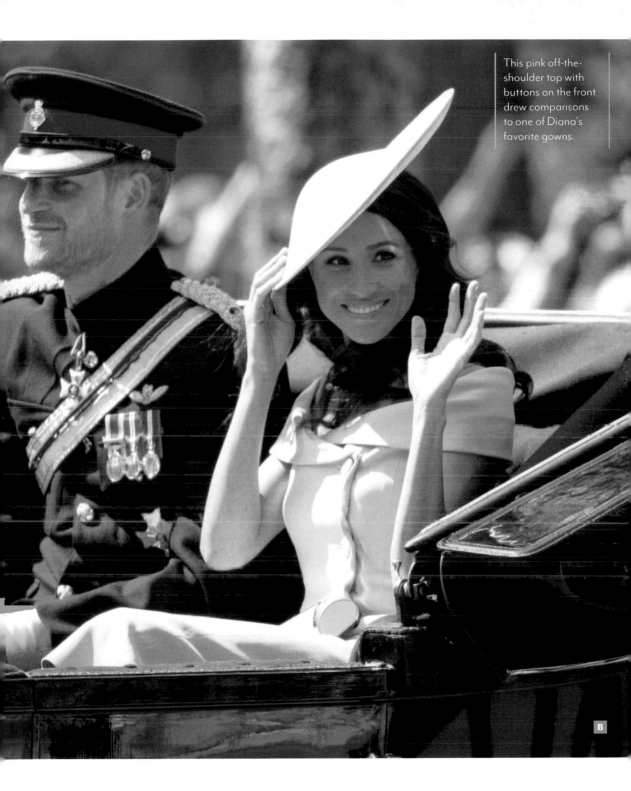

This pink off-the-shoulder top with buttons on the front drew comparisons to one of Diana's favorite gowns.

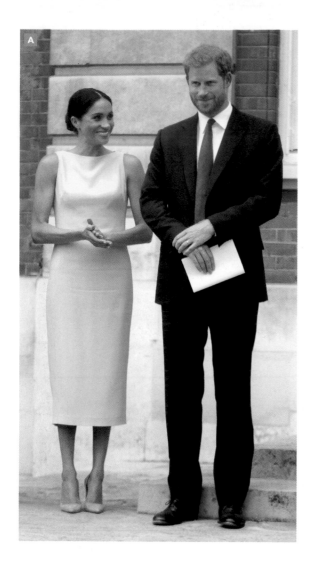

MEGHAN BROKE HER OWN POST-WEDDING STREAK OF BLUSH AND BEIGE WITH a bright yellow sheath for the Commonwealth Youth Reception that July. (A) It was the most gorgeous pop of color, and the start of a three-look style story of bateau neckline dresses. She wore a similarly slim olive green dress for Prince Louis's christening, followed by a navy full-skirted dress to mark the 100th anniversary of the Royal Air Force in London. (B, C) Note the progression in these looks: the yellow dress opens the story, then the olive adds sleeves, a belt, and a hat. The navy ensemble keeps the belt, slims the hat, and lengthens the sleeves, adding a fuller skirt.

A FEW MONTHS INTO LIFE AS THE DUCHESS OF SUSSEX, MEGHAN'S SARTORIAL pendulum found a happy middle ground. She infused more fashion into her appearances, like the trendy voluminous trousers she wore to Wimbledon. (A) The look was by Ralph Lauren, the designer American brand that hosted the duchess two years prior when she is thought to have met Harry. The hat she carried looked like the same one, too. How cute is that!

In the fall of 2018, for the duke and duchess's first visit to their namesake county of Sussex, Meghan wore what I consider to be her quintessential royal ensemble. (C) The monochrome emerald green look with nude heels was what one might expect from a royal. But the relaxed texture of the pieces, with the leather Hugo Boss skirt and silk blouse by & Other Stories, made it all her own.

Sealing it with a kiss. At a polo match with Harry, wearing a classic denim dress by beloved American luxury label Carolina Herrera.

FIRST COMES LOVE, THEN COMES marriage, then comes . . . rampant speculation about a pregnancy? At the wedding of Princess Eugenie to Jack Brooksbank in the fall of 2018, Meghan wore a navy Givenchy coat with only the top two buttons fastened. (A) The internet convinced itself that it was a sign—and for once, the internet was right! At the start of their first major tour, to Australia, New Zealand, Fiji, and Tonga, the couple announced they were expecting. Meghan stepped out in Sydney in a white dress by Australian designer Karen Gee. (B) The style name was fittingly called "Blessed."

Lasting sixteen days, the tour itinerary included an ambitious slate of seventy-six engagements and more than thirty ensembles, many of which paid thoughtful tribute to her host countries. Her tourdrobe, as it were, was an impressive array of choices, highlighting local talent and female-founded brands.

Meghan gave several speeches during the trip. The chance to *hear* a royal woman on tour rather than simply see her was so exciting, and helped shape the coverage. Celebrating the 125th anniversary of the women's right to vote in New Zealand, the duchess stood in front of a portrait of a young Queen Elizabeth II. (C) It was a powerful image paired with powerful words: "Women's suffrage is about feminism, but feminism is about fairness," she said.

Wearing a spiral diamond necklace by Jessica McCormack, a New Zealand jeweler based in London, designed to resemble the ancient Maori tradition of tattooing.

THE SUSSEXES' TOUR OF AUSTRALIA, New Zealand, Tonga, and Fiji gave Meghan her first chance to deliver on what I like to call the princess promise. Royal tours are a chance to razzle and dazzle, after all, and Meghan did with two stunning, fashion-forward looks in four days. Upon arrival in Fiji, Meghan attended her first state banquet in a gorgeous cape gown in sea blue—Fijian blue, to be precise—by British label Safiyaa. The minimal gown showcased her tiny bump, while the length of the cape, hanging just below the hem of the dress, added an extra regal touch.

Back in Sydney a few days later, the duchess wowed again in an Oscar de la Renta tulle bird dress at the Australian Geographic Society Awards. The black laser-cut seagulls were a clever nod to the evening's eco-theme, and the voluminous tulle skirt was straight out of a Disney dream. I remember gasping at the first sight of this, delighting in both its fanciness and its modernity rendered not as a gown but at tea length. Her signature Aquazzura bow pumps, seen often on daytime engagements, worked well here, too—the perfect punctuation on a gorgeous look.

The pace and duration of the Sussexes' first tour was intense, as were the fashion demands. Meghan wore more than thirty looks that spanned an impressive range from fancy formal to sporty casual, the latter being for events surrounding the Invictus Games. (A) The trip ended not with a glamorous airport tarmac departure but with Harry and Meghan strolling casually through the Redwoods Treewalk in Rotorua. (C) The duchess swapped her Givenchy ensemble from earlier in the day for her husband's puffer jacket. It was an intimate and cinematic ending to a hugely successful tour.

Embracing a fan in a Diana-esque moment of personal connection, in Queensland's Fraser Island. The thigh-high slit made headlines with false claims it violated royal protocol (it did not).

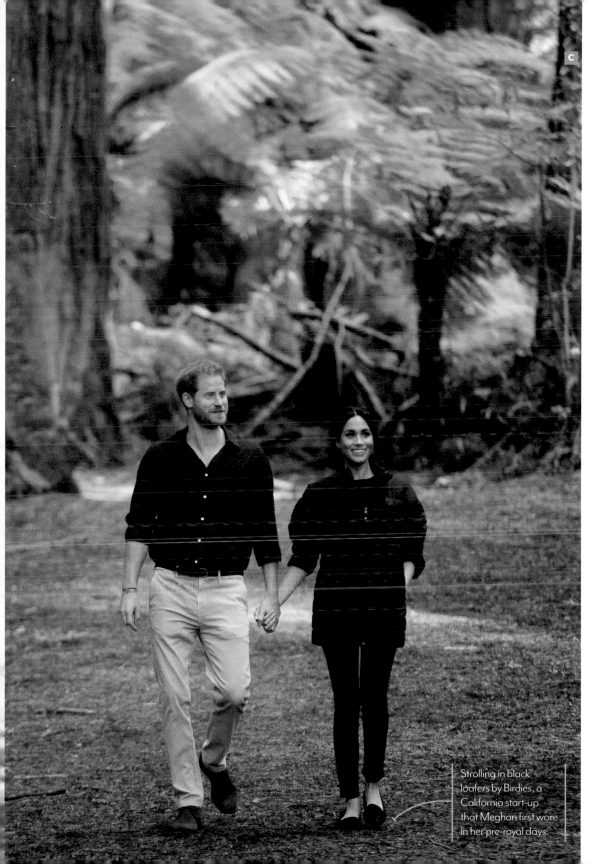

Strolling in black loafers by Birdies, a California start-up that Meghan first wore in her pre-royal days.

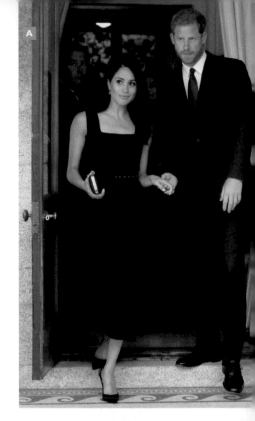

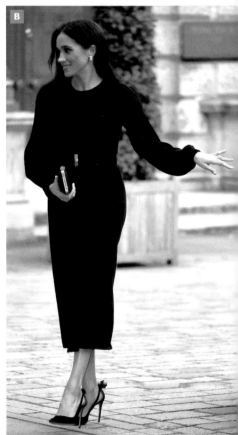

BLACK MAY BE A COLOR THE QUEEN RE-serves for mourning. But for the rest of us, it's among the chicest and most flattering hues. Meghan loved a good little black dress long before joining the royal family, and maintained her affection for the style as a duchess.

Three of my favorite black-dress moments made the news for other reasons, evidence of growing hostility in the press coverage of the duchess. On tour in Ireland in July 2018, Meghan looked gorgeous in an A-line dress by Emilia Wickstead. (A) It was the first time Meghan had worn the brand after the designer publicly criticized the fit of her wedding dress, reported by the *Daily Mail*. For her first solo engagement that September, Meghan, clad in Givenchy, closed her own car door. (B) The protocol police jumped, claiming—incorrectly—that she had violated some made-up rule.

And then there was her appearance at the British Fashion Awards in December, where she was *GLOWING* in a one-shouldered black Givenchy gown. (C) The dress became an afterthought in the headlines, which focused on her two-handed abdomen cradling pose. "Why can't Meghan Markle keep her hands off her bump?" read a headline in the *Mail on Sunday*. "Is it pride, vanity, acting—or a new age bonding technique?" The piece was filled with the kind of nasty criticism that ultimately contributed to her and Harry's departure.

Consider for a minute the point of her pose. It highlighted her gold bracelets, which had been made in Kabul, Afghanistan, by Pippa Small, through an arts foundation co-founded by Prince Charles.

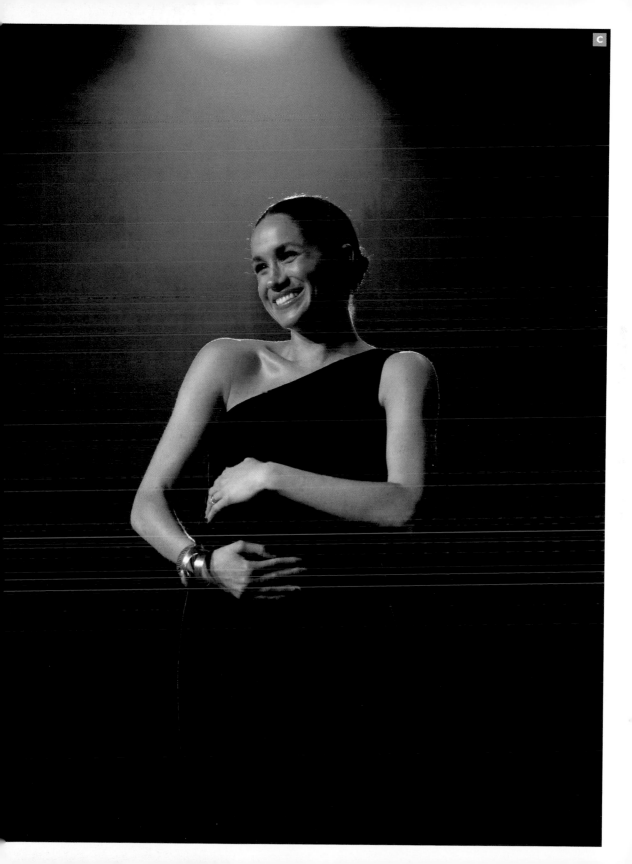

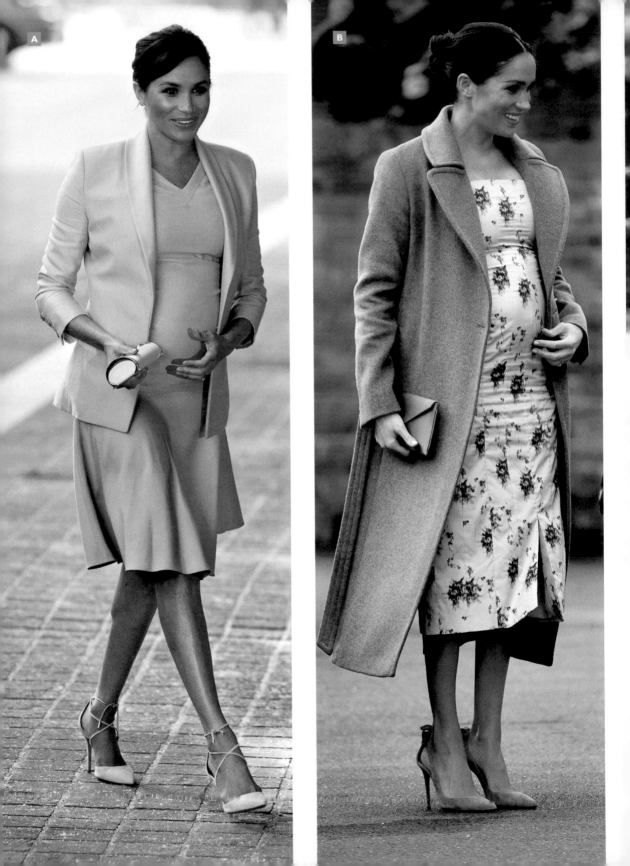

She has established a royal maternity wardrobe for the ages.

VANITY FAIR

MEGHAN STAYED TRUE TO HER personal style during her very public pregnancy, largely avoiding traditional maternity clothes and anything even remotely mumsy. The duchess adapted ready-to-wear pieces from her favorite designers or had bespoke garments made. Much more so than her royal predecessors, and very much in line with modern pregnant women today, she wore clothing that hugged her abdomen. She often layered an open blazer or coat on top, giving the ensembles a workwear feel. (A, B) And how about those stilettos!

Toward the very end of her pregnancy, Meghan favored voluminous statement swing coats, which brought delightfully nostalgic comparisons to Diana's maternity fashion. For her last day of public appearances before maternity leave, the duchess chose an emerald Erdem coat with swirl embellishments modified from one of the designer's recent runway collections. It was particularly reminiscent of a memorable style Princess Diana had worn while pregnant. (C, D)

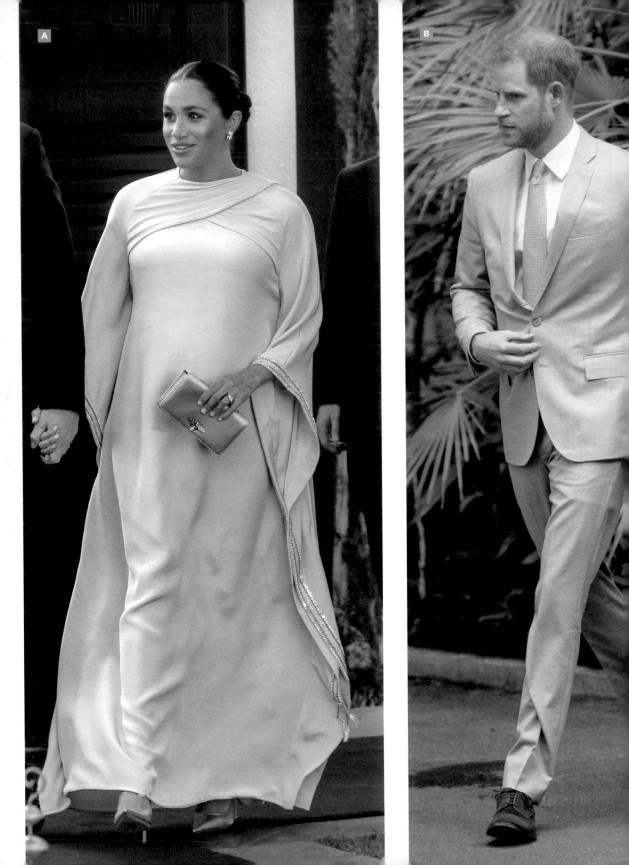

Every royal visit needs some glamour.

VOGUE

MEGHAN KEPT UP HER PACKED schedule of engagements well into the late stages of her pregnancy, including a tour of Morocco in late February when she was more than seven months along.

In forty-eight hours, she wore six different outfits, ranging from super affordable casualwear to high-end evening pieces. During the day she was dressed like an all-American girl, in a navy blazer or a Breton striped top. (C) At night, she transformed into a princess, floating into a reception in a custom Dior caftan and later a flowing Carolina Herrera gown. (A, B)

That sort of sartorial range is a part of a royal wardrobe; Diana, after all, wore both tiaras and bike shorts. "She looked amazing and there were moments of huge glamour," said Bethan Holt, fashion news and features director at the *Telegraph*. But without any ties to local designers, the expensive eveningwear in a developing country drew criticism, something Meghan would rethink on subsequent tours.

I have the best two guys in the world.

MEGHAN

ARCHIE HARRISON MOUNTBATTEN-WINDSOR ARRIVED ON MAY 6, 2019, JUST SHY of his parents' first wedding anniversary. The newest member of the family joined the ranks as seventh in line to the throne; but he was not given a title—a signal of his parents' desires for him to lead a normal life.

The Sussexes decided to keep the details of their first child's birth private. They did not release a due date or share where Meghan would be giving birth. And they announced in advance that they would not be appearing on the hospital steps as Will and Kate, or Charles and Diana, had. It prompted plenty of soul-searching about the best way to present a royal baby, and whether seeing a brand-new mom all dolled up was antifeminist. I felt all of the criticism was sorely misplaced. Free from the pressures that come with the direct line of succession, Harry and Meghan were under no obligation to follow the unofficial precedent. They could do their own thing, and they did!

Before we saw Archie, we saw Harry—and what a sight he was. The prince appeared the day his son was born to give a brief press statement, beaming with pride. "It's been the most amazing experience I could have ever imagined, how any woman does what they do is beyond comprehension," he said. "I am so incredibly proud of my wife." Two days later, the Sussexes appeared as a family of three in the stately St. George's Hall. There was just a small press crew for the brief photo call. The resulting shots are every bit as lovely, and the experience was probably much more manageable for the new parents.

Meghan had worn white for her other major royal moments: the button-up shirt for her dating debut, followed by the engagement trench, her wedding gown, and the sheath for her pregnancy announcement. To present her baby, Meghan chose a sleeveless white double-breasted trench dress by Grace Wales Bonner. The up-and-coming twenty-eight-year-old British Jamaican designer is known for her menswear—a sweet nod to Meghan's newborn son. The custom piece featured a belted waist, which showed off her relatable still-visible baby bump. Following in the footsteps of his father, Harry wore a suit (by J.Crew!) and tie for his son's public debut.

Both Meghan's turquoise necklace and diamond earrings featured three stones for her new family of three.

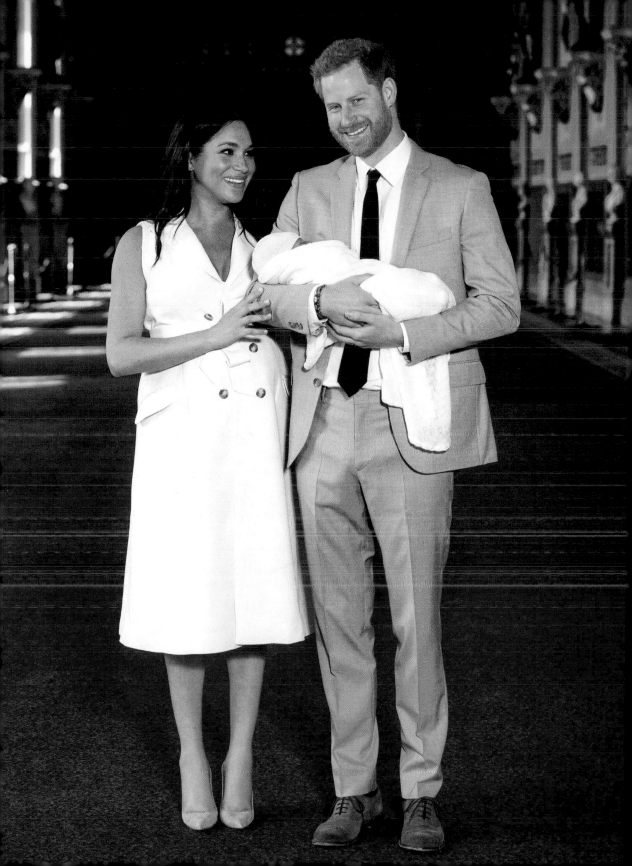

A

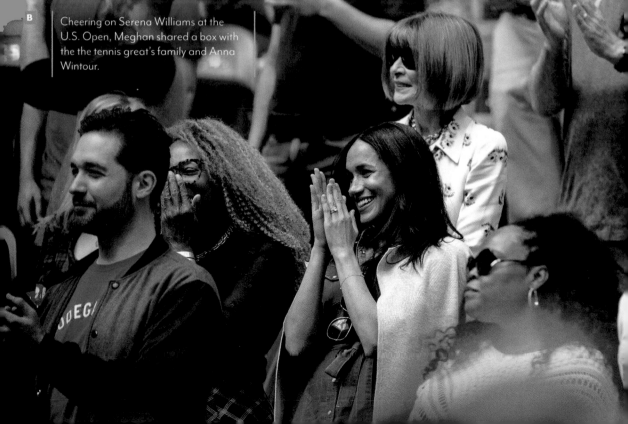

B

Cheering on Serena Williams at the U.S. Open, Meghan shared a box with the the tennis great's family and Anna Wintour.

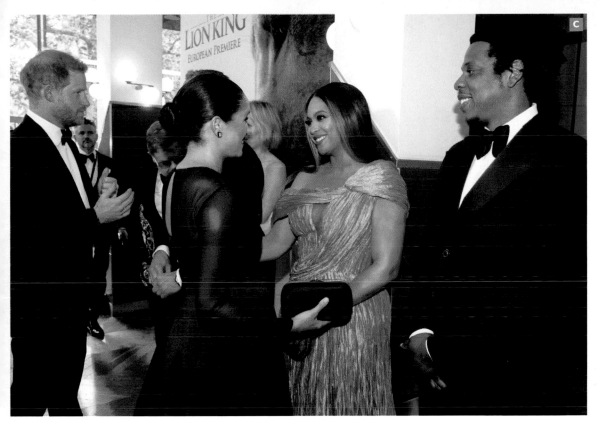

My princess!

———

BEYONCÉ

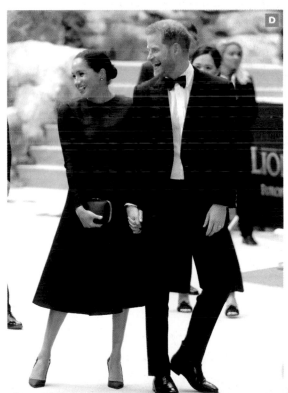

AFTER A BRIEF MATERNITY LEAVE, Meghan stepped back into the spotlight in the summer of 2019 to cheer on one friend and finally meet another. The duchess watched Serena Williams at Wimbledon in July and again at the U.S. Open come September. (A, B) She wore denim twice, a casual and low-key look of a fan who didn't want to distract with fashion. In between sporting events, the Sussexes glammed up for the London premiere of *The Lion King*. There, Meghan met—and hugged—Beyoncé for the first time. (C) The new mom was glowing in a black Jason Wu dress. (D)

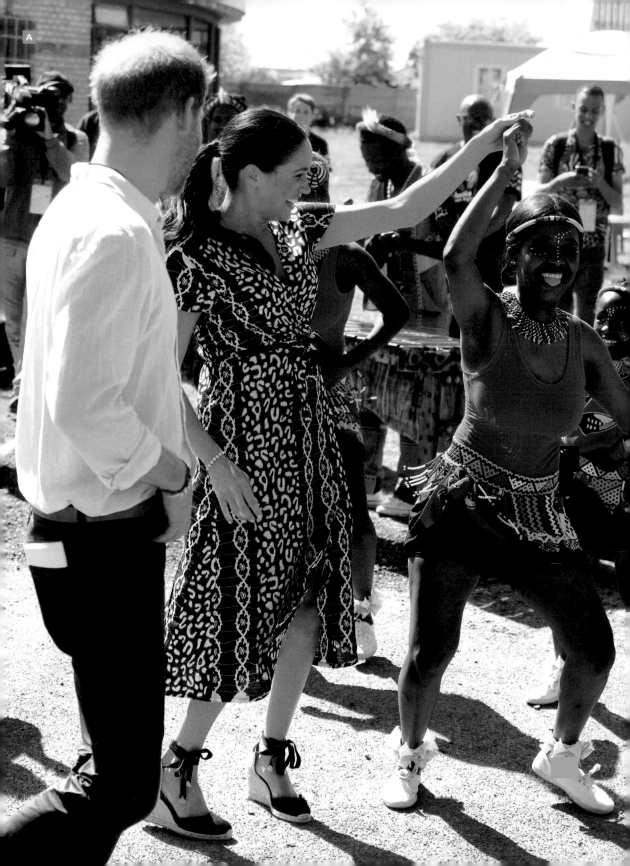

I am here with you as a wife, as a woman, as a woman of color, and as your sister.

MEGHAN

WITH BABY ARCHIE IN TOW, THE SUSSEXES TRAVELED TO SOUTHERN AFRICA in the autumn of 2019. The trip came after a summer of relentlessly critical and one-sided headlines accusing them of hypocritical, over-the-top behavior. Perhaps it was in response, or perhaps it was the plan all along, but Meghan's wardrobe was very casual, a super savvy sartorial clap back. The schedule matched this low-key vibe, filled with daytime events rather than evening receptions that would require dressier attire.

The tour began with a visit to a township. Meghan wore a pitch-perfect £69 wrap dress by Mayamiko, a sustainable British brand produced in Malawi. The black-and-white print complemented the traditional dress of the dancers, and coordinated with the T-shirts of the women who surrounded her while she gave a brief speech. "She bridged the gaps between the people who she was speaking to, herself as a member of the royal family, as a woman of color and as a fashion icon. It was an incredible moment," said Russell Myers, royal editor for the British tabloid the *Daily Mirror*.

Meghan repeated several previously seen styles on the tour, including a Veronica Beard dress (left) and Huaraches sandals by Brother Vellies. Fans also loved her Madewell jean jacket.

It's very heartwarming, let me tell you, very heartwarming
to realize that you really, genuinely are caring people

ARCHIE'S FIRST PUBLIC ENGAGEMENT WAS ONE FOR THE HISTORY BOOKS. WHILE on tour in South Africa, the three Sussexes met with Archbishop Desmond Tutu, the anti-apartheid and human rights activist. The Nobel Peace Prize laureate, a towering figure in South Africa's history, cooed over the wiggly four-month-old and kissed him on the forehead. "It's not lost on us just how huge and significant a moment that is," Meghan said afterward.

While meeting with the Archbishop, Harry gestured to Archie as he remarked on "the responsibility that we all have to try and make their lives better, however we can." Was it foreshadowing the news to come? On the second-to-last day, the duke released his second statement in three years, condemning the unfair and often viciously racist treatment of Meghan in the media. "There is a human cost to this relentless propaganda, specifically when it is knowingly false and malicious," Harry wrote. "I cannot begin to describe how painful it has been."

Unlike the first release, this statement was not issued by Buckingham Palace. It came directly from Harry, alongside the announcement that Meghan was suing the *Mail on Sunday* over publication of a private letter to her father. "There comes a point when the only thing to do is to stand up to this behaviour, because it destroys people and destroys lives," Harry wrote. It was heartbreaking to read, laying plain why the couple was taking legal action.

Their pain became even more visible after they returned home, with the airing of an ITV documentary. Most of the hour-long special focused on the humanitarian work from the tour, but the heartfelt comments on their own well-being received the most attention. The interviews with Meghan and Harry were not conducted in a formal, seated setting, with stiff chairs or flattering lighting. They were filmed on the fly, contributing to the raw, intimate feeling. Harry confirmed tensions with William and spoke of how haunting he finds the press in the wake of his mother's death. Meghan teared up when reflecting on how she had been treated. "I never thought that this would be easy, but I thought it would be fair," Meghan said.

When the interviewer asked her if she was OK, she thanked him but didn't offer up an answer. He pressed: "Would it be fair to say, not really OK? That it's really been a struggle?"

"Yes," Meghan replied.

Bloggers rushed to identify Archie's dungarees from the H&M Conscious collection and socks by Bonpoint.

| 304 | HRH

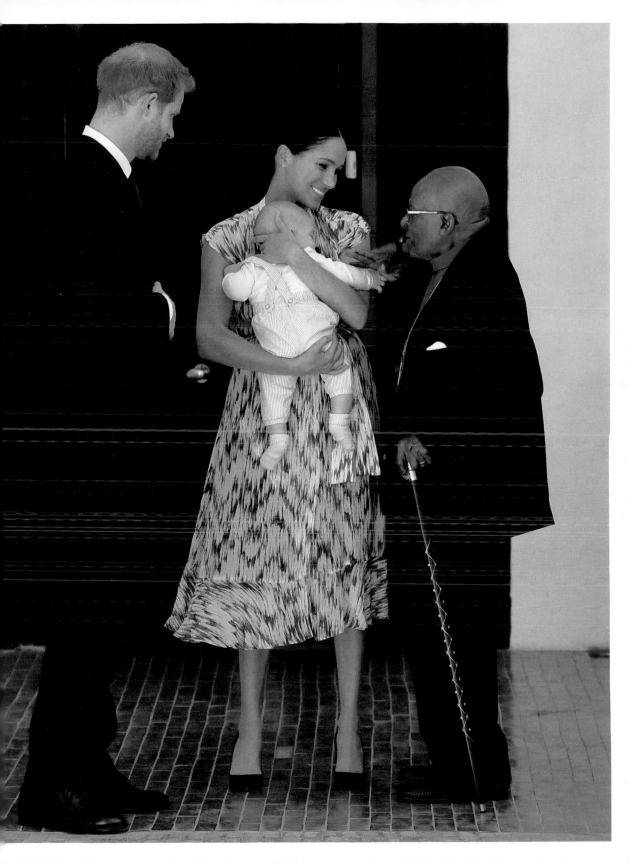

CONSISTENCY IS A HALLMARK OF ROYAL DRESSING—WE'VE WELL ESTABLISHED that by now. The Queen does it, Diana did it, Kate does it, and Meghan does it, too, with similar-looking pieces to build a visual brand. On tour in Australia in 2018, Meghan first appeared in Sydney in a white shift dress by Karen Gee and a trench from Martin Grant, both Australian-born designers. (A) Two weeks later, on the same tour, she wore a white dress by American designer Brandon Maxwell and a classic British Burberry trench. (B) What girl doesn't like to have options when traveling! Both times she scrunched up the sleeves of the coat, a trick stylists love to zhoosh up a look (in this case, make it a little less formal).

The sleeveless belted trench dress is perhaps Meghan's most-worn style, and most symbolic look. It was in her regular rotation, for smaller moments and big ones; it's as close as a dress can get to a suit, with just enough seriousness but without any of the stuffiness. She wore two on back-to-back days in the fall of 2019 while touring South Africa. First up was a style by Banana Republic. (C) Then she repeated a House of Nonie trench dress to meet Graça Machel, Nelson Mandela's widow. (D) It was a poignant re-wearing, as Meghan had first worn the dress the prior year while visiting the Nelson Mandela Centenary Exhibition in London. And it was blush, back to that color of love.


Although we would have preferred them to remain full-time working members of the Royal Family, we respect and understand their wish to live a more independent life.

THE QUEEN


A T THE START OF THE NEW DECADE, the Sussexes sought a new life. The couple had taken a six-week break to close out 2019, relocating with Archie to Canada for the winter holidays. They went largely undetected and returned to London to much fanfare in the new year. It was such fun to see Meghan again after a long absence. Her gorgeously textured outfit paired a wool turtleneck with a satin skirt and velvet pumps. The earth tones of tan and copper were reminiscent of her first appearance at Christmas in Sandringham just two years earlier.

The very next day, Harry and Meghan stunned the world by releasing a statement about their intent to pursue a "progressive

Strolling to church on Christmas in 2017.

new role" within the institution, to work on behalf of the Queen but also become financially independent. In the end, the Sussexes' desire for a half-in, half-out approach was untenable. Ten days after their initial statement, Buckingham Palace announced they would step down as senior working royals, allowing them the freedom to move abroad and make their own money. They would be known as the Duke and Duchess of Sussex and retain their HRH titles but not use them. "I want to thank them for all their dedicated work across this country, the Commonwealth and beyond, and am particularly proud of how Meghan has so quickly become one of the family," read a statement from the Queen. "It is my whole family's hope that today's agreement allows them to start building a happy and peaceful new life."

The arrangement was subject to a review in twelve months' time, giving both sides a little cushion to figure things out. The future was uncertain, opinions were strong and varied, but after seeing how much pain the couple was in, who could blame them for forging a new path?

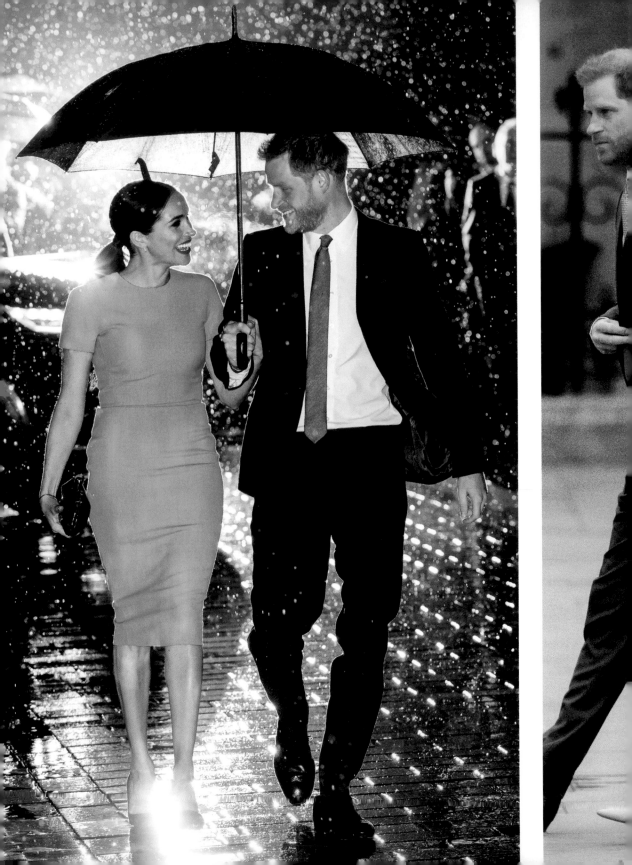

WHAT IS THE SARTORIAL EQUIVA-lent of a mic drop? When the Sussexes returned to the United Kingdom in March 2020 for a final series of engagements as senior working royals, Meghan stepped out in her best fashion yet. The couple began with a magical stroll through the rain on their way into the Endeavour Awards, the same event she had worn the black Alexander McQueen suit to two years earlier. This time Meghan chose a bright blue dress by Victoria Beckham, upping the glam with a darker eyeshadow and bold lip. Photographer Samir Hussein used the flashbulbs from the crowd behind to light his iconic shot. They were glowing, their star power evident.

To mark Commonwealth Day at Westminster Abbey, the Duchess wore an elegant emerald dress by Emilia Wickstead and a netted veil fascinator by William Chambers. The wind blew ever so slightly as the couple made their way inside, catching Meghan's cape in a cinematic whoosh. The sweetest detail was the lining of Harry's suit jacket, visible when it flapped open briefly. It was the same shade of green as his wife's dress, an unmistakable show of their strength and commitment as a couple.

Comparisons were drawn between Meghan's final look (especially her blue eyeliner!) and Princess Diana's style.

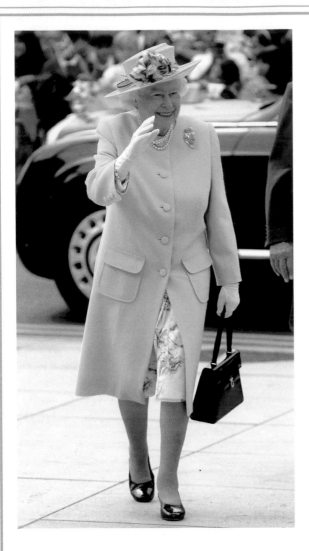
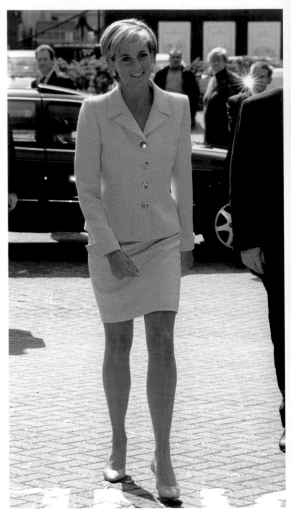

CLOSING THOUGHTS

WHILE WRITING THIS BOOK I FOUND MYSELF WONDERING WHICH OF THESE women I relate to the most. The answer is: all of the above! There are times I feel like the Queen, sensibly approaching my wardrobe as if it were a uniform. I definitely have an inner Diana, using style to delight, distract, or boost my mood. Some days I want to dig deep into my closet and re-wear a favorite piece as Kate might; on others, I am inspired to forge my own fashion-forward path like Meghan.

These women have given me a profound appreciation for fashion in its many iterations, and the ways in which clothing can support a much bigger goal. The Queen, Diana, Kate, and

Meghan have dressed extremely thoughtfully, perpetually balancing their own self-expression with honoring the family and tradition they so publicly represent. The spotlight comes with a very specific set of parameters and critics waiting to pounce. Each has risen to the occasion in her own unique way and used fashion to tell a story. I deeply admire all four of them.

But mostly, I hope that these women inspire you and your own wardrobe. We can all embrace and celebrate the power of fashion, and dress in a way that represents us and our values. The next time you pick out an outfit, stop to consider: what would you like your clothes to say about you?

ACKNOWLEDGMENTS

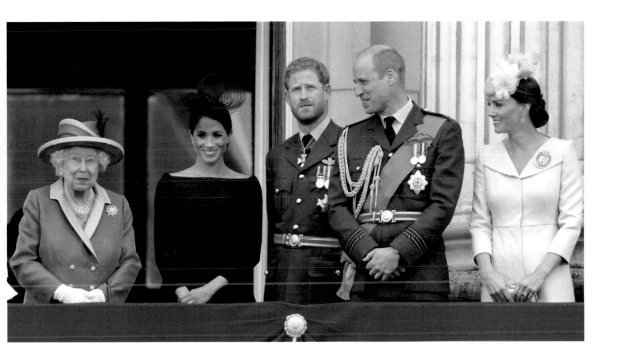

My work on *HRH* began in earnest about three weeks after the birth of my third child and finished in the midst of a global pandemic, and I could not have done it without the help of so many wonderful people.

First and foremost, my sincerest thanks to the *So Many Thoughts* Instagram community. Tens of thousands of you, scattered around the globe, have come together through a shared admiration of royal women and a belief in the power of fashion. My royal commentary began back in December 2017 while nursing my second son. Kate and Will's holiday portrait popped up on my Instagram feed and I had . . . so many thoughts! I took a screenshot, added an assortment of tiny text bubbles, and shared it with my followers. The response was unlike anything I had ever seen before, a flood of direct messages from people eager to discuss the picture. When Meghan and Harry released their engagement portraits a few days later, I weighed in again on Instagram. Same response! It was thrilling

to tap into a community of smart, enthusiastic women (and some fantastic men, too) who wanted to discuss royal fashion.

So Many Thoughts has evolved markedly since that first spontaneous posting, with more insights informed by more of my research. *HRH* was a thrilling way to expand beyond Kate and Meghan, a chance to dive deep into Elizabeth and Diana and explore the connections among them. I am so excited to share this book with you and deeply appreciative of your support. Your encouraging comments and messages kept me going—thank you, thank you!

The Celadon Books family—Ryan Doherty, Christine Mykityshyn, and Cecily van Buren-Freedman—enthusiastically took this project on and stuck with me as it grew in size and scope. I'll never forget Christine's energy in our first meeting or the exclamation points! From Ryan! Thank you for your patience and guidance; I am so honored to be a part of your small, mighty team. On the design side, Anne Twomey obsessed over the details of this cover with me; Shubhani Sarkar took all of my words and pictures and made them into this beautiful book. I am so grateful to you both.

Kate Childs is the true queen of this project. She saw the potential of *So Many Thoughts* beyond Instagram, and brought a vision and dedication to this book that made it immeasurably bigger and better. Kate went so far beyond what is required of an agent, editing copy, scouring photos, spending hours on video calls perfecting each page. She never let me settle, and was always ready with a tough-love pep talk. This book is as much yours as it is mine, Kate. My thanks to you and your outstanding crew—Evelyn Harbert, Darcy Donelan, and Khalil Roberts—for everything you all did to make *HRH* possible.

A group of talented individuals helped guide this book from its inception. Thank you to Allison Gumbel De Avila, photo editor extraordinaire, for finding and managing all of the gorgeous photos you have in your hands today. She jumped in at the beginning and stuck with me until the bitter end, through so many texts, and emails, and spreadsheets. Designer Elizabeth Spiridakis Olson delivered this gorgeous, thoughtful cover that I hope finds a special spot in your home. Editor Katie Adams came to my rescue more than once, shaping the text and tone of *HRH* into something both inspired by Instagram *and* worthy of a book. My trio of researchers, Katie Starr, Laura McCallen, and Tallulah Gradley, diligently dove into each of these subjects and provided robust weekly briefs that served as *HRH*'s foundation. Andy Young veered from his usual subject matter to fact-check *HRH*. My mentor, Teri Agins, graciously read the book early and provided her hallmark candid feedback. Lyneka Little and Epiphany Espinosa also shared their thoughts on the manuscript, which I appreciate so much. Thank you to all of the journalists, bloggers, and experts who spoke to me on and off the record; and to the veterans of the royal style world, especially Susan E. Kelley and Christine Ross, for their kindness.

Shout-out to my IRL friends who have indulged my royal enthusiasm for so many

years, even if (and especially when!) they did not share it: Erin, Jamie, Katie, Sarah, Lyneka, Loretta, Kim, Candace, Rachel, Eliza, Jarrard, Stacie, Katie, Jen, and Mo. You all are too good to me. And to Kit, I feel like you would've gotten a real kick out of this.

My family has been a wonderful source of much cheerleading long before this project began. My in-laws, Lois and Larry, bought me my first book about Kate nearly a decade ago; my sister-in-law, Sarah, always had a kind text at the ready. Thank you to my sisters, Emily and Carolyn, for your endless encouragement (and occasional tough love!) about *HRH* and the rest of life. Mom was right; you girls are my best friends. And Dad, thank you for always pushing me to reach higher . . . and for figuring out Instagram so you could keep tabs on what *So Many Thoughts* was all about! Mom, I love you and I miss you—and I wish you could have read *HRH*. What I wouldn't give to hear your thoughts on royal style.

To my boys, Fitzgerald and Oliver: thank you for understanding, as much as you could, why Mama was working so much. You served as a motivating force each day to wrap it up and get back to playing trains and reading books. Fitz, thank you for helping me pick so many pictures of the Queen. My book is finally done, can't you believe it? And, O, can I tell you something? Because that's all my day! To my sweet Eleanor: telling the stories of strong women with you by my side (first in my arms and then crawling around my feet) was a privilege. I hope to one day explain to you how we did this together, Bird.

And finally to Matthew, my rock. I pushed our little brood to the brink more than once in the name of this book. You always held us together. Thank you for believing in me, and in this project. Your love and support made *HRH* possible. This is for you.

SELECTED BIBLIOGRAPHY

Bates, Stephen. "William and Kate Leave Stars Starstruck at Los Angeles Dinner." *The Guardian*, July 10, 2011.

Bayley, Leanne. "Meghan Markle Chats to *Glamour* About VB Dresses, Her Personal Style & Her Fashion Cringe Moments." *Glamour*, May 22, 2017.

Bilyeau, Nancy, and Chanel Vargas. "The Story of Queen Elizabeth's Wedding Day." *Town & Country*, May 18, 2018.

Blanchard, Tamsin, and Tim Graham. *Dressing Diana*. United Kingdom: Weidenfeld and Nicolson, 1998.

"'Bobo' McDonald, Queen's Lifelong Servant, Dies at 89." *AP News*, September 23, 1993.

Borders, William. "Prince Charles to Wed 19-Year-Old Family Friend." *The New York Times*, February 25, 1981.

Bradford, Sarah. *Diana*. New York: Penguin Publishing Group, 2007.

Brown, Tina. *The Diana Chronicles*. New York: Anchor Books, 2007.

Burchill, Julie. *Diana: An Extraordinary Life*. United Kingdom: Phoenix Illustrated, 1998.

Clayton, Tim, and Phil Craig. *Diana: Story of a Princess*. New York: Atria Books, 2003.

Corbella, Licia. "Wild West Welcome to Calgary." *Calgary Herald*, July 8, 2011.

Crawford, Marion, 1950. *The Little Princesses: The Story of the Queen's Childhood by Her Nanny, Marion Crawford*. Foreword by Jennie Bond. 1st U.S. ed. New York: St. Martin's Press, 2003.

Darton, John. "Prince Charles, in TV Documentary, Admits to Infidelity." *The New York Times*, June 30, 1994.

Davides, Caroline. "Meghan Markle Begins Royal Induction with Nottingham Walkabout." *The Guardian*, December 1, 2017.

Diana: An Amazing Life: The People *Cover Stories 1981–1997*. New York: Liberty Street, 2007.

Diana: An Extraordinary Life. London: Phoenix Illustrated, 1998.

Diana: Her Fashion Story; an exhibition at Kensington Palace in 2017. London: Pitkin Publishing, 2017. Exhibition catalog.

Dismore, Jane. *Princess: The Early Life of Queen Elizabeth II*. Guilford, Conn.: Lyons Press, 2018.

Driscoll, Margarette. "'Diana Wept in Front of Me Before She Got Married': Designer David Sassoon on the Only Time He Saw the Princess He Helped to Become a Fashion Icon Cry." *Daily Mail*, February 4, 2017.

Eastoe, Jane. *Elizabeth: Reigning in Style*. London: Pavilion Books, 2012.

Edwards, Anne. *Royal Sisters: Queen Elizabeth II and Princess Margaret*. Guilford, Conn.: Lyons Press, 2017.

Edwards, Arthur. *Arthur Edwards' Magical Memories: The Greatest Royal Photographs of All Time*. London: John Blake, 2013.

———. "Q & A Weds." *Diana One Year On*. BBC Online Network.

Feitelberg, Rosemary. "The Meghan Markle Halo Effect Helps Lift Sales for Canadian Brands Line." WWD, November 28, 2017.

Forsey, Zoe. "Princess Diana Had a Burka Designed for Her 1986 Visit to Saudi Arabia—and the Sketches Are Fascinating." *Daily Mirror*, August 30, 2018.

Foussianes, Chloe. "Princess Diana Inspired Tory Burch's Latest Runway Collection." *Town & Country*, September 9, 2019.

———. "Queen Elizabeth's Umbrellas Are Custom Made to Match Her Outfits." *Town & Country*, March 23, 2019.

Francis, Ian. "Royal Wedding: Lip-reader Reveals the Moments of Harry and Meghan's Day That You Didn't Hear." *News Key*, May 21, 2018.

"From 80s Romantic to 90s Working Woman: The Key Dresses from the New Princess Diana Fashion Exhibition." *The Telegraph*, February 17, 2017.

Gere, Charlotte. *Garrard: The Crown Jewellers For 150 Years, 1843–1993*. London: Quartet Books, 1993.

Graham, Tim, and Peter Archer. *William: HRH Prince William of Wales*. New York: Atria Books, 2010.

Graham, Tim, and Tamsin Blanchard. *Dressing Diana*. London: Weidenfeld and Nicolson, 1998.

Guy, Jack. "Princess Diana 'Travolta' Dress Sells for $347,000." CNN, December 11, 2019.

Hallemann, Caroline. "The Story Behind That Stunning Photo of Prince Harry and Meghan Markle in the Rain." *Town & Country*, March 10, 2020.

Hartnell, Norman. *Silver and Gold: The Autobiography of Norman Hartnell*. London: V&A Publishing, 2019.

Harvey, Anna. "From the Archive: Anna Harvey on Princess Diana." *British Vogue*, August 31, 2017.

Hoey, Brian. *At Home with the Queen: Life Through the Keyhole of the Royal Household*. London: HarperCollins, 2003.

Holt, Bethan. "Why Princess Diana's Revenge Dress Is Still Relevant, 25 Years On." *The Telegraph*, June 26, 2019.

Horyn, Cathy. "Diana Reborn." *Vanity Fair*, July 1, 1997.

"How Princess Diana Changed Attitudes to AIDS." BBC, April 5, 2017.

Hughes, Sali. *Our Rainbow Queen: A Tribute to Queen Elizabeth II and Her Colorful Wardrobe*. London: Penguin Publishing Group, 2019.

Indvik, Lauren. "First Look: Virgil Abloh's Princess Diana–Inspired Collection for Off-White." *British Vogue*, September 28, 2017.

"It's a Little Princess!" *People: Royal Baby special issue*, Summer 2015.

Jephson, Patrick. *Portraits of a Princess: Travels with Diana*. New York: St. Martin's Press, 2004.

Jobson, Robert, and Ken Wharfe. *Guarding Diana: Protecting the Princess Around the World*. London: John Blake Publishing, Limited, 2018.

Junor, Penny. *The Firm: The Troubled Life of the House of Windsor*. New York: St. Martin's Press, 2008.

Katz, Gregory. "BBC DJ Fired After Royal Baby Tweet with Chimpanzee Picture." *AP News*, May, 9, 2019.

Kay, Karen. "How the Queen Led the Way in Power-Dressing for the World Stage." *The Guardian*, April 2, 2016.

Kelley, Kitty. *The Royals*. New York: Grand Central Publishing, 2009.

Kelly, Angela. *The Other Side of the Coin: The Queen, the Dresser and the Wardrobe*. London: HarperCollins, 2019.

Kyung Kim, Eun. "Photographer Shares Story Behind Iconic Princess Diana Moment." *Today*, May 2, 2017.

Lara, Maria Mercedes. "Why You'll Probably Never See Princess Diana's Wedding Tiara on Princess Kate." *People*, March 25, 2016.

Leaper, Caroline. "All Hail the Silk Scarf: How the Queen's Favourite Accessory Made a Catwalk Comeback This Fashion Month." *The Telegraph*, March 7, 2017.

Lyall, Sarah. "Diana's Legacy: A Reshaped Monarchy, a More Emotional U.K." *The New York Times*, August 30, 2017.

Mackelden, Amy. "More than 70 Female British Politicians Sign a Letter Supporting Meghan Markle." *Harper's Bazaar*, October 29, 2019.

"May 1954: Queen Returns After Lengthy Tour of Commonwealth." BBC News, April 4, 2012. First broadcast May 15, 1954.

McGhie, Caroline. "The Way We Lived." *The Telegraph*, March, 20, 2002.

Morton, Andrew. *Diana: Her True Story, in Her Own Words*. Completely revised edition. New York: Simon & Schuster, 1997.

Moss, Victoria. "Why Catherine Walker Was the Woman Who Dressed Diana Best." *The Telegraph*, February 18, 2017.

Mower, Sarah. "Stephen Jones, Bruce Oldfield, and More of the Designers Who Dressed Her Remember Princess Diana." *Vogue*, August 29, 2017.

———. "The Designers Who Kept All Her Secrets and How She Used Her Headgear for Diplomacy: The Hats That Made Diana Feel Like a Princess." *Daily Mail*, August 16, 2017.

Murphy, Deirdre, and Cassis Davies-Strodder. *Modern Royal Fashion: Seven Royal Women and Their Style*. London: Historic Royal Palaces, 2015.

Mzezewa, Tariro. "Diana Was the People's Princess. What Might Meghan Markle Be?" *Vanity Fair*, May 11, 2018.

National Geographic. *Remembering Diana: A Life in Photographs*. Washington, D.C.: National Geographic Society, 2017.

Nicholl, Katie. *Kate: The Future Queen*. New York: Hachette Books, 2015.

———. "Kate Middleton's Royal Catwalk." *Vanity Fair*, August 20, 2012.

Okafor, Kelechi. "Dear Meghan, Now You Know the U.K.'s Deep Dark Secret." *Essence*, January 20, 2020.

Ostler, Catherine. "Nostalgia: Queen Elizabeth II's Style Evolution." *British Vogue*, June 1, 2012.

Perry, Simon. "Celebrating Queen Elizabeth and Prince Philip's Incredible Love Story." *People*, June 10, 2018.

Peters, Marquita. "Bishop Michael Curry's Royal Wedding Sermon: Full Text of 'The Power of Love,'" *NPR*, May 20, 2018.

Peyton-Jones, Julia. "Inside the Party Where Princess Diana Wore the Revenge Dress: 'She Showed Dignity and Grace, Giving No Hint Anything Else Was on Her Mind.'" *The Telegraph*, December 29, 2019.

Phillips, John. "Britain's Prince Charles and Princess Diana Embark Friday On . . ." UPI, April 19, 1985.

"Princess Elizabeth Starts Training to Be ATS Officer." *The New York Times*, March 5, 1945.

"Queen Wears 'Recycled' Dress to Banquet in Toronto." *Fashion Telegraph*, July 6, 2010.

Rainey, Sarah. "Diana's Dress of the Century: Mystery of the Back-up Wedding Gown That Vanished, How Her Waist Shrank Five Inches in Six Months and a Secret Message in Her Shoes." *Daily Mail*, August 17, 2017.

Rogo, Paula. "How Meghan Markle Made Sure Her Blackness Was Represented at the Royal Wedding." *Essence*, May 19, 2018.

Rothman, Lily. "The World War II Auto Mechanic in This Photo Is Queen Elizabeth II. Here's the Story Behind the Picture." *Time*, March 25, 2018.

Rothman, Michael, and Lesley Messer. "Full Transcript of Prince Harry and Meghan Markle's Engagement Interview." *ABC News*, November 27, 2017.

"The Royal Family's Visits Around the Commonwealth." Royal UK.

Schibli, Jana. "Pretzels, Switchboards and Faux Fur: The Royals' Most Controversial Hats." *The Guardian*, November 6, 2019.

Scobie, Omid, and Carolyn Durand. *Finding Freedom: Harry and Meghan and the Making of a Modern Royal Family*. New York: Dey Street Books, 2020.

"See Who Is Part of the Queen's Team of Trusted Aides." *Hello! Canada*, April 20, 2016.

"70 Facts About the Queen and the Duke of Edinburgh's Wedding." Royal UK, the Royal Family's official website.

Smith, Sally Bedell. *Elizabeth the Queen: The Life of a Modern Monarch*. New York: Random House Publishing Group, 2012.

Sullivan, Rebecca. "New York–based Designer Jason Wu on What It's Like to Dress Meghan Markle." *News.com*, March 16, 2018.

"Their Perfect Day." *People*, May 16, 2011.

Vargas, Chanel. "Princess Michael of Kent Apologizes for Wearing Racist Brooch to Lunch with Meghan Markle." *Town & Country*, December 27, 2017.

Walano, Rose. "Meghan Markle's Necklace Is Further Proof of Her Relationship Status with Prince Harry." *US Weekly*, December 6, 2016.

Weinraub, Judith. "They Make Their Clothes Fit for Their Queen." *The New York Times*, July 4, 1976.

Weisbrode, Kenneth. *Churchill and the King: The Wartime Alliance of Winston Churchill and George VI*. New York: Penguin Books, 2015.

"What Makes Kate Great." *People: Kate's Style special issue*, September 2011.

Whittaker, Alexandra. "Why Meghan Markle's Wearing So Much Pink, According to Royal Experts." *InStyle*, June 27, 2018.

"Why Can't Meghan Markle Keep Her Hands off Her Bump? Experts Tackle the Question That Has Got the Nation Talking." *Daily Mail*, January 26, 2019.

Yuhas, Alan. "Prince Harry Retraces Princess Diana's Steps in Angolan Minefield." *The New York Times*, September 27, 2019.

PHOTO CREDITS

Kristina Bumphrey/Starpix/Shutterstock: *p. 259 (C)*

Cassidy and Leigh/Shutterstock: *p. 158*

Alan Davidson/Shutterstock: *p. 170 (right)*

Reginald Davis/Shutterstock: *p. 79 (top)*

Darren England/EPA-EFE/Shutterstock: *p. 290 (B)*

David Fisher/Shutterstock: *p.195 (C)*

Li Gang/Chine Nouvelle/Sipa/Shutterstock: *p. 71*

Javier Garcia/BPI/Shutterstock: *p. 300 (A)*

Paul Grover/Shutterstock: *p. 130*

Neil Hall/EPA-EFE/Shutterstock: *p. 232 (B)*

Terry Harris/Shutterstock: *p. 308*

David Hartley/Shutterstock: *pp. 143 (top), 194 (B)*

David Hartley/Rupert Hartley/Shutterstock: *pp. 195 (D), 200*

Rupert Hartley/Shutterstock: *pp. 201, 294 (A)*

Nick Harvey/Shutterstock: *p. 263*

Andy Hooper/Associated Newspapers/Shutterstock: *p. 228 (A)*

Chris Jackson/Pool/EPA-EFE/Shutterstock: *pp. 233, 307 (D)*

Nils Jorgensen/Shutterstock: *pp. 148, 164, 199 (D)*

Dominic Lipinski/Shutterstock: *p. 156 (bottom)*

Dominic Lipinski/PA/EPA-EFE/Shutterstock: *p. 299*

Stephen Lock/Shutterstock: *p. 170 (left)*

Mediapunch/Shutterstock: *pp. 248, 260 (B)*

Yui Mok/Pa Wire/Shutterstock: *p. 67*

Eddie Mulholland/Shutterstock: *p. 196*

Geoff Robinson Photography/Shutterstock: *p. 281*

Tim Rooke/Shutterstock: *pp. 68 (A), 73 (bottom left), 83 (right), 153 (C), 174, 197 (C), 198 (A), 202, 215, 216 (A), 217 (C), 227, 245, 252, 267 (C), 270 (A), 294 (B), 295 (C), 303 (right), 309*

David Rose/Shutterstock: *p. 191 (D)*

James Veysey/Shutterstock: *p. 226 (B)*

KARA BRIDGESELL

ELIZABETH HOLMES is a journalist and contributing editor to *Town & Country*. She spent more than a decade on staff at *The Wall Street Journal*, most recently as a senior style reporter and columnist. Her work has also appeared in a host of national publications, including *The New York Times*, *InStyle*, *Real Simple*, and *The Business of Fashion*. Elizabeth lives outside of San Francisco with her husband and three children.

CELADON
BOOKS

Founded in 2017, Celadon Books, a division of
Macmillan Publishers, publishes a highly curated list
of twenty to twenty-five new titles a year.
The list of both fiction and nonfiction is eclectic
and focuses on publishing commercial and literary books
and discovering and nurturing talent.